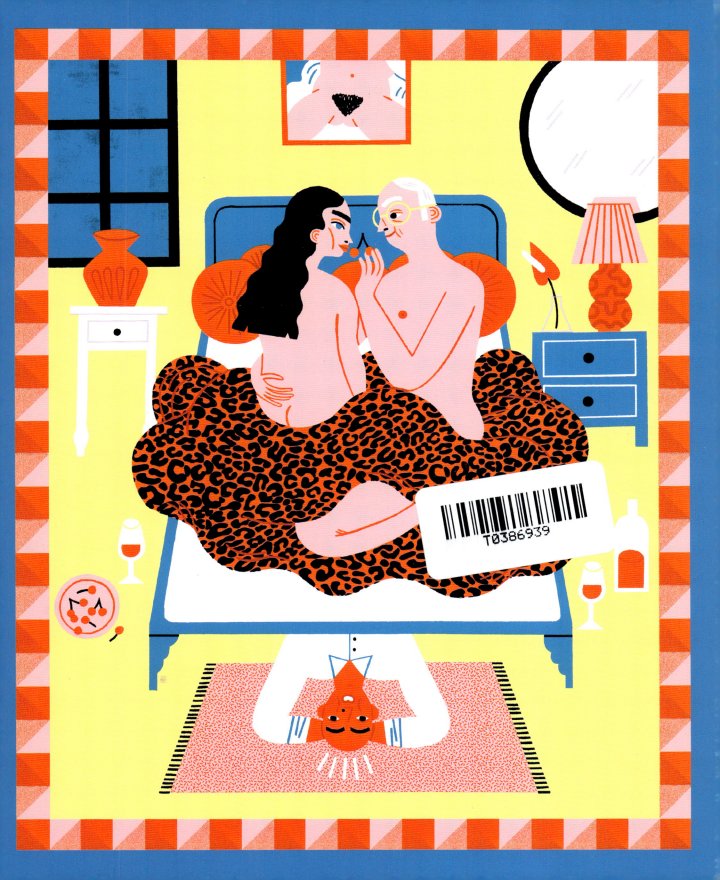

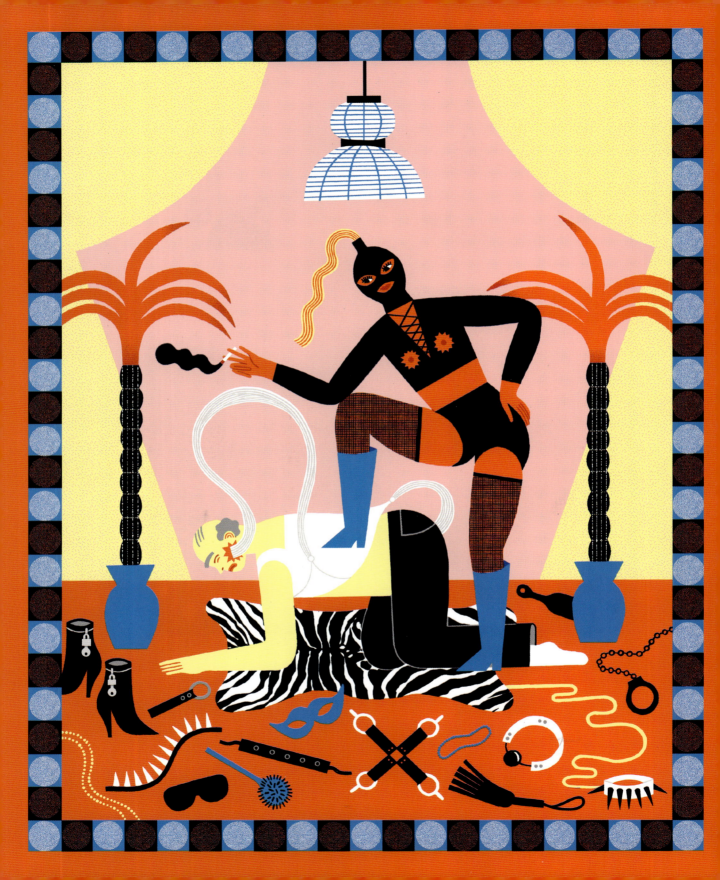

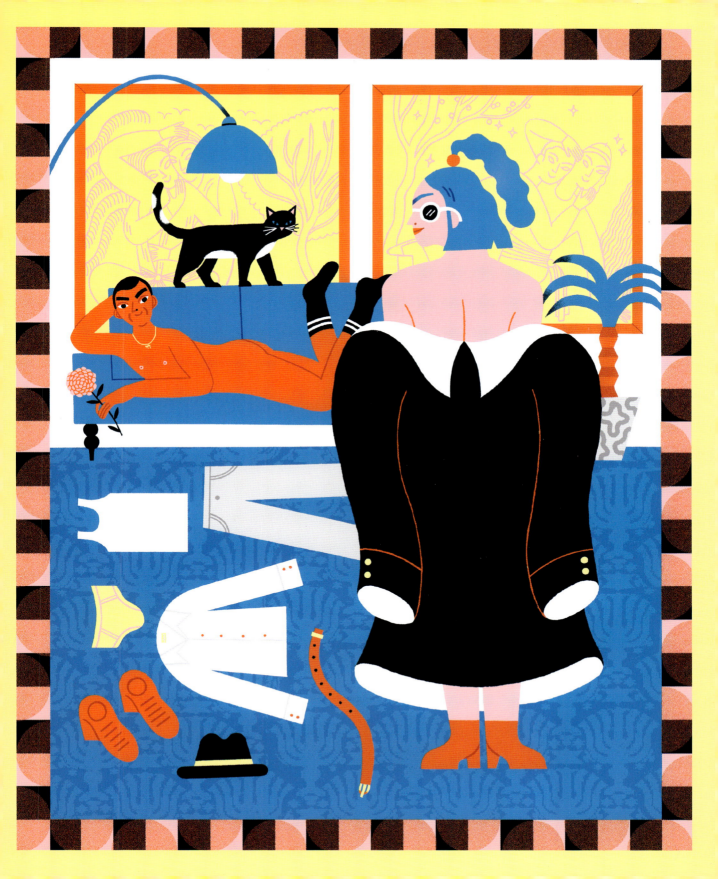

HIRMER

Edited by
Miriam Goldmann,
Joanne Rosenthal,
and Titia Zoeter

Sex
Jewish Positions

Joods Museum

JÜDISCHES MUSEUM BERLIN

Contents

A Word from the Museum Directors	9
Introduction by the Curators *Sex: Jewish Positions*	11

I Procreation and Pleasure 15

Evyatar Marienberg
Traditional Sexual Instruction 21

Gail Levin
Women's Sexuality in the Work of Jewish-American Feminist Artists 27

Michal Raucher
Babies, Bodies, and Books: Haredi Women's Reproductive Ethics 35

Gil Yefman
Artist Statement 63

II Desire and Control 65

Interview with Talli Rosenbaum
"Sex Is a Force" 71

David Sperber
The Art of Breaking Taboos 79

Ronit Irshai
Sexuality and Gender 85

III Sexuality and Power 115

Ilka Quindeau
Freud and His Sexual Theory 121

Nathan Abrams
Jewish Sexuality on Film 127

Rainer Herrn
Magnus Hirschfeld and the Birth of Sexual Science as an Emancipatory Discipline 133

IV Eroticism and the Divine 167

Jay Michaelson
The Eruption of Eros in Jewish Messianic Heresies 173

Ilana Pardes
The Song of Songs: Between Literal and Allegorical Loves 181

Appendix 203

Authors	204
Index of Exhibited Works	206
Acknowledgements	213
Literature	214

A Word from the Museum Directors

Hetty Berg, Jewish Museum Berlin
Emile Schrijver, Jewish Museum, Amsterdam

Why put on an exhibition about sex and Judaism?
Indeed, most of what we know about Jewish sexuality today comes from movies and TV shows—and unsurprisingly, that knowledge rarely rises above stereotypes. Disrupting these stereotypes is the goal of our exhibition, *Sex: Jewish Positions*. Through ancient texts, artworks old and new, and at times surprising objects, we have showcased the diversity of Jewish attitudes towards this subject. The religious rules about sexuality, as with every aspect of Jewish tradition, are not set in stone. They can evolve to suit current realities of life and shifting social structures through a process of interpretation, discussion, and fresh insight. This adaptability and flexibility have enabled Judaism to sustain itself over centuries. We can see it both in medieval rabbinical discussions around whether financial hardship exempts a couple from the commandment to "be fruitful and multiply" and in deliberations about how women can observe the laws of family purity when mikvahs (ritual baths) are closed during a pandemic. Traditional interpretations have been questioned anew in every generation, and so we are inviting our visitors now to acquaint themselves with the full spectrum of traditional and modern attitudes towards Jewish sexuality and identity.
It is our immense pleasure to present an exhibition that has emerged from a thorough collaboration between the Jewish Museum Berlin and the Jewish Museum in Amsterdam. The exhibition was envisioned and planned in close cooperation between our teams; we are grateful to everyone involved, especially the curators and staff for their tireless efforts. Assembling objects from various collections for an interdisciplinary exhibition is always a serious undertaking, and we could never have made this innovative and at times provocative show happen without our lenders, artists, and sponsors, to whom we likewise extend our deep gratitude.
We hope that *Sex: Jewish Positions* will reach a wide audience—and offer some new answers to the questions about sex—and Judaism—you were afraid to ask.

Sex: Jewish Positions

Joanne Rosenthal, Miriam Goldmann, Titia Zoeter

In recent years there has been a notable rise in interest on the topic of Jews and sex in popular culture. Award-winning dramas including *Unorthodox* and *Shtisel*, as well as reality TV and dating shows such as *My Unorthodox Life* and *Jewish Matchmaking,* all seem to satisfy—as well as generate—a surprisingly large appetite for peering into the intimate lives of Jews, be they ultra-Orthodox, secular, or somewhere in between. However well intentioned, these productions often obscure as much as they reveal, rarely offering much more than reductive or stereotypical representations of how Jews love and make love.

Alongside this rising interest in the wider public is a fascinating shift in the nature and volume of conversations on sex and Judaism within the Jewish world itself. Popular podcasts, sex therapists, religious leaders, and organizations are tackling communal taboos and opening up frank discussions about sexuality, Judaism, and the intersections between the two.[1] These emerging voices are navigating what a Jewish sexuality might look like in a world of unprecedented sexual and gender diversity, reckonings with issues of consent and abuse, and rapidly changing social mores.

Sex: Jewish Positions was conceived and developed in this climate, a time in which ideas of sexuality and Judaism are being examined from both the outside and within. As the title suggests, the exhibition seeks to present Jewish positions (pun intended!) on sex in all their diversity. At its core is the assertion that Jewish tradition cannot be characterized as either affirming or repressing sexuality. Both can be true, as well as everything in between; it is simply a question of whose position you take. Judaism does not speak with one voice on any issue, and sex, a fundamental element of Jewish life and law, is of course no exception. The exhibition therefore presents multivocal perspectives—of Talmudic sages and contemporary artists, of medieval philosophers and sex therapists, of mystical thinkers and TikTok commentators.

While the focus is on presenting differences, contradictions, and a variety of positions, when we look at rabbinic literature throughout the ages, certain areas of consensus start to emerge. Heterosexual marriage is presented as the only

context for "kosher" sex, and a couple's sex life is regulated with extreme precision through the laws of *taharat ha-mishpahah*, or family purity,[2] which prohibit sex during and immediately after menstruation.

But even within the certainties of Jewish law, the ambivalences are difficult to miss. When, in the opening book of Genesis, God commands humans to "be fruitful and multiply," the first Jewish sexual ethic was born, privileging reproduction as a religious duty. Furthermore, throughout rabbinic literature the demonization of male masturbation and sex acts which "waste seed" suggest the main purpose of sex to be the creation of new life. And yet, the principle of *onah,* the husband's legal requirement to sexually satisfy his wife, is not confined to procreative sex alone but extends beyond the wife's childbearing days and applies equally to couples who aren't able to conceive. Pleasure and restraint are generally held in a dialectical relationship; the sexual drive, commonly associated with the *yetzer ha-ra* or "evil inclination," is often viewed as a dangerous threat, one which must be carefully channeled towards religiously appropriate ends.

Sex: Jewish Positions explores the early Jewish positions found in the Talmud and the canon of rabbinic literature, bringing these into conversation with contemporary and modern art, historic objects, manuscripts, film, audio, and social media. Rather than exhaustively presenting a continuous history, it shines a light on discontinuous positions, drawn from centuries of debate and social norms, making unexpected connections across time. The diverse material on display is organized into thematic sections which were conceived through extensive conversations within the curatorial team, aimed at distilling the principal positions into four constellations of meaning. This publication is organized according to this thematic structure and offers a chance to expound on the exhibition topics in greater depth.

The first of the four core themes, "Procreation and Pleasure," explores the centrality of marriage and reproduction in Jewish tradition, the complicated meanings of sexual pleasure, and the resonance of these ideas in the present day. "Desire and Control" looks at notions of bodily purity, the control of sexual urges, and attempts at reconciling religious regulation with sexual liberation. "Sexuality and Power" considers the role taboo and fantasy play in expressions of human sexuality, the influence of pioneering thinkers such as Sigmund Freud on how we understand sexuality, as well as the relationship between sexuality and identity building, both in terms of the collective and the self. Finally, "Eroticism and the Divine" illustrates the fascinating links between the erotic and the divine in mystical thought, ritual, and worship, and explores the influence of the Song of Songs, an extraordinary collection of erotic poetry in the Hebrew Bible, famously described by the first century scholar Rabbi Akiva as the "Holy of Holies."

These themes are investigated through the assembly of rare and beautiful objects and artworks loaned from public and private collections across Europe, North America, and Israel. In addition, the exhibition features new commissions, including a series of illustrations by Noa Snir, an Israeli artist based in Berlin, which bring to life a selection of sexually explicit Talmudic scenes and discus-

sions. This series highlights the fact that the Talmudic rabbis were far from prudish in their sensibilities and frequently argued amongst each other on all aspects of sexual ethics.

One of the most curious scenes in this series comes from Tractate Berakhot[3] in the Babylonian Talmud. The story describes how, as a young man, the great sage Rav Kahana sneaked into his teacher Rav's bedroom to observe and learn from his behavior during sexual intercourse. Hiding under the bed as Rav and his wife made love, Kahana is shocked to witness Rav's playfulness and affection towards his wife, perhaps expecting something more restrained from the revered teacher. When Rav finally realizes in horror that Kahana is spying on him and his wife in this most private of moments, he angrily orders his student to leave. Interestingly, the Talmud gives the last words to Kahana, who, rather than offering a respectful apology to his teacher, presents an extraordinary defence of his snooping: "This is Torah and I must learn."

Whether or not Rav Kahana succeeded in convincing the sages of the Talmud on this point, this scene has served as an ongoing inspiration for the development of the exhibition. The audacity of Kahana to insist on his innocence in this moment is astonishing, as is his confidence in proclaiming sex as inseparable from Torah. It's the audacious voice of Kahana to which we have turned throughout the curatorial process as a steadying reminder of the value of this topic—not just as a field of study, but as a subject worthy of being interrogated in an exhibition.

Whichever "Torah" it is that you follow—sacred or profane!—we hope you will uncover many pleasurable surprises, and much to learn.

1 The podcasts *Intimate Judaism* (2018–present) and *The Joy of Text* (2016–2022) are indicative of this trend. Both jointly presented by an Orthodox sex therapist paired with a Rabbi, they explore sexual issues pertaining to the Orthodox world and interpret relevant religious texts as well as feature guests from the therapeutic, religious, and academic worlds.

2 The laws of family purity (in Hebrew, *taharat ha-mishpahah*) originate in the purity laws found in Leviticus, and were later developed in the Talmud and further rabbinic literature. According to these laws, the husband and wife can have no physical contact during and immediately after menstruation. Sex is only permitted after the woman immerses in a mikvah, or ritual bath. These laws regulate the couple's sexual intimacy and are considered fundamental religious obligations, observed very strictly by Orthodox Jews.

3 More specifically, Berakhot 62a; another version of the same story can be found in Hagiga 5b, also in the Babylonian Talmud.

Procreation and Pleasure

Love, lust, stress relief, even jealousy...there are many reasons that drive people to have sex. But when we look at how Jewish law approaches the subject of sex, religious duty is the focus of attention, more than emotional or physical needs.

In the first chapter of Genesis, when God commands Adam and Eve to "be fruitful and multiply," the biological drive to reproduce was recast as a divine commandment of profound religious importance. These words, although directed at the mythic first couple, are the blueprint for a Jewish ethics of reproduction, guiding observant Jews in their sex lives to this day. The influence of this biblical commandment can be seen in many contemporary ultra-Orthodox Jewish communities in which married couples are often expected to produce children as soon as possible and have large families. Concerns over Jewish continuity have also intensified the meaning of the religious imperative to reproduce, particularly after the devastation of the Holocaust.

But medical advancements over the past hundred years have dramatically changed the relationship between sex and reproduction. Sexual intercourse is no longer the only route to creating new life. Treatments such as IVF (in vitro fertilization) and legal structures such as surrogacy now offer new reproductive opportunities for single parents, people with fertility issues, or those in same-sex relationships. If reproduction is considered by some to be a religious duty, sex is no longer the only means to fulfill this duty. Nor does sex need to lead to reproduction. Access to contraception is now widely considered a human right, and new, more effective contraceptive methods have created the conditions for increased sexual freedoms.

Modern medicine may have enshrined the idea that sex is not solely a means to a (reproductive) end, but this idea—that sex can be an end in itself—is found in the Jewish tradition as well. The ancient sages who shaped Jewish law were interested in questions of sexual pleasure, not just making babies, and rabbinic literature encompasses a wide range of voices,

from the repressed to the affirmingly erotic. Some religious thinkers, particularly those in the Kabbalistic tradition, celebrated sexual pleasure as an expression of God's will, while others saw it as a sinful indulgence which must be minimized where possible.

Although famously lenient in some matters of sexual conduct, the twelfth-century philosopher Maimonides is harsh in his judgement of sexual excess, viewing it as shameful and animalistic. In his masterwork, the *Mishneh Torah*, Maimonides denounces men who enjoy excessive sexual activity with their wives, as behaving "like a rooster," issuing praise instead on those who minimize their sexual conduct where possible.[1] Perhaps in response to Maimonides is the anonymously authored thirteenth-century Kabbalistic work, the *Iggeret ha-Kodesh* (Holy Letter). In what could be considered one of the earliest Jewish sex manuals, the author provides detailed instructions on how to arouse and please one's wife, characterizing sex as a phenomenon that is transcendent and divinely inspired.

The pages of the Talmud are filled with rabbinic voices debating what is permitted in the bedroom, often in explicit detail. For some, a couple's desires are a private matter for them alone to decide, while others take a stricter view, issuing prohibitions on specific sexual activities. It is interesting to note that many of the prohibited acts are those which serve no procreative function, simply offering sexual pleasure. While many opinions are expressed as to what is allowed and what is forbidden, two important points of consensus appear in Jewish law: the husband has a duty to provide his wife with sexual fulfillment on a regular basis (the biblical commandment of *onah*)[2] and sex must be consensual.[3] The reference to husband and wife here is deliberate, as whether for procreation or pleasure (or perhaps both!), traditionally speaking, Jewish law only permits sex in the context of heterosexual marriage. In the religious tradition, it is marriage that sanctifies sex, elevating it from a physical act to something infused with spiritual meaning. This can be deduced through the language used for

the wedding ceremony, as the Hebrew word for the betrothal ritual is *kiddushin*, meaning "sanctification."

It should be noted that for those who live according to traditional Jewish law, marriage represents a dramatic shift in their relationship to sexuality. In Orthodoxy, premarital sex is strictly forbidden and physical contact with the opposite sex is limited. However, as soon as a couple are married, a dramatic reversal takes place: previously prohibited, sex becomes not only permissible but also a religious duty, both for procreation but also for its own sake. The religious principle of *shalom bayit*, or domestic harmony, offers another framework for negotiating sexual intimacy. If something can be said to enhance *shalom bayit* and promote marital peace, there is often room to negotiate for greater leniency on sexual matters.[4]

However, reality is more complex than anything which can be codified into written form. Even within traditional Jewish life, laws rarely align neatly with lived experience. And as new interpretations of Jewish law—and new expressions of Jewish sexuality—continue to emerge, the picture becomes both complicated and enriched. Successive waves of feminism and the growth of the LGBTQ+ movement have reshaped both the institution of marriage and what can be said to constitute "sanctified sex." Furthermore, beyond the parameters of religious thought, Western, secular cultures offer a set of different positions on sex, including the notion that sexual freedom and expression are vital to human happiness. From religious to secular, gay to straight, it is clear that many positions exist as to what sex is for—and how it should be done.

[1] Maimonides, *Mishneh Torah*, Issurei Biah, 21:9,11.

[2] The commandment of *onah* first appears in the Hebrew Bible in Exodus 21:10 in a list of three things a husband must provide for his wife: food, clothing and *onah*. Although the word *onah* literally means "time" or "season," it is understood in this context to mean conjugal rights or sexual intimacy and is an important legal concept developed further in rabbinic literature.

[3] Marital rape is prohibited explicitly in the Talmud; see Tractate Eruvin 100b.

[4] As one example, in this online forum an anonymous author asks a rabbinic authority for permission to masturbate in order to preserve *shalom bayit* with his wife, who has less in interest in sex than her husband: https://asktherav.com/16810-a-sensitive-marital-question/.

Traditional Sexual Instruction

Evyatar Marienberg

At some point, generally during the second decade of our lives or a few years earlier, most of us become interested, to a small or a large extent, in sex. If a natural curiosity will not pull someone earlier to reflect on the issue, hormones later will. Our young selves may ask, what is sex about? What do people who have sex actually do? Often, the information we get is rather brute. Most humans now and in the past probably were not immediately offered, the moment they expressed an interest in the matter, a crash course adapted for them and prepared by experts of sexuality, child psychology, education, law, and health. But we get some information, from someone, somehow, and it becomes our first piece of knowledge on the matter. Later, maybe a few or more than a few years later, as we age, we might want to know more by actively seeking such information from family members, friends, or, if we are literate, written works. Today, it is almost certain that the main source most people worldwide use to get that knowledge is the Internet, and that much of the information they encounter there is likely to be, literally, graphic. In the not-so-distant past, most information was probably given to them orally through friends and family. And yet, there were always people who got this information, directly or indirectly, from written sources.

Of all the many interesting and important questions about Jews and sex, mine is the following: when literate Jews, through the ages, searched Jewish books for clear, technical, no-nonsense, sexual instruction—and they surely did, just as they looked in these books for so many other pieces of guidance—what did they find? What did those sources tell them to do, or not to do? It should be clear that my question is, by definition, limited to a very specific type of sexual activity:

heterosexual marital. Instructions about all other types of sexual activity were almost always brief: don't. Instructions about marital heterosexual relations were almost always longer: do, but in the way I tell you to. I will try to provide a few insights into what was prescribed by different authors of many times and places.[1]

Where should we start our survey? Naturally, many might argue, with the Bible. The Bible—and here, the word Bible refers only to books that are considered part of the Jewish Bible—supposedly acts as the basis of anything Jewish. Does the Bible, a complicated collection of texts, guide its readers regarding sex? Does it instruct them to have relations and tell them how? Not too frequently, we must admit. The blessing "Be fruitful and multiply" in Genesis 1:28 clearly encourages reproductive sexual activity, but it does not guide humans how to do it. Not many biblical texts, if any at all, tell how to have relations in a prescriptive way. One exception though is another famous text from the book of Genesis: "That is why a man leaves his father and mother and is united to his wife, and they become one flesh" (Genesis 2:24). We will concentrate on the three later parts of the verse: "a man leaves his father and mother," "is united to his wife," and "they become one flesh." The first one, the "That is why," we will keep for another opportunity. One possible interpretation of this verse is that the first two of these segments describe a reality: Men leave their parents and unite with their wives. Linguistically, this is most probably the correct meaning, as the form used here is generally used to describe a habit. Another possibility though is that the verse prescribes good behavior: Men should leave their parents and unite with their wives. Even if perhaps not exactly the original meaning, it was clearly read like this by many. The end of the verse can also be read in various ways, for example, that the "becoming one flesh" happens in their conjugal union, or that the "one flesh" is the offspring—one flesh made from and by two. Taking these possibilities into account, one possible reading is that the first part of the verse describes a desired behavior, and the second, an outcome: Men should leave their parents and become "one flesh" with their spouse. If we adhere to this reading, union of the flesh, which is probably a reference to penetration, when one body gets into the other, seems to be condoned, or even wished for, by this verse. Together with the verse about procreation in the first chapter of Genesis, one can say that we have already two positive statements about conjugal relations in the first fifty-five verses of the Bible. But how exactly this union should take place, we are still not told.

In some other biblical books, we do find direct or indirect references to sexual relations, including in a few cases material that can be read as describing the "how-to" of sexual relations (marital or not). Thus, for example, several passages suggest that using perfumes, scented oils, beautiful clothes, and sumptuous bedclothes can attract and arouse the partner (Ezekiel 23:40–41; Proverbs 7:16–17; Ruth 3:3; Song of Songs 3:6 and various other verses in the same book; Esther 2:12). One can also learn that there can be an element of joy in sexual relations (Genesis 26:8), and that alcohol can enable unconscious or less-conscious sex (Genesis 19:31–36). Both men and women can initiate sex (Genesis 30:16). Sexual

relations may include the revealing of the man's lower parts (Ruth 3:4,8), spreading of the woman's legs (Ezekiel 16:25), active repeated movements (Job 31:10), and fondling and caressing of breasts and bosom (Ezekiel 23:3,8; Proverbs 5:19). In one book—the strongly erotic Song of Songs—one can also hear that a man might enjoy holding the woman's breasts and resting between them (Song of Songs 1:13; 7:9), and that an appropriate position during intimate relations is one in which the man's left arm is under the woman's head, and his right arm embraces her (Song of Songs 2:6). And last, but certainly not least, in one place in the Bible—the story of Samson and Delilah—acts that we might describe today as "bondage, discipline, sadism, and masochism," or "BDSM" for the connoisseurs, are rather apparent. At least, it seems to be a plausible reason for why Samson asked his fair lady, Delilah, to tie him with ropes (Judges 16:4–22).

All these texts where the how of the sexual act is discussed in the Bible are not much by way of guidance. Jewish authors had more than enough freedom to bring their own ideas on the matter. The next major corpus of Jewish writings, texts that are part of the Talmudic literature, do not contain any systematic discussion of the matter, but include many, generally short, statements that, if taken together, can provide some guidance to readers. These statements and stories speak about the when of relations (day, night, midnight, certain days of the week or the year), the right frequency (from daily to twice a year), the setup (in a dark or lit room, in the presence or not of others, near sacred objects), the initiators (the husband, the wife), foreplay, legitimate and less legitimate positions, the length of the act, the partners' behavior (talking, keeping silent, being dressed or undressed), and more. In fact, the wealth of information on the matter in the Talmudic literature is substantial, and those ideas and prescriptions cover a very significant part of any list of possible questions a reader might have. Theoretically then, later authors did not have much wiggle room to bring their own ideas. In reality, though, most of these Talmudic texts are not entirely clear, can include different or even contradicting opinions, and are not developed enough to become actual guidance. Even more significant is the fact they are not organized in any way in the vast Talmudic literature, and are spread, often for obscure or random reasons, over thousands of pages of non-related material. Without being systematized and explained, they cannot be considered very useful for lay people, even those with a decent level of literacy. Medieval, early modern, and modern authors had still a rather open field of knowledge in which they have been able to bring their thinking on the matter. And yet, with the Talmudic literature becoming so central in rabbinic culture, they always had to do it by using their selection of those Talmudic texts as building blocks for their own teachings.

It seems useful to divide most subsequent Jewish works on the matter, at least until the mid-twentieth century, into two main groups: on the one hand, authors who base their instructions on what they consider to be reason (as much as, of course, "reason" can be a part of any discussion in the context of revealed religion), and authors for whom mystical, or Kabbalistic, concepts are of paramount

importance. In some cases, these variances resulted in contrasting interpretations of the rationale behind Talmudic texts. Thus, for example, if a Talmudic text says that relations should happen around the middle of the night, rationalists explained this by issues of privacy or digestion, while mystics saw this rule as an attempt to imitate divine realities. And if the Talmud spoke about Friday night as an appropriate time for relations, rationalists explained this by referring to the burdens of weekdays, while mystics saw it as related to the cosmic movement of souls. Talmudic discouragement of certain positions, or of relations in a lit room, was explained by rationalists as an attempt to keep the dignity of the partners, while mystics saw it as a means to protect the couple from destructive invisible forces. The very act of relations was seen by rationalists as a means to fecundity, a health issue, and an essential element of marriage, while mystics saw it as a tool to repair the brokenness of the world. One should note that it is not possible to characterize any one of these two schools as more or less permissive than the other, or as seeing sexuality in a more positive or negative way. All those shades exist in the writings of both the rationalists and the Kabbalists.

Since around the middle of the twentieth century and until today, many stand-alone books on the matter have appeared in Orthodox circles. Differences in their authors' attitudes to reason and mysticism can explain some of the discrepancies between them, but factors such as psychological concepts, modern understanding of physiology, gender roles, equality, the search for happiness and fulfillment, new age ideas, and even political stands, are of great, and often greater, importance. Many authors selectively use material from previous generations and do not feel obliged to stick to a certain viewpoint. Unlike in the past, some of those authors or coauthors are women, and more and more works address women as well as men.

The impact of all these novelties is obvious: many practices that were condemned in previous generations are now considered to be fully legitimate. Many of those modern manuals make such a big effort to claim that almost everything done with consent is legitimate that, in some way, they undermine their own authority. A person does not really need to consult them to know the bottom line: acts that are done by a married Jewish couple, while the wife is not in a state of menstrual impurity, if done by consent, are legitimate. Yes, some of these guides might discourage some acts, but even in such cases, it is generally stated that the acts are not in reality forbidden.

Is this a surprising phenomenon? I believe the answer is no. Religions in general, and religious legal systems in particular, have generally two options: to adapt to cultural trends and new realities or to become irrelevant. Of course, the level of adaptation and the speed of those adaptations are not always the same, and not always predictable. In the general culture around us, a negative attitude towards sexuality in general, and marital sexuality in particular, is currently out of fashion. Reasonable rabbinic authors know that even if they declare something forbidden, someone else will allow it. The game of prohibition seems to be, at this point, almost over.

[1] I have dedicated an entire volume to this question: Evyatar Marienberg, *Traditional Jewish Sex Guidance: A History*, Leiden/Boston: Brill, 2022.

Women's Sexuality in the Work of Jewish-American Feminist Artists

Gail Levin

Prominent sexual imagery in the art of Jewish-American feminist artists from the 1960s through the 1980s caught my attention nearly two decades ago, when I investigated the social and political contexts surrounding these works.[1] I observed parallels with the work of Jewish-American women in the theater, from Sophie Tucker to Eve Ensler's *Vagina Monologues*.[2] The activism of these feminist artists also fits in with the heritage of Jews, who, motivated by their belief in social justice and desire for political reform, turned to radical politics, first in Eastern Europe and then in America, such as Emma Goldman.
Some feminist artists' sexually explicit work provoked attempts at censorship, ignoring the frequently metaphoric force of the subject. I concluded that the works of art and the struggles I examined should heighten awareness that the drive for free expression in art is intimately linked with women's quest to claim their sexuality, agency, and power, and that Jewish women, who were unfettered by Victorian Protestant ideals of women's purity and piety, have been trailblazers in that quest.
Artworks engaging sexuality with an openness about the female body appear from the 1960s through the 1980s in the work of Jewish-American feminist artists, among them Joan Semmel, Judy Chicago, Hannah Wilke, Nancy Spero, Anita Steckel, and many others. Were Jewish women artists more likely to engage creatively with sexuality?

In the early twentieth century, Sophie Tucker, a Russian-born Jewish immigrant, performed songs that challenged codes of morality and presented an image of women's sexuality that clashed with America's Puritanical mores.[3]

More overtly political and ideological, the Jewish anarchist and feminist Emma Goldman demanded equality and independence for women, including absolute freedom of expression, sexual freedom, and the right to birth control, which was then illegal. Goldman, born like Tucker in the Russian Empire, emigrated to the United States in 1885 at the age of sixteen, only to be deported in 1919. Lecturing on sex, she challenged Puritan tradition as well as Freudian theory that creativity was linked to sexual repression. "The creative spirit is not an antidote to the sex instinct," she insisted, "but part of its forceful expression.... Sex is the source of life.... Where sex is missing everything is missing."[4]

The legacy of Jewish women like Tucker and Goldman and their bold approach to sexuality appears in the work of feminist artists who happen to be Jewish. Among women artists in America, a small but vocal number make feminist art. Some of these express their feminism through sexual content, which, depending on the cultural matrix of the artist, ranges from self-torment to celebration. Jewish feminists' use of sexual imagery often celebrates both sexuality and female agency.

Images of female anatomy and nudity are often misread as merely erotic. But to a feminist in the early 1970s, the political issue of female identity often trumped other meanings. "Much of feminist art that has been labeled 'erotic' because it depicts or alludes to genital images is nothing of the sort," argued Barbara Rose in her 1974 article, "Vaginal Iconology." Rose understood that women's images that "glorify vaginas...attack one of the most fundamental ideas of male supremacy—that a penis, because it is visible, is superior."[5]

Women artists' images of female genitalia have often been rejected as shameful by art critics and laypersons alike. Yet many of the same critics have deemed acceptable male artists' images of phalluses, some as thinly veiled or metaphoric as Constantin Brâncuși's *Princesse X* or Claes Oldenburg's giant lipstick; or of female genitalia, from Gustave Courbet's *The Origin of the World* (1866) to Marcel Duchamp's *Given: 1. The Waterfall, 2. The Illuminating Gas* (1946–1966).[6]

A feminist agenda targeting such double standards motivated Hannah Wilke, who performed a striptease behind Duchamp's *The Large Glass* on June 15, 1976, at the Philadelphia Museum of Art. She expressed the second meaning of Duchamp's punning pseudonym, "Rrose Selavy" (*Eros c'est la vie*, "Eros, that's life"), insisting: "'Eros affirms life,' but *The Large Glass* does not."[7]

By then Wilke had already produced vaginal imagery, beginning with her terracotta sculptures in the early 1960s, which she showed in New York in 1966. For Wilke, the vagina was a symbol of strength: "Nobody cringes when they hear the word phallic."[8] Since Wilke aimed to preempt the site of the traditional male gaze upon the female nude, she presented herself nude in her art, now controlling what the view would be. She also put her Jewish heritage expressly into some of her work, most notably in *Venus Pareve*, which she produced as a three-dimensional self-portrait of her body in chocolate in 1982. Both the metaphoric title and the medium of this work suggest pleasure associated with the body and with Venus, the goddess of love, and that this pleasure, like pareve food, has no restrictions, as it can be consumed with either milk or meat by those keeping kosher.

Wilke, who was born and raised Jewish, said, "I made up my own religion, feminism, for the survival and regeneration of life."[9] In her *Starification Object Series* (1974), Wilke attached vaginally shaped pieces of chewing gum to her body like scars, while she posed seductively for photographs like a starlet. Wilke insisted on

> self-realization with respect to the physical superiority of woman as the life source: To get even is to diffuse the dangerous power of male separatist religious ideals; the virgin as superior being, the nun, the celibate priest, the bleeding Christ—a female fertility figure in disguise...recognizing the marks, the wounds, the suffering, the pain, the guilt, the confusion, the ambiguity of emotions.[10]

Sexuality is also central to the work of Joan Semmel, born to Eastern European Jewish immigrants in the Bronx in 1932. In the early 1970s, she painted couples making love. Later, in an allusion to both patriotism and censorship, she titled a depiction of intertwined male and female figures: *Red, White, and Blue*. Next, she produced monumental, realistic nude portraits and self-portraits, depicting herself with her male lover as seen from her own unromantic point of view, looking down upon her body, as in *Hold* (1973 |see page 59|), *Antonio and I* (1974), *Intimacy/Autonomy* (1974), and *Touch* (1977).

"The sexual relationship of men and women tended to set the stage with male domination precluding female aspirations in other arenas," comments Semmel.[11] She views women's sexuality—like their intellectuality—as something men have "suppressed and then denied. Religion and art have come together to create the idealization of the 'virgin' birth and the 'pure' woman. The male has had free reign to invent sexual mythology in terms of his own fears and fantasies."[12]

Having lived in Franco's Spain from 1963 to 1970, Semmel explained, she was reacting to the government-sponsored cultural repression she had observed. Speaking out about the repression of female sexuality from the woman's point of view became political activism for Semmel and other women artists of her generation, many of whom, like her, were Jewish but not ritually observant. They voiced their protest through the Fight Censorship Group, originally organized by Anita Steckel and eventually including not only Semmel, but also Judith Bernstein, Martha Edelheit, Eunice Golden, and Hannah Wilke, among others.

Steckel, born in New York to Russian immigrants who spoke Yiddish at home, recalls her family as permeated by Jewish culture, although not religiously observant. Her parents' experience of injustice against Jews and of hardships suffered by immigrants encouraged dissent. Steckel commented: "When you come from a culture that has been the underdog in a very brutal way, you tend to speak out against injustice."[13]

Steckel dealt with images of sexuality and with political and gender issues. She held a show of "Mom Art" in 1963, intended to send up the sexist imagery characteristic of Pop Art. Of note in our context is *Eat Your Power, Honey, Before It Grows Cold* (1973), in her *New York Skyline* series |see pages 142–143| begun in 1970. Jewish stars fill the sky, and schools of oval gefilte fish swim in the Hudson River. Against the skyline, a muscle-man is spoon-fed his own sperm by

his mother, who tells him: "Eat your power, honey, before it gets cold." The Empire State Building is equated with his giant phallus. A tattoo on his arm reads: "Lenny Bruce Lives," a reference to the notorious Jewish comedian who challenged standards of free speech; below it, Steckel writes: "Although because of this tattoo he cannot be buried in a Jewish cemetery" (Jewish law prohibits tattoos; cf. Leviticus 19:28). On the right side, Hitler (labeled "Adolph 6,000,000") is depicted as a patriarchal menace with his throat being sliced by a nude female figure wielding an ax between her legs. In the river among the gefilte fish, the artist signs her name.

Eunice Golden, who joined Fight Censorship, wrote:

> We proposed to inform the art world that our "Erotic Art" was a celebration of sexuality and should not be confused with pornography, which denigrated and exploited women. We shared a common vision, which was to uphold a consciousness about our art that was primal in nature and autobiographical in its source.[14]

Nancy Spero, another Jewish feminist artist and activist who made sexually explicit art, adopted archaic erotic imagery from ancient Greek sculptures and vases. In *Chorus Line I* (1982), primitive female figures grasp at their large vaginas. Spero said:

> I want the idea of a woman's body to transcend a male ideal of woman in a male-controlled world.... What I suppose might be most subversive about the work is what I am trying to say in depicting the female body; that woman is not the "other," that the female image is universal.[15]

"It must have been done by Jewish women; it's so blatantly sexual," was typical of responses to *The Dinner Party* (1979) by Judy Chicago, in which so many of the place-settings feature vulvate forms. Chicago's "vagina" plates awed some viewers and shocked others, setting off a backlash against sexually explicit art in the United States.[16]

Born Judith Sylvia Cohen in Chicago in 1939, the artist was inspired by the theme of "The Last Supper," which, according to the Synoptic Gospels, was a Passover Seder. In making her plates for the third and chronologically latest wing rise up into three dimensions, Chicago created a metaphor for women's liberation. Thus, the entire work echoes the theme of the Passover Seder—liberation—but it represents the emancipation of women rather than of the Jews.[17] "The female artist's obsession with vaginas," she declared, "represents her attempt to get in touch with who she is."[18]

In her imagery, as in her life, Chicago was determined to prioritize women's pleasure and agency. Her imagery was meant to convey an active female role: "We've always been imaged by males as a passive hole. What I've wanted to create is a new, active sense of womanhood."[19]

Already in 1964 (then known by her first husband's surname, Gerowitz), Chicago had produced and exhibited a painted clay sculpture of a vagina-like opening

set in a curvilinear structure, which she called *In My Mother's House* [see page 201]. The title derives from the Song of Songs, considered by many to be "the most erotic text in the Jewish tradition."[20] In the verse to which the title alludes, the Song's female narrator says of her lover, "I held him fast, I would not let him go/ Till I brought him to my mother's house" (Song 3:4). Chicago's metaphorical reading of "mother's house" as "vagina" echoes the interpretations of Jewish writers such as Judah Leib Ben-Ze'ev (1764–1811), who read this verse as describing vaginal penetration.[21] The activism of these feminist artists fits in with the heritage of Jews who took part in radical politics, first in Eastern Europe and then in America. Finding harsh conditions in the New World, they felt compelled to continue the struggles begun in Europe, taking part in strikes for better working conditions and wages. Women's activism in the Jewish immigrant community led to notable protests, including the kosher meat boycott of 1902, the garment strike of 1909, rent strikes, and strong support of women's suffrage. The legacy of these bold protests nurtured Jewish American feminists from the 1960s to the 1980s.

Today, a huge divide has emerged between the proponents of an open, liberal society with equality for women, and social conservatives who would impose severe limits on women's attire, occupations, power, and freedom of choice in such vital areas as whom they can marry, the right to abort a pregnancy, where they can go, and what they can say. For Jewish women in the arts, the right to make their own work say what they want is hampered by moves to limit freedom of expression, particularly where it comes to discussion of women's sexuality. On occasion, efforts to stifle sexually explicit work have generated antisemitic remarks about visual art and theatrical productions made by Jewish women. The artwork and the struggles summarized here should serve to heighten our awareness that the drive for free expression in art is intimately linked with women's quest to claim their sexuality, agency, and power, and that Jewish women have been among the pioneers in that quest.

1. A longer version of this article with extensive source notes appeared as "Censorship, Politics and Sexual Imagery in the Work of Jewish-American Feminist Artists," *Nashim: A Journal of Jewish Women's Studies and Gender Issues* 14 (2007), 63–96. I interviewed eight of the nine artists discussed in that article: Judith Bernstein, Judy Chicago, Martha Edelheit, Eunice Golden, Joyce Kozloff, Joan Semmel, Nancy Spero, Anita Steckel. I had also had extensive conversations with the late Hannah Wilke, whom I knew well.

2. Ellen Schiff, "What Kind of Way is that for Nice Jewish Girls to Act? Images of Jewish Women in Modern American Drama," *American Jewish History* 70/1 (1980), 106.

3. On Tucker, see Lewis A. Erenberg, *Steppin' Out: New York Nightlife and the Transformation of American Culture, 1890–1930*, Chicago: University of Chicago Press, 1981, 197–99; and Armond Fields, *Sophie Tucker: First Lady of Show Business*, Jefferson, NC: McFarland & Company, 2003, 91.

4. Quoted in Candace Falk, *Love, Anarchy, and Emma Goldman*, New York: Holt, Rinehart and Winston, 1984, 160.

5. Barbara Rose, "Vaginal Iconography," *New York* 7 (1974), 59.

6 Robert Hughes, 1980, "An Obsessive Feminist Pantheon," *Time,* December 15, 85. See also Robert Hughes, *Nothing If Not Critical: Selected Essays on Art and Artists,* New York: Alfred A. Knopf, 1990, 99–100 and 177–78. See also, for example, Hilton Kramer's positive comments on Duchamp, Brâncuși, Courbet, and Oldenburg's lipsticks in: *Revenge of the Philistines: Art and Culture, 1972–1984,* New York: The Free Press, 1985, 277, in sharp contrast with his dismissal of the imagery of the plates in Judy Chicago's *Dinner Party,* 92.

7 Hannah Wilke, quoted in Joanna Frueh, "So Help Me Hannah," in: Thomas H. Kochheiser, ed. *Hannah Wilke: A Retrospective,* Columbia: University of Missouri Press, 1989, 35.

8 Ibid., 48, quoting from a 1985 interview with Wilke.

9 Quoted in Frueh, "So Help Me Hannah," 71.

10 Hannah Wilke, "Intercourse With…," in: Thomas Kochheiser, ed. *Hannah Wilke,* 139; Wilke's essay was originally written in 1976 as an application for a Guggenheim Memorial Foundation grant and "Visual Prejudice," 141.

11 Author's interview with Joan Semmel, 29 November 2004.

12 Joan Semmel, "Imaging Eros: The Politics of Pleasure," unpublished essay.

13 Anita Steckel to the author, 7 January 2007.

14 Eunice Golden, "Sexuality in Art: Two Decades from a Feminist Perspective," *Woman's Art Journal,* 3/1 (1975), 14.

15 Nancy Spero in an interview with Jeanne Siegel, "Nancy Spero: Woman as Protagonist," *Arts Magazine* (1987), quoted in Jon Bird, Jo Ann Isaak, and Sylvère Lotringer, *Nancy Spero,* London: Phaidon, 1996, 134.

16 This comment, overheard by Diane Gelon, administrator for *The Dinner Party,* was reported by Letty Cottin Pogrebin in "Anti-Semitism in the Women's Movement," *Ms.* (1982), 66; reprinted in: Letty Cottin Pogrebin, *Deborah, Golda, and Me: Being Female and Jewish in America,* New York: Crown, 1991. See also Gail Levin, *Becoming Judy Chicago: A Biography of the Artist,* New York: Harmony Books, 2007.

17 See Gail Levin, "Beyond the Pale: Jewish Identity, Radical Politics, and Feminist Art in the United States," *Journal of Modern Jewish Studies* 4 (2005), 205–32; and Levin, *Becoming Judy Chicago,* 6 and 251. Chicago treasures a photograph of her father, at about age thirteen, at his family's Seder.

18 Judy Chicago, quoted in Mary George-Geisser, "Judy Chicago: Artist and Feminist," *Gold Flower* 6/7 (1975), 1.

19 Haider, 1975, "Chicago's Butterfly," *Chicago Sun-Times,* June 19, Section 2, 81.

20 David Biale, *Eros and the Jews: From Biblical Israel to Contemporary America,* Berkeley, CA: University of California Press, 1997, 31.

21 Ibid., 161.

Babies, Bodies, and Books: Haredi Women's Reproductive Ethics

Michal Raucher

Reproduction in Israel has garnered sustained attention from political scientists, historians, sociologists, demographers, and anthropologists. This is partly because the government and Israeli society maintain strong pronatalist attitudes. Since the pre-state period, the government has directed their pronatalist policies at increasing the birth rate of Jews in particular.[1] Israel's pronatalism manifests itself through financial support for reproduction, the proliferation of fertility treatments, as well the cultural desires to replenish the Jewish people after the Holocaust and maintain a demographic majority in Israel. These policies and attitudes have resulted in higher birth rates across religious identities. In Israel the birth rate is about 2.9 children per family, whereas among other Westernized, developed, and democratic countries, the average birth rate is around 1.2 children per family. Fertility rates are highest among Haredi (ultra-Orthodox) Jewish women in Israel. Since the 1990s, Haredi women have had a birth rate of between 5 and 8 children per family. This is often thought to derive from a commitment to the biblical injunction, "be fruitful and multiply" (Genesis 1:28) as well as a string of rabbinic laws governing the way Haredi Jews should reproduce. Several authorities attempt to supervise and direct Haredi women's reproductive practices due to their particular interests in maintaining high fertility rates. The Israeli government continues to supply financial stipends to Haredi families that have many children. This often encourages higher rates of reproduction. Furthermore, doctors and rabbis work together, sometimes reluctantly, to oversee Haredi women's reproductive healthcare. Each sees the other as instrumental in their own goals. Rabbis claim authority over reproductive decisions because what is at stake in reproductive medicine is nothing short of establishing

kinship with the next generation. Rabbis want their authority to be a central part of the family structure. Doctors, for their part, cooperate with rabbis either because they have a financial interest in the Haredi clientele or because they see cooperating with rabbis as the only way of providing medical care to Haredi patients.

The matrix of control surrounding a Haredi woman's prenatal care might give one the impression that Haredi women are restricted in their decision-making capacity and are limited in their authority over pregnancy. Yet, in general, Haredi women recognize this context and simultaneously talk about pregnancy as *their* space. When they are pregnant, they make decisions *without* their rabbis, husbands, or doctors. Instead, the embodied experience of pregnancy shapes a woman's ability to make decisions without male authorities and to develop a sense of authority over pregnancy-related decisions like birth control, where to give birth, and whether to see an ultrasound image. For example, Haredi women know that most rabbis will only permit birth control—hormonal birth control, that is—after a woman has given birth to a male and a female child. Rabbis are reluctant to provide permission for birth control for longer than six months, and will not approve the use of birth control if the reasons given are financial. However, Haredi and other Orthodox women often have their own reasons for wanting to prevent another pregnancy. They might need a physical or mental break from childbearing, suffer from postpartum depression, want to finish school, or are struggling to care for the children they have. Sometimes they can find a rabbi sympathetic to these reasons. Other times, they will seek out birth control without asking. Birth control is widely used among Israeli Orthodox women.[2]

Haredi Jews understand pregnancy to be, as one of my informants described, "what a Jewish woman does," meaning she has ownership and authority over reproduction. This sense of authority gives Haredi women the ability to override the influence of the rabbis. This is surprising given the fact that Haredi life is predicated on the interpretation of God's laws by rabbis, but Haredi women see rabbis (all male) as those who have never experienced and will never experience divine authority granted through pregnancy, a fact that leaves men at a disadvantage when making reproductive decisions. By drawing on her bodily experience of pregnancy and the cultural norms that dictate her role as biological reproducer, a Haredi woman can exert authority over her reproductive life.

Haredi individuals are expected to consult their rabbis when making most decisions, especially those that are related to healthcare. Women are aware of that expectation, but they maintain that because of the responsibility they alone have to reproduce and raise children, and the fact that pregnancy happens in their bodies, they can make decisions outside the normative decision-making structure.

Relationships and Sex

Haredi couples often get married at the ages of 20, 21, or 22 after a short courtship, and they begin having children before they know each other well. Their marriage is set up by a matchmaker and approved by the respective families, though sometimes a family member serves as a matchmaker. Matchmakers play

an important role in the maintenance of social priorities. Matchmakers and other community leaders often teach young girls and boys how to judge their intended: by particular characteristics that should be compatible, including religious perspectives and observance. The young couple also must agree to the match. Though they do not date for very long, a young couple on a match date will meet in a hotel lobby or other public place and get to know each other. They may discuss their families, their plans for the future, how many children they would like to have, where they would like their children to be educated, religious inclinations they share, and where they would like to live. If the match is suitable to the couple, then their parents will begin planning for the wedding, a community affair that usually takes place within a couple of months of the match.[3]

Before marriage, young women and sometimes young men attend gender-segregated premarital education classes, where they learn about their roles in marriage and the observance of menstrual laws, an entire body of Jewish law that has been hidden from them until the eve of marriage.[4] These marital preparation courses teach women in particular about the values of selflessness and the need to communicate with one's spouse and find common ground, especially on religious issues. Women learn about the laws regarding family purity and how to mark their menstrual cycles in accordance with halakhah (Jewish law), but they learn very little about physical intimacy. Brides are eager to learn about this, but their teachers, older Haredi women who have not been trained to provide this type of instruction, are embarrassed and reluctant to discuss these topics with young women.[5] These classes, then, do not sufficiently prepare young men and women for the new sexual encounter that faces them on their wedding night. After having grown up in a completely sex-segregated community and not ever exposing one's body to a member of the opposite sex, the wedding night can be a terrifying experience.

Thus, during the first few years of marriage Haredi couples struggle with their new lives as a couple while they are also raising young children. Haredi women are still the primary caretakers in their families, despite some recent changes. Haredi men have begun taking on more responsibilities and are frequently seen walking the streets of Haredi neighborhoods with strollers and children in hand and sitting at playgrounds with their children. Rabbinic leaders have encouraged Haredi men to take a more active role in family duties to help their wives and prevent the family duties from taking too large a toll.[6] Despite more involvement from male partners, Haredi women and men live segregated lives, even as a married couple.

This segregation can facilitate Haredi women's reproductive authority. For instance, the silence between a woman and her husband on issues related to pregnancy and the lack of direct communication between a woman and her rabbi leave an opening for a Haredi woman to act with agency on matters related to pregnancy. If a Haredi woman is uncomfortable discussing her desire for birth control with her husband, then her request will never reach the rabbi. Some scholarship reveals that husbands might consult with various rabbis independent of her involvement, though.[7] However, if her husband considers it

immodest to attend a doctor appointment with her, then a pregnant woman can receive ultrasound scans that might otherwise be forbidden by the community. Viewed in this way, we see that the nature of private relationships and a woman's role in her family actually help create women's agency by leaving space for women to act without the regulation of male authorities.

People of the Book, Women of the Body

Jews have often been referred to as "People of the book." This is because books, specifically those that contain rabbinic legal discourse, are understood to be authoritative guides for Jewish life, and those who have achieved mastery in the content of the books are considered authorities. This is especially true among ultra-Orthodox Jews in Israel, where communities of scholars have been created as a result of their investment in studying these books. While women's lives are undoubtedly shaped by religious books and those who read the books, ultra-Orthodox women are not permitted entry into the yeshiva, and the access they have to rabbinic texts is limited and mediated by interpreters, namely fathers, sons, husbands, or rabbis. Although women are educated in non-religious topics and serve as primary breadwinners for their families, they are not literate or skilled in the reading of these texts. This is largely due to the strict division of male and female roles within Orthodox society and the fact that women—and their bodies—are needed for other endeavors, namely working and raising children. In this way, although women are part of book culture, they are not directly the people of the book. Furthermore, because religious authority is granted through one's knowledge of the books, women are generally understood to lack religious authority in ultra-Orthodox Judaism.

Haredi women challenge this paradigm by insisting that their pregnant bodies replace books and rabbis. While a woman's body might be seen as an impediment to her religious authority, instead, women become capable of exercising religious authority through their embodied experiences of bearing children. After a woman has two or three children, she develops a kind of "reproductive literacy," meaning she knows how to use her embodied reproductive experiences as knowledge, expertise, and thus authority over reproduction. With each subsequent pregnancy, women feel more comfortable challenging the received authorities—doctors and rabbis—relying instead on their own reproductive agency.

Embodied reproductive experiences are sources of authoritative knowledge because of theological and cultural ideologies that draw a direct line between a woman's pregnant body and God. Written in pregnancy advice books and contained within Haredi teachings is the idea that, when pregnant, a woman is acting in a God-like capacity of creation, and that the umbilical cord connects her not only to the fetus, but also to God. According to this theology, this direct line bypasses the rabbis and legal books that otherwise serve as interpreters of divine will. Just as Haredi men use their knowledge of the books to understand God's will and implement it, Haredi women use their knowledge of reproduction to do the same.

Conclusion

Haredi women's reproductive practices remain a focus of national and religious interest in Israel and elsewhere. Sometimes admired for their contribution to the demographic growth of Jews, other times derided for what is thought to be unwieldy reproduction, Haredi women and their particular way of approaching reproduction and making decisions about reproduction have long been overlooked. Many assume that Haredi women have been subjugated to patriarchal authorities and lack any control or authority over their pregnancies. Yet their approaches to reproduction reveal a completely different relationship between embodiment and authority.

As Haredi women draw on their embodied experiences of pregnancy, they both challenge and reinforce Haredi norms. By participating in biological reproduction, Haredi women reinforce the gendered norm that their bodies were intended for this purpose, a norm that buttresses inequalities and subordination. However, the norms that require a Haredi woman to remain in a state of pregnancy are those same norms that she draws on to resist male authorities. The conditions that have led to her gendered role in the community—the requirement for her to reproduce and raise a family, her seclusion from the male sphere of decision-making, the emphasis placed on her body and when her husband can access it—have also been the sources for her self-formation and her ability to rely on those embodied experiences for authority.

This article has been adapted from Michal Raucher, *Conceiving Agency*, Bloomington: Indiana University Press, 2020; and Michal Raucher, "People of the Book, Women of the Body: Ultra-Orthodox Jewish Women's Reproductive Literacy," Body and Religion 3/2 (2019), 108–29.

1 Lilach Rosenberg-Friedman, *Birthrate Politics in Zion: Judaism, Nationalism, and Modernity under the British Mandate*, Bloomington: Indiana University Press, 2017.

2 Lea Taragin-Zeller, "Have Six, Have Seven, Have Eight Children: Daily Interactions between Rabbinic Authority and Free Will" [Hebrew], *Judaism, Sovereignty, and Human Rights* 3 (2017), 113–38.

3 David Lehman and Batia Sibzehner, "Power boundaries and institutions: Marriage in Ultra-Orthodox Judaism," *Archives of European Sociology* 50/22 (2009), 273–307.

4 Tova Porush, "A Study of Pre-marital Education Predominantly within the Haredi Community," MA Thesis, Touro College, 1993.

5 E. R. Goshen-Gottstein, *Growing Up in Geula: Mental Health Implications of Living in an Ultra-Orthodox Jewish Group*, Ramat Gan, Israel: Bar Ilan University, School of Education, 1980.

6 Nurit Stadler, *A Well-Worn Tallis for a New Ceremony: Trends in Israeli Haredi Culture*, Boston: Academic Studies Press, 2012.

7 Lea Taragin-Zeller, "A Rabbi of One's Own? Navigating Religious Authority and Ethical Freedom in Everyday Judaism," *American Anthropologist* 123 (2021).

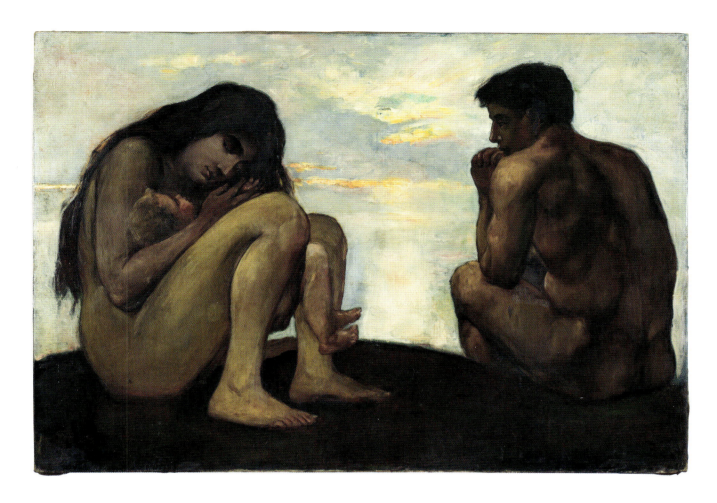

↑
Adam und Eva mit ihrem Erstgeborenen
Lesser Ury
Berlin, 1896

The painting shows the first biblical couple, Adam and Eve, sitting on the ground after being expelled from Paradise. Adam has shifted his gaze from the bright sky to Eve, who is holding their child in her arms.

Couples
Procreation and Pleasure

41

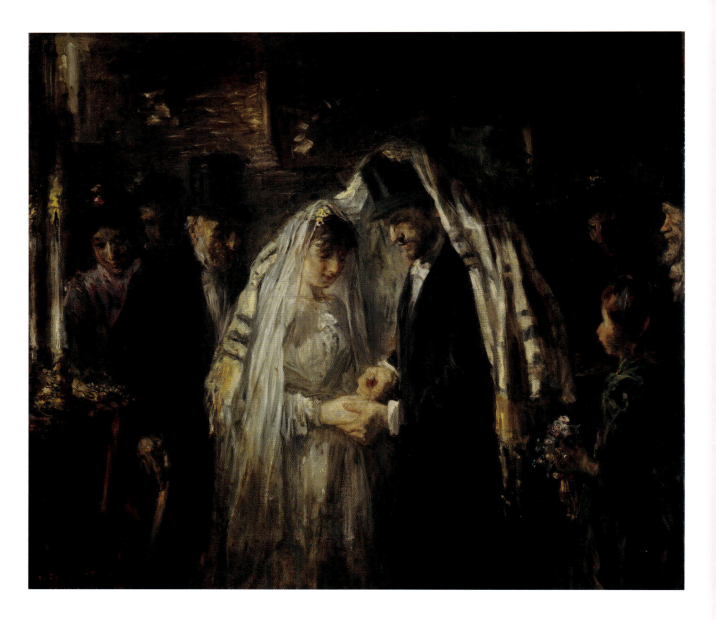

↑
Joodse Bruiloft
Jozef Israëls
The Hague, 1903

The elegantly dressed wedding guests are watching events closely. The groom has just slipped the ring onto his bride's index finger, a symbol of the traditional "acquisition" of the woman. The guests usually hold the chuppah, or wedding canopy, over the couple's head. Here the bride and groom are covered by a traditional prayer shawl called a tallit.

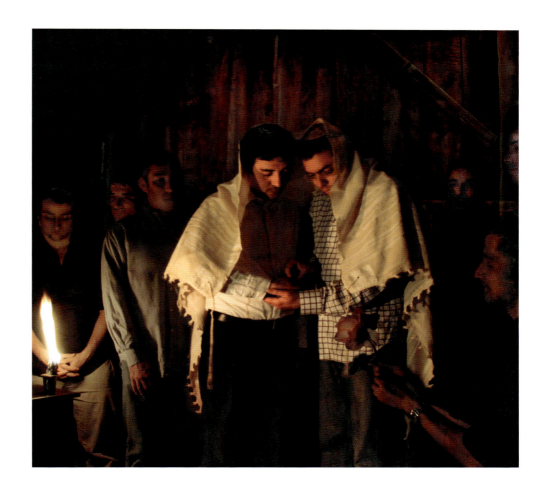

↑
A Jewish Wedding
Yitzchak Woolf
Jerusalem, 2008

The couple Benny and Nir based their wedding ceremony on the painting by Jozef Israëls. It took them a long time to find a congregation willing to marry a gay couple. In the end they married under a tallit, using a less common custom to call attention to the unresolved status of same-sex couples in their congregation.

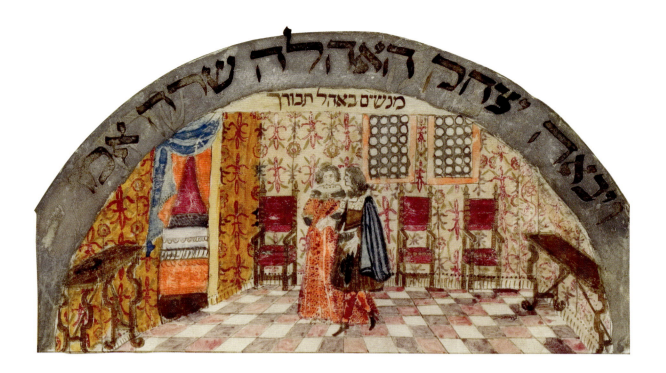

Ketubbah with Image of the Bridal Chamber
Padua, 1750–1828

Jewish marriage contract commemorating the wedding of a couple in Padua, Italy. The scene above the text features a man and woman walking towards their nuptial bed.

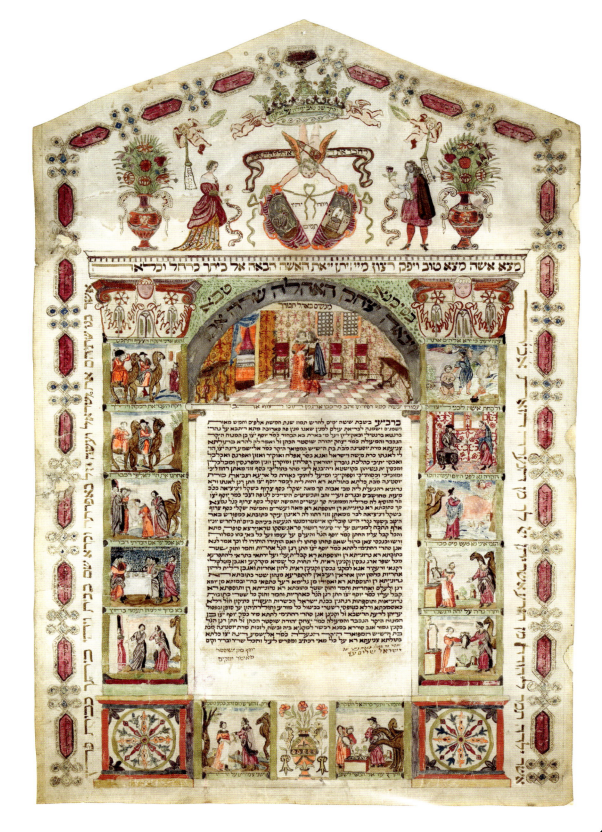

Couples
Procreation and Pleasure

45

↑
Brit Ahuvim
Israel, 2023

The *Brit Ahuvim* is an egalitarian alternative to the traditional Jewish wedding ceremony. Originally devised by the American theologian Rachel Adler for her own wedding, in recent years it has been adopted more widely in progressive Jewish communities. Unlike the traditional kiddushin ceremony, in which the husband "acquires" his wife, the lovers' covenant provides a legal basis for marriage in which the partners have equal rights and obligations.

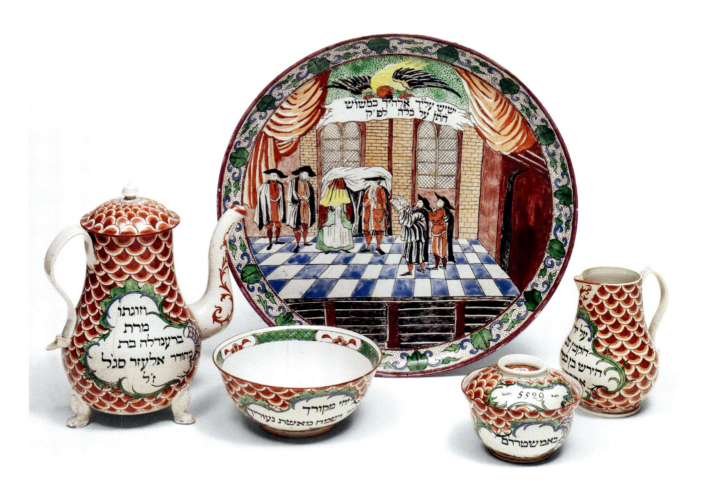

↑
*Coffee Service Given
as Wedding Gift*
Staffordshire, England, 1769

The plate in this coffee service depicts a traditional wedding ceremony. The eagle hovering over the bride and groom bears a banner inscribed with the words "As a bridegroom rejoices over his bride, so will your God rejoice over you." This verse is often sung at weddings and emphasizes the sacredness of marital sexuality.

Couples
Procreation and Pleasure

47

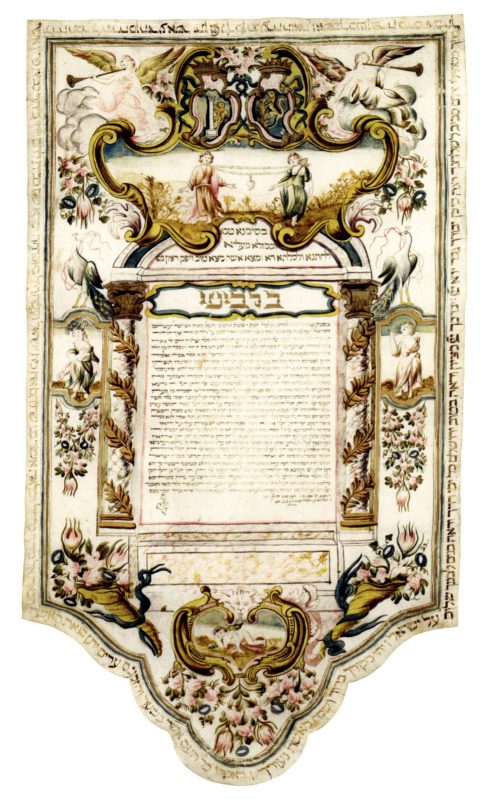

←
Roman Marriage Contract
Rome, 1763

The couple enters into a written contract, or ketubbah, in front of witnesses. The husband's duties are to provide for all his wife's needs, including sexually, which is referred to as *onah*, or time spent together. The contract also specifies the dowry and possible later settlements. Depictions of harmonious married couples are typical of Roman ketubbot, which are characterized by elegant calligraphy and illustrations. The parchment is rolled up from top to bottom and tied at the tapered end.

→
A Recontextualized Ketubbah
Gay Block and Malka Drucker
USA, 1994

Artist Gay Block and rabbi Malka Drucker here frame their wedding portrait within the backdrop of an ornately decorated Italian ketubbah. With this recontextualisation, both portrait and ketubbah are transformed; a late 20th century lesbian marriage is conferred with the sanctity of a traditional marriage contract, and an 18th century ketubbah is reinvigorated with the possibility of a more inclusive future.

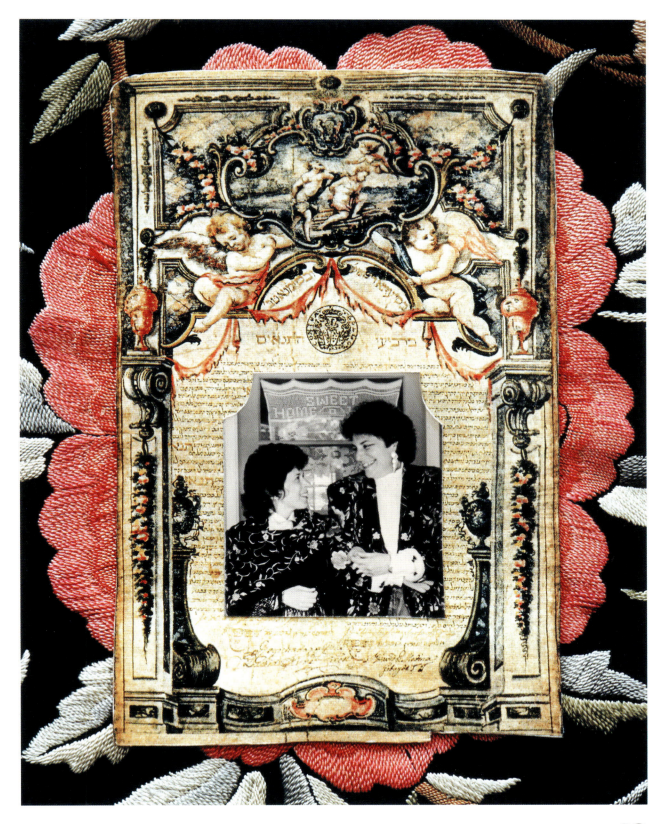

→
Fertility Figurine
Syria, Middle Bronze Age

Humans have always been fascinated by the creation of new life. For thousands of years, many regions and cultures have celebrated female fertility through sculptural forms such as these clay figurines. With their prominent female sexual characteristics, they reveal a respect for the miracle of childbirth and the associated dangers to the mother's life.

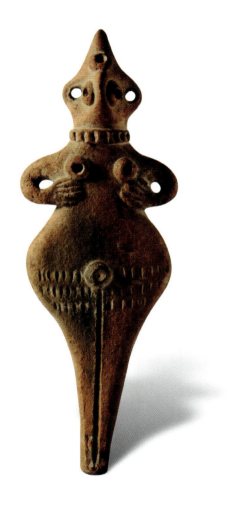

↑
Recipes for Love
Found in Cairo, before 1899

From antiquity to the Middle Ages, the efficacy of spells and magical amulets was part of popular Jewish belief. The demonic Lilith, Adam's first wife, was thought to seduce men and threaten babies and new mothers.
The paper amulet contains instructions for love and the prediction of pregnancies. In the table, magic words and syllables are carefully noted with their vowels.

Children
Procreation and Pleasure

51

← *Glass for the Bride*
Austria-Hungary, ca. 1790

The Hebrew inscription on this richly decorated glass wishes the bride, Rachel, a life with many children: "Thou shall multiply. Good luck Rachel."

→ *Be Fruitful and Multiply*
Andi LaVine Arnovitz
Jerusalem, 2019

The family purity laws prohibit sexual intercourse during and after menstruation. These rules therefore make it difficult for women with short menstrual cycles to conceive. In this work Andi LaVine Arnovitz calls attention to the phenomenon of halakhic infertility and the children yet to be born.

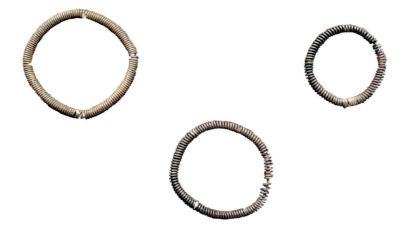

← *Gräfenberg Rings*
Ernst Gräfenberg
1925–1935

The Gräfenberg ring is an intrauterine device that was one of the first widely available contraceptives. Invented in the 1920s by the German-Jewish gynecologist Ernst Gräfenberg, it was used until the advent of plastic alternatives in the 1960s. The G-spot, an elusive erogenous zone, was posthumously named after Gräfenberg in honor of his research into female pleasure.

**Procreation and Pleasure
Children**

52

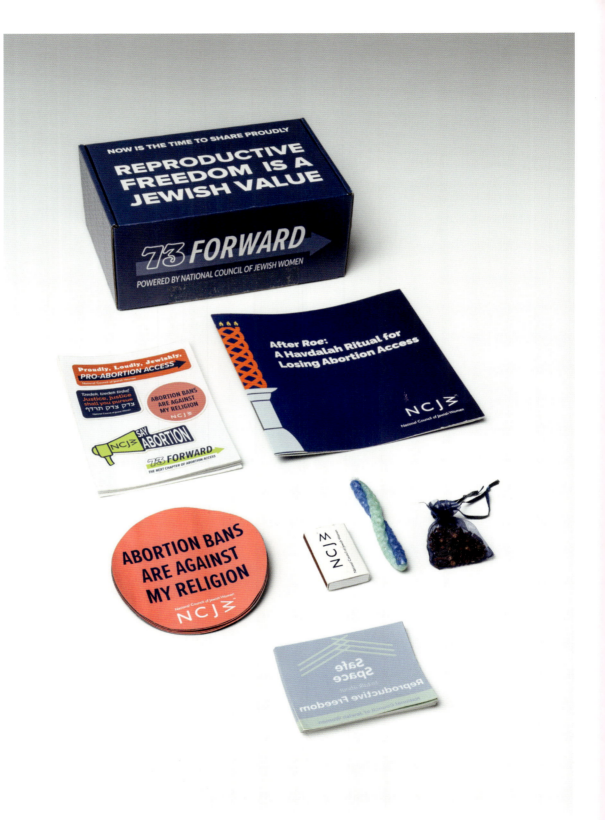

→
Adam en Eve
Eli Content
Amsterdam, 2018

Eli Content's depiction of the first humans in Paradise emphasizes their nakedness, highlighting in particular their exposed sexual organs.

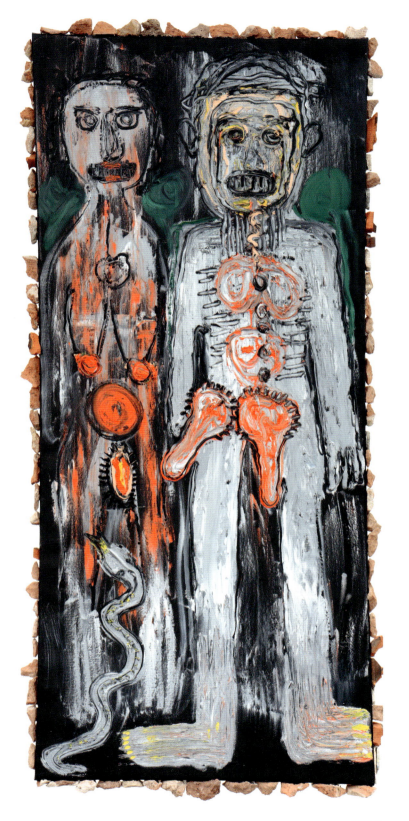

←
Reproductive Freedom Kit
USA, 2022

In June 2022, the US Supreme Court struck down the constitutional right to abortion, overturning nearly fifty years of reproductive rights. In response, the National Council for Jewish Women developed this kit. Containing stickers, magnets, and a Havdalah set, it allows Jews to express their support for abortion rights in a Jewish context.

55

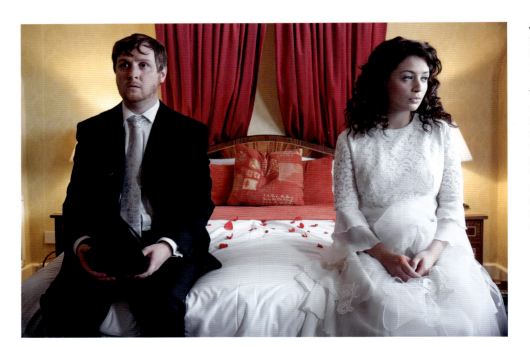

←
The Honeymoon Suite
Sam Leifer
UK, 2010

This short film follows a bride and groom as they take their first awkward steps toward marital intimacy. For many Orthodox couples, the prospect of having sex for the first time right after the wedding ceremony is a great challenge, after a youth spent with virtually no contact with the opposite sex.

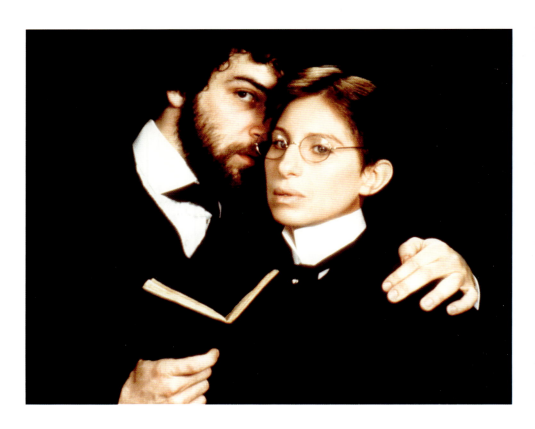

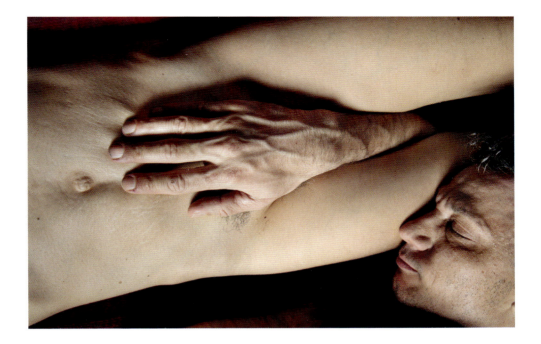

↑
Signs of Time
Elinor Carucci
New York, 2017

In her *Midlife* series, Elinor Carucci documents life with her husband and family. The relationship with her spouse has deepened over the years and the traces of time on their bodies have become part of their shared intimacy.

←
Yentl
Barbra Streisand
USA, 1983

The *Iggeret ha-Kodesh*, or Holy Letter, provides kabbalistic instructions on marital sex and pleasure. This medieval text plays a role in the American film *Yentl,* where it is given as a wedding gift. Played by Barbra Streisand, the eponymous hero who is disguised as a man receives advice for the wedding night: "Speak words which arouse her to love, desire, and passion; her mood must be as yours [...] when her mood is ready, let her desire be satisfied first; her delight is what matters."

Lust
Procreation and Pleasure

57

It Is So
Nicole Eisenman
USA, 2014

With humor and tenderness, Nicole Eisenman explores interpersonal relationships in her work. Her highly accessible characters defy gender categorizations. The intensely colorful scenes often focus on queer love.

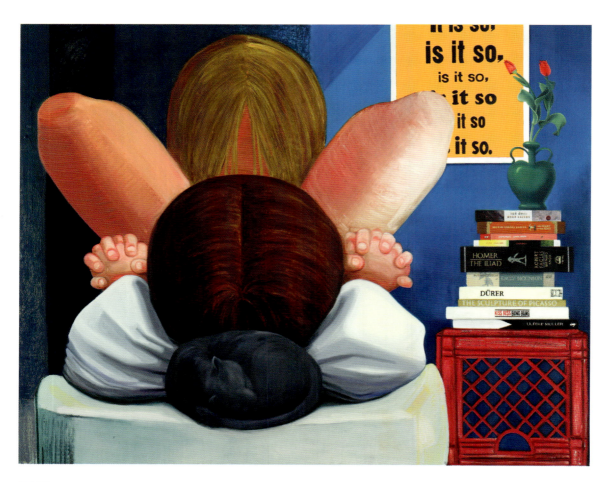

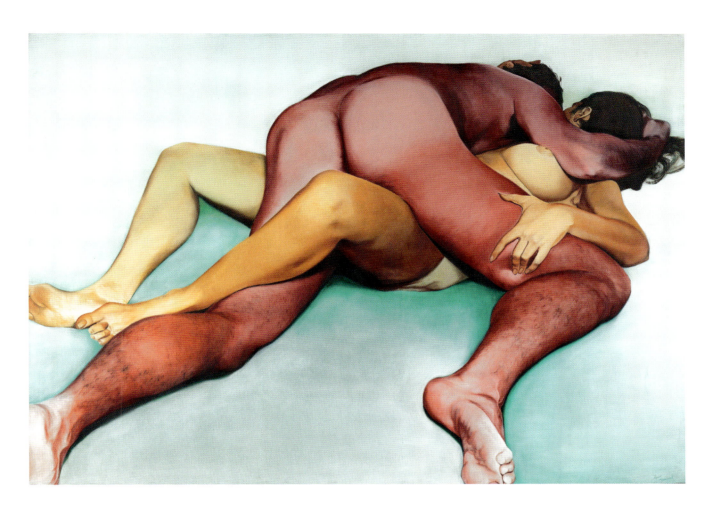

↑
Hold
Joan Semmel
New York, 1972

Joan Semmel's nude paintings transformed perceptions of the female body. Her *Erotic Series* emphasized female desire, presenting a vision of heterosexual sex based on equality between men and women. Semmel was a member of the Fight Censorship Group, founded in 1973 to counteract sexism in the art world and establish women's bodies as subjects.

Lust Procreation and Pleasure

59

→
WaterSlyde™
Maureen Polack
2014

WaterSlyde™ is a pleasure product for women that provides sexual stimulation in the bathtub. Developed in 2014 by the intimacy coach and Orthodox Jew Maureen Pollack, it also promotes sexual health and feminine hygiene. Before marketing her creation, Pollack obtained her rabbi's blessing. He considered it permissible because it had the potential to improve sexual intimacy between spouses.

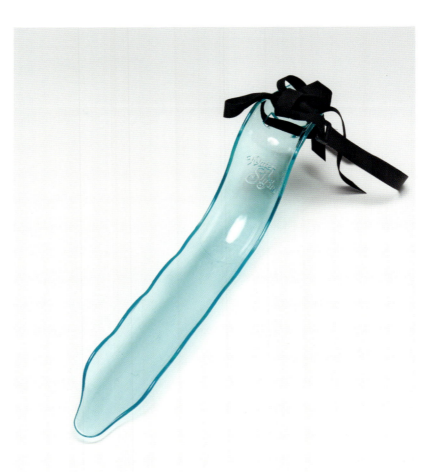

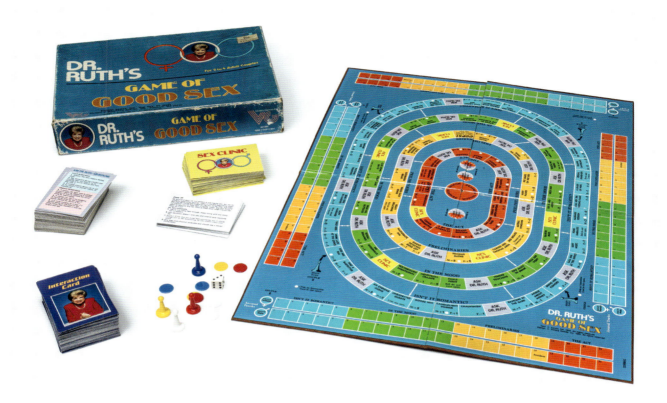

↑
Dr. Ruth's Game of Good Sex
Ruth Westheimer
Victory Games Inc., New York, 1985

Ruth Westheimer achieved fame as a sex therapist with her own TV show. This board game deals with the topic of sex in marriage. The spaces represent different phases of intimate married life and the cards pose questions about everyday scenarios. Receiving both rewards and penalties, players attempt to reach the circle at the center of the track called "Mutual Pleasure."

Lust
Procreation and Pleasure

61

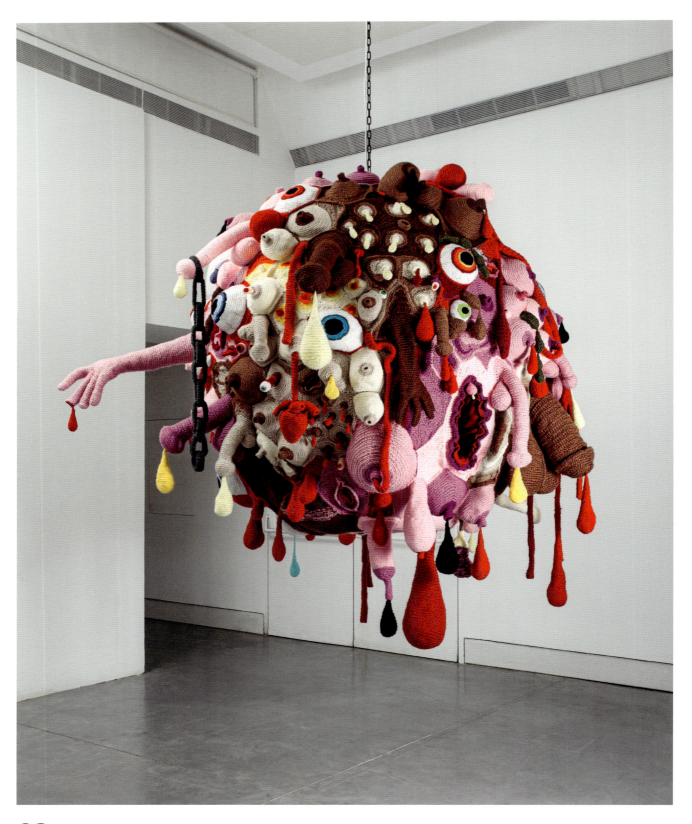

Artist Statement
Gil Yefman

As for the person with a leprous affection: the clothes shall be rent, the head shall be left bare, and the upper lip shall be covered over, and that person shall call out, "Impure! Impure!"
Leviticus 13:45

A tumtum and an androgynus should cover their heads, rend their garments, and cloak their faces, because their status is in doubt.
Mishneh Torah, Leprosy Halakhah 10:9

The word *tumtum* is a pre-medical term from the Mishnah, the first major work of rabbinic literature, consisting of teachings transmitted over hundreds of years and compiled around 200 CE. It is interesting to note that rabbis believed they were able to identify the stage of embryonic development at which sex is determined. Six or seven sexual identity categories appear in the Talmud and in the Mishnah: *male*, *saris* (two types), *tumtum*, *androgynous*, *aylonit*, and *female*. Of these, *tumtum*—someone with hidden or covered sexual organs—and *androgynus*—someone whose genitalia cannot be distinguished as male or female—stand independently as different sexes, furthest from either male or female. To this day, there is still a great deal of debate among rabbinic authorities about what to do with a person who is a *tumtum* or an *androgynus*.

The term *tumtum* acquired presence and primacy through the rabbinic sage the Rambam and his Jewish legal (halakhic) rulings on the laws of keeping kosher. Phonetically, *tumtum* is associated with *tumah*, which translates as "unclean" or "impure" and carries a negative moral connotation. In modern Hebrew, the term has evolved into the vernacular and acquired a derogatory aspect referring to stupidity. (Observing this etymological evolution raises the question of whether the meaning of *tumtum* today is the result of a society caught up in its own prejudicial and political agendas of separation and control, along with the simplistic association of nonbinary forms with the transgressive.)

The installation *Tumtum* stemmed from my search for the origin of the Hebrew word. Aiming to explore religious restrictions and dislodge them from this ambiguous position, my installation expands the term by exploring its range of meaning: *tumtum* is a combination of the word for "sealed" and the word for "unclear, ambiguous" and describes genitalia that perform differently and look different from the normative.

My own experience with anorexia nervosa during puberty, a result of gender dysphoria, further informed my exploration of sex and gender within the confines of social norms. As a transdisciplinary conceptual artist, I recognized the valuable qualities and characteristics of using fiber and textile. The soft materials balance and hold together harsh subject matters, while the therapeutic quality and slow durational nature of knitting help to dissolve and transform trauma and hurt.

Knitting and needlework have been seen as non-fine art techniques, made by women and other marginalized groups. When incorporating this notion into my work, I connect to a historical and cultural lineage of alternative identities.

Crocheting, for me, resembles writing: the yarn signifies the string of thought, while the needle, the size of a pen, makes small monotonous and round movements, creating a chain of loops (known as "eyes") that metaphorically stand for testimonies, various points of view which construct the object. These intertwined relations between text, textile, texture, and context are continually reexamined, unraveling and constructing traditional narratives, fabricating alternative histories and individual experiences.

Tumtum features a plethora of dripping, multicolored body parts hung in midair, including hands, eyeballs, and breasts as well as organs linked to reproduction such as vulvas and penises. The amalgamation is crocheted together into a beautifully monstrous creation, one that is unclear yet abundant with meaning and matter. This visceral sphere in a chain-like object could be seen as a soft wrecking ball, threatening to demolish dogmatic notions of the binary and give freedom to various interpretations of a new order. It should be seen as a powerful and thought-provoking work of art that challenges viewers to reconsider their own understanding of sex, gender, and the binary. *Tumtum* is a reminder that there are many different ways to be human, and that we should celebrate the diversity of our bodies and experiences.

←
Tumtum
Gil Yefman
Installation view, Petach Tikva, 2013

II

Desire
and Control

Unlike Christianity, Judaism takes a strong stand against celibacy. No one is exempt from the duty to marry and the Talmud prohibits even the greatest sages from renouncing sex. Sex is considered an intrinsic part of what it means to be human, but not without its limits. Measured against contemporary social norms, sex is strictly regulated in Rabbinic Judaism. While desire is not in itself a problem, it must be controlled within strict parameters and channeled towards positive ends.

According to traditional Jewish law, sex is legitimate only within (heterosexual) marriage, and even then only at certain prescribed times of the month. Originating in the Hebrew Bible, and developed further in the Talmud, the laws of family purity prohibit sex—and any form of physical contact—during and immediately after menstruation, for nearly half the month. The couple can only come back together after the woman immerses in a ritual bath, the mikvah.

These laws are fundamental tenets of religious practice around which strictly observant Jews regulate their sexual intimacy. These recurring intervals of separation have a profound impact on both the wife and husband. Contemporary advocates of these ancient rituals often claim that the enforced period of abstinence functions as a kind of religiously inspired aphrodisiac, reigniting the spark and keeping passion alive within monogamy. But the rigidity of these laws which restrict sex and intimacy to such a great degree can also estrange husband and wife, thwarting desire.

Perhaps unsurprisingly, Jewish artists have been drawn to the laws of family purity in artistic explorations of both sexuality and the patriarchal foundations of Rabbinic Judaism. Notable artists such as Helene Aylon[1] and Mierle Laderman Ukeles[2] found rich creative opportunities in their practice through examining the rituals involved in both mikvah immersion and the extensive bodily practices leading up to it. Today the conversation continues with artists Gabriella Boros, Nechama Golan, Hagit Molgan, and many others casting an interrogating female gaze on the many male-authored rituals and texts

which have defined and controlled women's bodies throughout centuries.

In the eyes of Jewish law, sexuality is an explicitly gendered phenomenon; male and female sexualities are seen as innate and distinct from one another. While sexual desire must be carefully policed, men and women are tasked with specific duties and expectations in service of this goal. Speaking as it does to a male audience, rabbinic literature devotes little attention to the question of female sexuality, beyond specifying the husband's duties to his wife. Women are largely reduced to the biological reality of their menstrual cycle and are not considered on a par with men as rational beings, capable of restraint.

It is male sexual desire that the Talmud is concerned with; men are expected to control their desires and use them for the good. Interestingly, the concept of the *yetzer ha-ra*, the evil inclination which drives someone to sin is commonly associated with sexual transgression. In marital and procreative sex, this "inclination" is channelled towards holy purposes. Orthodox communities commonly disapprove of masturbation and non-procreative sex, both of which are transgressive on the grounds that they "waste seed." The language used by rabbinic authorities to condemn masturbation in particular is startling in its severity, with the medieval author of the *Zohar*, the central work of the Kabbalah, equating it with murder.

Prayer, ritual and even clothing are employed in the struggle to contain desire. In the Hebrew Bible God instructs the Israelites to attach fringes to their clothes as an embodied reminder to stay true to the divine path. The language used makes clear that the behavior the fringes are supposed to keep in check is primarily sexual: "That shall be your fringe; look at it and recall all the commandments of Yahweh and observe them, so that you do not follow your heart and eyes in your lustful urge"(Numbers 15:39). Furthermore, extensive rabbinic laws of modest dress, developed over centuries, place the burden of responsibility firmly on women to keep men free

from temptation. Arms, legs, and any flesh that might lead men's minds to wander must be safely covered up.

But the existence of these laws reveals tensions between what the law dictates and what people actually get up to behind closed doors. After all, prohibitions are only needed if the act in question is already tolerated or normalized to some degree. Looking at ancient sources through a contemporary lens can reveal surprising voices and challenge our assumptions about how people did or did not conform to sexual norms in the past. A case in point is the explicitly homoerotic nature of much medieval Hebrew poetry, composed by some of the greatest figures of Spanish Jewry such as Judah Halevi and Solomon ibn Gabirol. Whether or not it could be said to be drawn from actual homosexual experience, the poetry undoubtably suggests a far richer and more expansive erotic sensibility than halakhic literature of the time might lead us to expect.[3]

Moreover, turning away from the past and towards the present day, the application of new cultural values to traditional sources can unleash new interpretations and challenge orthodoxies. The experiences of feminists and LGBTQ+ artists and commentators offer important insights into how sexual norms are always in flux and can be challenged and redefined. New artistic and cultural engagements with Jewish law that are firmly rooted in the fight against sexism and homophobia demonstrate that sexual liberation need not stand in conflict with religion. When religious traditions and sexual freedoms are given the space to coexist, new histories and new futures begin to emerge.

1 *My Bridal Chamber: My Marriage Bed / My Clean Days,* was created by Helène Aylon in 2000–2001 as part of a series of works by the artist entitled *The G-d Project.*

2 *Mikva Dreams* was first performed by Mierle Laderman Ukeles in 1977 in New York.

3 For more on this topic, see Norman Roth's authoritative article, "'Deal Gently with the Young Man': Love of Boys in Medieval Hebrew Poetry of Spain," published in 1982 (*Speculum* 57, 20–51, University of Chicago Press), which provides a useful analysis of the Hebrew poetry of medieval Spain and explores the influence of secular Arabic poetry on its development.

"Sex Is a Force"
Interview with Talli Rosenbaum

Talli, you are a certified sex and relationship therapist working with practicing Jews who, to varying degrees, are living their lives according to Jewish law. How would you say this impacts on their sexuality, on their sex lives, on their inner worlds in relation to sexuality?

In Orthodox society, the expectation is that you transition from a sex-free upbringing to becoming sexually active from your wedding night on. Couples who have difficulty consummating their marriage on their wedding night or thereafter may seek sexual counseling. What I noted from my clinical practice working with newly married women and couples was a very, very high level of anxiety—individual anxiety, family anxiety, societal anxiety—about this idea of consummating the act. What really began to break my heart was the experiences of women with sexual pain or vaginismus, a condition where the body tightens due to fear of intercourse. In my first career as a pelvic floor physical therapist, I saw women who were traumatized and who were dissociating. They would actually say, "Look, I need to be able to have sex. I need to be able to, but it hurts me and I need it not to hurt, so do what you have to do, don't mind me. I don't need to have pleasure, I just need for it not to hurt so that I can perform this act of service." It was clear that if they didn't have sex, there would be these very anxiety-driven repercussions. These experiences were what drew me to the mental health field.

What sort of communities or individuals do you work with?

I would say that the large majority, probably 95 percent, of the individuals and the couples I work with really are on the spectrum of Orthodoxy. That could be anywhere from open Orthodox, modern liberal, to very, very Haredi and Hasidic.

The title of our exhibition is *Sex: Jewish Positions*. If you had to distill Jewish values into key stances or ethics, what would you say they would be?

That's a broad question! I think we first have to look at the meaning of sexuality in Judaism—I don't think there's any monolithic position. The Talmud is replete with stories of *Tanna'im* and *Amora'im* who were confronted with sexual temptation and lust; the Jewish texts talk about sex in terms of a temptation or a force, a *yetzer*, that needs to be confronted and needs to be regulated.

In terms of how Judaism views sexuality, there's more than one stance. Some rabbinic sources seek to minimize the experience of sexual pleasure and indicate that asceticism is a preferred template. There might be minimal conversation about it, and that might be very technical. Conversely, there are sources, steeped in mystical Judaism, that glorify marital sexual pleasure and satisfaction, considering sex to be a divine gift and holy obligation.

And the third view would be the Rambam, the Maimonides approach, which is more practical and focuses on moderation. Rather than glorifying or vilifying sex, this approach recognizes that Jews have sex, just as all humans do, and engage in marital sex for pleasure as well as procreation. All in all, Judaism embraces the attitude that sex is a good thing, as long as it's in the context of marriage between a man and a woman. So the limitations and restrictions around sex aren't so much about the act of sex itself, but about the context in which it is experienced. When it comes to ethics, the ancient texts provide rules around sex that were consistent with the ethics, morals, and values of the day. But while the Torah is pretty set, society is not, and we as Jews need to be dynamic enough in our appreciation of contemporary ethics that we can continue to embrace them as we integrate them with the values of Torah.

Do you feel that there's a recognizable Jewish sexuality shaped by these values, whether they're coming from the halakhic literature or from cultural norms?

There are some different directions to go, answering that. I think the Talmudic stories about sexual temptation and lust really do teach us and indicate that the confrontation with sexuality, with human sexual development, is part of being human. It's part of being alive. The idea of a sexual self that is highly regulated and that interacts within the framework of what is halakhically allowed is probably considered the ideal. But these Talmudic stories also indicate to us that it is an ongoing struggle and that it's meant to be an ongoing struggle. For example, if we take masturbation—which is halakhically forbidden—as a human developmental reality, we will realize that there is an existential conflict in the framework of observant Judaism. The way this can affect a person is very individual.

I can't give a global perspective on the type of conflict that every young man or young woman is going to experience. But for some young men, this could create the beginning of a move away from Orthodox Judaism: If there's a law that I'm unable to keep, then maybe this is not for me. A different approach to the conflict is the splitting kind, where the sexual part of me is a part of me that I don't own. As a result, however, I end up being confronted with shame—which then, again, I will need to heal. With a healthy sense of development, there might be a healthier approach to integrating parts of me that are too difficult. That could be admitting I'm not able to follow a law 100 percent, just like I don't 100 percent follow the laws of guarding my tongue and not saying *lashon ha-ra*. Saying that I give myself permission to struggle, I forgive myself for the struggle. Part of therapy work would be teasing that out and seeing how it shows up within your sense of self.

You cohost the podcast *Intimate Judaism* and have written a lot on the intersection of sexuality and halakhah in the context of very twenty-first-century concerns, new sensibilities around mental health, and emotional well-being. Do you see some shifts happening in the last couple of years? There are lots of laws that may be tricky for people to keep if, as well as being Orthodox, they have a feminist sensibility, or for example marry much later.

Absolutely! And yet we still have a long way to go in terms of the integration of sexual education, contemporary ethics, and values with the teachings of Torah and halakhah. One example is consent. Consent is an important concept in negotiating sexuality, yet there is little direct discussion in the sources of the need to acquire mutual consent. When I questioned this, I was told that consent is implied in the sources, but in my opinion the idea of consent could definitely be spoken about much more. When sex is talked about, the language suggests you may do what you want with your wife—as long as you don't spill seed. But there isn't a very clear discussion of "as long as she allows it, as long as she wants it, as long as she desires it." Being able to add that into sex education, even as we talk about values, is important. So, for example, if Orthodox young people are taught the laws of *shmirat negiah*—which means not engaging in any kind of premarital touch—and there's no additional conversation about consent, about boundaries, about desire, about pleasure, then what? Then after marriage, anything goes? And what about consent and boundaries if shmirat negiah is not being observed?

Fortunately, the discourse around sex in the Orthodox world has become more open than in the past. I was involved in the first published study on the experience of married Orthodox women and their sexuality, which appeared in 2007. We did a survey of close to four hundred women and asked them many questions about their sexuality, their sexual function, things they wish they had known going into marriage.[1] These women reported not

having received basic information about sexual pleasure, basic information about their anatomy, or about what was supposed to happen on their wedding night. They certainly didn't have a sense of being entitled to consent or not consent.

When I see what's going on in the modern Orthodox world today in terms of sexual education for premarital instructors, I find more discussion about consent. The Eden Center in Israel provides trauma-informed premarital education courses. *Yoatzot halakhah*, female halakhic authorities in this area, report that they regularly receive questions such as "What if I don't want to have sex on my wedding night or on mikvah night?" There are more written materials, more books, and more blog posts. There's a great deal more exposure on social media, with Facebook groups and Instagram influencers talking about sex and intimacy in the Orthodox world. I see all this as a very, very positive move forward. The veteran Orthodox sex therapist Dr. David Ribner and I cowrote the book *I Am for My Beloved: A Guide to Enhanced Intimacy for Married Couples*.[2] While this book is written with sensitivity to Orthodox couples, it includes pictures of genital anatomy and different sexual positions, and discussions of sexual positions; we also discuss pornography and infidelity. I think it's really one of the first resources on intimacy and sexuality of its kind for Orthodox people.

It is! You spoke of the premarital teachers: what role do the *hatan* and *kallah* teachers play in all of this?

For many young Orthodox people and certainly in the more ultra-Orthodox societies, their first official discussion around sex will be in preparation for marriage. There's a great deal of diversity in how this sexual education is provided: there's no standardization. I would put a word in for the Eden Center that I mentioned earlier. It is an organization founded by Dr. Naomi Marmon Grumet, who has done a tremendous amount in Israel in terms of preparing women, preparing instructors to be very informed about sexuality and to give the right information, the proper information. She has done some research on the kind of societal messages that young men and young women get around sex in modern Orthodox or Zionist Orthodox communities. What she found was that for young women, there is very little sense of sexuality being acknowledged in their development: sexuality is basically about dressing and behaving modestly, taking care not to arouse the desire of men.

For young men, it is different. Sexuality is acknowledged and sexual thoughts and feelings are validated. Young men are told, "We know you struggle with it. But when you get married, then you will have a way to channel your sexuality." And this message, as true as it might sound, can also be very damaging. It sets up an expectation, so that many young men believe, "My salvation is going to be my wife; and all of these fantasies and desires that I've sat on, I can now play out." Again, if this isn't coupled or integrated with ideas of mutuality, of consent, of communication, of what feels good

for you and what feels good for me—how do we even talk about this before we get married? What are our concerns and how do we want to navigate the commencement of our intimate life? Or how do we want to continue the intimate life that we began beforehand? How do we want to navigate observance of the laws? When it comes to talking about these questions openly, the ultra-Orthodox and the Haredi, the more Hasidic societies are not quite there yet. And so, because secular messages filter in, especially nowadays, it's not unusual to have Haredi young women come in and say, "I didn't want to have sex on my wedding night. I hardly knew my husband. I am just an object for his needs." This awareness didn't come in from within the system—it came in from the outside. So as Western messages permeate through into Haredi societies, they, too, need to acculturate this idea. Similarly, for men, the commencement of sexual engagement can be fraught with anxiety. Men often feel as if they are the ones who have to know everything. They're in charge. And it can be very, very difficult for them.

Considering the laws of familiy purity: how do you feel they impact on intimacy, for both the woman and the man?

We all grew up hearing from our teachers that *taharat ha-mishpahah* is the way to ensure a sexually satisfying, intimate life. We were taught that if you keep these laws, they will be what will keep things fresh, because the monthly renewal makes you feel you're looking forward to it all over again. Because my colleagues and I were seeing quite a bit of sexual dysfunction in our Orthodox couples, we started to question this. The fact that some couples choose to modify the way they practice *taharat ha-mishpahah* may actually impact on their sexual life, and it may do so in positive ways, in the sense that it restores some sense of autonomy. But it may also create conflict, if each member of a couple has a different approach to how much they want to keep or not keep the laws. In general, I think a lot of the teaching we find today has a far more honest approach, when teachers will tell their couples or their clients: "It's not easy." And it's not.
But the family purity laws are just one example; premarital touch, premarital sex is another. And then certainly there's the whole issue of LGBTQ+ and being oriented in a way that's not in the sources, not approved, or not considered to be a real marriage. Men don't marry men in the Torah. Nor do women marry women. There's no template for that. And this often leads to identity crisis: How do I navigate with respect to my Jewish identity, my halakhic identity, my religious identity with my sexual identity, whom I'm attracted to, whom I love? That would be another example of an area which maybe even twenty years ago wasn't discussed in society; today there are several organizations that deal with it.

When it comes to LGBTQ+ issues, it seems that certain rabbis, particularly in the modern Orthodox world, have made progress. Are there

other areas where the worlds of therapy and mental health are convincing rabbis to work with more leniency?

Absolutely! And in many different areas, not just in sexuality. In most rabbinical programs today, rabbis as well as female rabbinic authorities are learning a lot about mental health. In Judaism, there is the concept *pikuach nefesh*, which means that there do need to be halakhic leniencies when there is a threat to life. For example, that's certainly true with fasting for somebody who has an eating disorder. So now, there's a recognition that there is an inherent kind of conflict between halakhah and people who are LGBTQ+, regarding their mental health. In order to provide empathy and prevent depression or—God forbid—suicides, there needs to be a lot more movement towards inclusion. However, in the world of LGBTQ+, there's a great desire for acceptance beyond just taking it into account: LGBTQ+ is not a pathology, and LGBTQ+ people do not want to be seen as having mental health issues when it comes to their identities. But I do think we need to recognize that if they are religious, if they are Orthodox, if they are Haredi, they are going to have conflicts. We have a podcast episode with Rabbi Benny Lau, speaking about *lo tov hayot ha-adam levado*—the concept that "it's not good for man to be alone." If you are a homosexual, then you should live with a man. And within the community, we don't ask you what you do in your bedroom, no matter whether you are heterosexual or homosexual. The Torah doesn't say you're not allowed to be a homosexual; the Torah states a certain prohibition against a certain specific act. That seems to be a more modern approach.

In the exhibition, we look at taboos and fantasies in relation to sexuality. Do you have observations on how our fantasies are shaped by our religious and cultural backgrounds?

This would have to be studied! I think the issue of fantasy is very human, not Jewish, not religious. I wouldn't necessarily say we can draw conclusions from a few anecdotal stories, but what I have found with some of the ultra-Orthodox women I have spoken to is that they talked about fantasies of domination, particularly when their reality is about feeling oppressed. People who are very inhibited by religious and cultural messages around sex may struggle very much with the content of their fantasies; the idea of controlling our sexuality can become almost oppressive. I think part of the message has to be that we can control our behaviors, but that our sexuality is very complex, and not every thought or desire that comes into our mind necessarily means that there's something wrong with us or even that we actually want to partake in this fantasy. There aren't really a lot of permissive cultural messages about fantasy. The idea of being very focused on your partner, being intentional, is a beautiful mindfulness principle and can certainly create incredibly focused, intentional sexual experiences with your partner. But they can't always be like that. And

sometimes people just fantasize. These are mechanisms our brain uses, and being able to feel some sort of sense of permission could be therapeutically helpful for many individuals. In a fantasy, you can be anyone, do anything, and not get punished; there's definitely a role for fantasy.

The #MeToo movement has had an immeasurable impact on contemporary culture and sexual politics. Has it made an impression in the Orthodox world?

Yes, I think it has had quite an impact! Because many women have had sexual experiences for which they feel a lot of shame and guilt and for which they blame themselves. Part of that blame comes from messages from society: if you drank or if you dressed a certain way or if you acted a certain way—what were you doing out with him that late at night? I think one thing the #MeToo movement might have done is help heal some of that shame. And it also helped to explain the freeze response, so that on a global level women and men go to therapy for trauma and finally understand why they didn't scream and cry.

The second thing is that the discussion of consent has begun to trickle in, and the idea that it's not okay to coerce or to take advantage. I think that in the past, young religious women who were sexually active would tell themselves, "You shouldn't be doing this stuff, you shouldn't break *shomer* in the first place—so if you do, you don't have the privilege or the right to consent or not." I think you need to be empowered to make your own decisions and then make your own decisions about boundaries and consent.

I have one last question on which I'm curious to hear your thoughts. A friend of mine once said that if you ask New Yorkers to close their eyes and imagine a sex therapist, they picture a Jewish woman. Going back to Hirschfeld and Freud, through to Dr. Ruth and Esther Perel—is there a particularly Jewish interest in this area, and if so, do you have a sense of why that might be?

I think, essentially, Jews do not play into the Catholic or Puritan value system. I would like to say that Judaism is essentially sex positive, even if it is limited to sanctifying sex within marriage. There's never this feeling that sex itself is wrong or bad or evil. It's a force. The Jewish values around it are more about regulation and sanctity, but sex is meant to be playful, pleasurable, and connecting, and is considered to be important in building and maintaining intimacy and marital harmony.

The interview was conducted by curator Joanne Rosenthal.

1 Michelle Friedman et al., "Observant Married Jewish Women and Sexual Life: An Empirical Study," *Conversations* 5 (2009).

2 David Ribner / Talli Rosenbaum, *I Am for My Beloved: A Guide to Enhanced Intimacy for Married Couples*, Jerusalem: Urim Publications, 2020.

The Art of Breaking Taboos

David Sperber

Women of Jewish origin occupied a central place in the second-wave feminist movement in the United States, including thinkers and writers in the canon of feminist and gender theory,[1] as well as groundbreaking feminist writers in the disciplines of history,[2] literary criticism,[3] psychology,[4] and queer theory.[5] The same holds true of the central role that Jewish artists played in the feminist art movement. The long list includes, among others: Miriam Schapiro, Nancy Spero, Ida Applebroog, Anita Steckel, Audrey Flack, Joan Semmel, Eleanor Antin, Judy Chicago, Hannah Wilke, Judith Bernstein, Joyce Kozloff, Ruth Weisberg, Elaine Reichek, and Martha Rosler.[6] These artists took a central place in the arena of breaking taboos concerning women's bodies and sexuality—as in the vaginal works of Chicago | see pages 200–201 | and Wilke, the sexual imagery of Steckel | see pages 142–143 | and Lee Lozano, and sex relation depictions of Semmel | see page 59 |— topics that had been received and discussed as the most significant artistic contribution of art to feminism.[7]

Mierle Laderman Ukeles was unique among feminist Jewish artists of 1970s America; while, for the most part, her peers did not incorporate Jewish religion into their art, she dealt with the subject directly.[8] When she performed *Mikva Dreams* at New York's Franklin Furnace Gallery in 1977, it was the first time the immersion of a Jewish woman in the mikvah (ritual bath) had been presented to an audience for American art.[9] In traditional halakhah (religious Jewish law), the mikvah serves to achieve ritual purity after the *niddah* (menstruation), during which a Jewish couple is forbidden from having physical contact or performing any act that might lead to physical intimacy. After the cessation of her menstrual

period, the traditional Jewish woman immerses herself in a mikvah before resuming sexual relations with her husband. In her performance, Ukeles described the immersion in the mikvah as an act of rebirth and a return to the Garden of Eden, extolling it as a ritual that connects a woman with her inner being. She followed her methodical description by reading from a script about her personal experience of the ritual immersion, from the preparations, through the act itself, to the feeling of joy it gave her: "She goes in, naked, all dead edges removed [...] The mikvah is for her intrinsic self. Her self-self. [...] The blood stopped flowing a week ago. She is the moon."[10] The performance concluded with a meditation, during which the artist repeated the words "immerse again" 210 times, the number of times which, according to her calculation, she might immerse in the mikvah during her reproductive years.

In a second version of the performance, produced for a 1978 issue of the magazine *Heresies,* Ukeles again draped herself in a white sheet.[11] This time she performed the work alone, with no audience, standing on the banks of the Hudson River in New York |see pages 94–95|. Ukeles transformed the performative and vocal properties of the work into three pages of text and a static image for the magazine. The photograph, depicting the artist from behind, draped in a sheet and standing before the river, was surrounded by 210 repetitions of the words "Immerse Again." As such *Mikva Dreams* presented the mikvah and the act of immersion as exalted worship. Ukeles reappropriated and brought to the forefront women's rituals, thus connecting feminist consciousness of the body and femininity to the Jewish ritual.

With her *Mikva* work, Ukeles participated in the spirituality movement, a significant part of American feminist art in the 1970s.[12] Her language is comparable to that used in the Great Goddess movement, which many feminist artists joined, adopting matriarchal ideas from the past to enrich the feminist experience and discourse of their present:[13]

> Like most goddess traditions, Matronit-Shechina, the Jew's female divinity, has been pictured from ancient times as magically combining all these aspects: eternal renewed virgin, and eternal passionate lover, and eternal creating mother. *Mikva* is the site-intersection of all these holy energies.[14]

Therefore, the artist designed *Mikva Dreams* in the spirit of the Great Goddess. She sought to connect herself and the viewers of her performance to the ceremony of Jewish ritual immersion, which she saw as a source of divine energies handed down by women from generation to generation.

Despite the evident connection between *Mikva Dreams* and the feminist Great Goddess movement, Ukeles's work is also distinct from it. The dominant feminist exchanges in the United States during the 1970s linked Jewish law regarding menstruation with the patriarchal view that menstrual blood is impure, which led feminists to critique the Jewish laws of purity. In an interview by Linda Montano, published in 2000, Ukeles explained that many feminist women in the 1970s objected to the ritual of the mikvah and viewed it as primitive, whereas she saw

it as a continuation of the matriarchal religion of the past.[15] In contrast to dominant feminist beliefs of the 1970s, Ukeles consistently produced work that aimed to reclaim immersion practices as empowering rituals for women.

Moreover, Ukeles's *Mikva* works are crucial to her broader preoccupation with institutional critique and her desire to undermine the (often gendered) division between public and private, a central theme in her better-known "maintenance art."[16] Displaying women's ritual immersion to the public represented a radical departure from Jewish religious practice in the 1970s, when the ritual was seen as a personal and intimate act that should remain invisible and was never discussed in public. In 1976, shortly before Ukeles presented her *Mikva* performances in the US, Yocheved Weinfeld, who was one of the key figures in Israeli art during the 1970s and among the pioneers of body art in Israel, featured at the Debel Gallery in Jerusalem a performance that intertwined purity and mourning laws from the Jewish codex *Kitzur Shulhan Arukh*.[17] In contrast to Ukeles's presentation of the mikvah as a sublime female cult, Weinfeld presented it in a gloomy spirit.

The performance was designed as a bridal preparation for her wedding ceremony: Weinfeld was portrayed as a passive woman, her body subjected to humiliating acts bordering on abuse. Dressed in black, she read passages of Jewish law aloud—such as the requirement for couples to abstain from sexual relations during the woman's menstrual impurity or about different mourning customs— while sitting on a chair. Next, she performed the ritual tearing of her garment to show mourning, or as performed by the priest on a suspected adulteress (*sotah*), along with disheveling her hair (Numbers 5:1–31; Mishnah Sotah 1:5). A woman in white uniform (in the role of the mikvah attendant, nurse, or priestess) wiped her feet with a wet cloth, which Weinfeld then tucked between her legs in an act reminiscent of the ritual detection of traces of menstrual blood with strips of white cloth. The attendant then thrust the cloth into Weinfeld's mouth which she shut with surgical tape, symbolizing the silencing of the female voice by the power of imperatives and limitations. After removing the rag from Weinfeld's mouth, the attendant applied rouge and lipstick to her cheeks and lips.

At the end of the performance, during which her hair is cut, the artist approached the audience with a tray bearing her hair and a glass of wine poured from an old dirty bottle, and offered them a sip from the liquid in the glass, passing it around as in the Friday night kiddush ritual.

The performance shifted from social control of women's bodies and sexuality to elements of death and mourning, emphasizing "the abject" in culture construction. The private, concealed ceremony was intensified in the public performance, thereby opening it to a conceptual interpretation linking the intimacy of body images subjected to regulation in Judaism to artist-observer relations in art. As in Judaism, whose values are expressed by bodily ritual, Weinfeld, too, lent meaning to artistic concepts through her own body.

Both artists, Ukeles and Weinfeld, in the 1970s dealt with the niddah rituals. Despite the similarity between them regarding their taboo-breaking work, their respective positions on niddah laws are opposites: Ukeles praised niddah rituals, while Weinfeld's performance can be read as critical of them. The appropriative

move of Ukeles and the critical move of Weinfeld both constitute a feminist move of breaking taboos by actually dealing with these topics that, until recently, were considered inappropriate to talk about in public.

Since the early 2000s, many artists have dealt with *tevilah* (immersion) and the mikvah. They continue the aforementioned two moves. Hagit Molgan continues the critical trajectory of Weinfeld. Her video work *Five Plus Seven* is amorphic and mysterious but directed intensely at the state of oppression implemented on women by controlling their bodies. The work depicts seven women whose heads are not visible, wearing white dresses with a square-shaped exposure at the navel alongside three metal towers lit in neon blue. To the ticking of a metronome that sounds like dripping water, the women march in a line, stepping in bowls filled alternately with red water and clear water. The marching women's feet stay red even after they "immerse" them in the water. As the video ends, the camera zooms in on one of the women, as though penetrating through her exposed stomach. A superimposed hand appears in the frame, holding a rod wrapped in cloths. It penetrates the stomach, uncovers a receptacle reminiscent of a tampon cover, and clears it out.

Molgan also brought the *bedikah* cloths—pieces of cloth an Orthodox woman uses to check whether her monthly bleeding has stopped—into the art world and encouraged a discussion of the meaning and effect of the religious practices surrounding a woman's menstrual cycle in the Israeli Modern Orthodox society. Like Molgan, Ayelet Weil Nebensal also used bedikah cloths in her work, printing images of well-known, prominent Israeli women from various fields (Golda Meir, Ilana Dayan, and Gila Almagor) onto them. The cloths were sewn into small pillows combined with images of ants. She explained the work:

> I see the customary self-examination with the cloths as minimization and reduction of the woman's essence. [...] With this work, I wanted to draw attention to how the rituals associated with the *mitzvoth* [Jewish religious Commandments] of *niddah* minimize and diminish the woman.[18]

Likewise, Andi LaVine Arnovitz, created an artwork in book form that is a collection of bedikah cloths printed with red, yellow, or brown letters (a hint of the variety of colors of stains blood can leave on the fabric), stored in an envelope. The cloths inside the envelope echo the customary practice of showing the rabbi the stained cloth so that he can rule on purity or impurity. *He Loves Me* directly connects the blood to the marital relationship and permission to have sex. According to the artist, "even when a woman feels menstrual bleeding has stopped, the fabric often tells otherwise."[19]

Unlike the critical art, and in direct continuation of Ukeles, since the early 2000s, the works of American artists such as Janice Rubin and Shari Rothfarb Mekonen portrayed the mikvah as part of a separate "feminine religion" that operates in an arena safe from male infiltration.[20] These works reflect the religious eroticism of the mikvah and depict tevilah as an exhilarating moment, a connective channel to the days of Genesis.

In conclusion, although I used the dichotomous distinction between critical art and appropriative art throughout the article, the above review and analysis undermine these decisive diagnoses. It clarifies the necessity of a critical look at the concepts of criticism themselves. Often, what at first glance seems like a surrender to and the preservation of the existing patriarchal order, can also be interpreted as an expression of critical feminism that promotes women's empowerment. Precisely religious piety can empower women who interpret and reproduce patriarchal texts and laws and turn them into sources of inspiration as well as meaningful practices.[21]

1 Among them Betty Friedan, Gloria Steinem, Letty Cottin Pogrebin, Adrienne Rich, Susan Moller Okin, and Andrea Dworkin.

2 Gerda Lerner, Natalie Zemon Davis, Joan Wallach Scott.

3 Sandra Gilbert and Susan Gubar, Elaine Showalter.

4 Nancy Chodorow, Phyllis Chesler, Carol Gilligan.

5 Judith Butler, Eve Kosofsky Sedgwick; see more in Joyce Antler, *Jewish Radical Feminism: Voices from the Women's Liberation Movement,* New York: NYU Press, 2018.

6 See the article by Gail Levin on page 27.

7 See Gail Levin, "Beyond the Pale: Jewish Identity, Radical Politics, and Feminist Art in the United States," *Journal of Modern Jewish Studies* 4.2 (2005), 205–32. On the contribution of feminist art to the broader feminist discourse, see Laura Meyer, "Power and Pleasure: Feminist Art Practice and Theory in the United States and Britain," in: Amelia Jones, ed. *A Companion to Contemporary Art since 1945,* Oxford: Blackwell, 2006, 317–42; Jane de Hart Mathews, "Art and Politics in Cold War America," *American Historical Review* 81 (1976), 774.

8 Lisa E. Bloom, *Jewish Identities in American Feminist Art: Ghosts of Ethnicity,* New York: Routledge, 2006, 3.

9 On Ukeles's Jewish-religious works in the 1970s and the 1980s, see David Sperber, "*Mikva Dreams*: Judaism, Feminism, and Maintenance in the Art of Mierle Laderman Ukeles," *Panorama: Journal of the Association of Historians of American Art* 5.2 (2019), 1–22, https://editions.lib.umn.edu/panorama/article/mikva-dreams.

10 In Mierle Laderman Ukeles, "*Mikva Dreams*–A Performance," *Heresies: The Great Goddess* 5 (1978), 53.

11 Ibid., 52–54.

12 On the feminist spirituality movement, see Cynthia Eller, *Living in the Lap of the Goddess: The Feminist Spirituality Movement in America,* Boston: Beacon Press, 1995, 38–61.

13 Jennie Klein, "Goddess: Feminist Art and Spirituality in the 1970s," *Feminist Studies* 35.3 (2009), 575–602.

14 Ukeles, "*Mikva Dreams*–A Performance," 52.

15 Linda Montano, *Performance Artists Talking in the Eighties: Sex, Food, Money/Fame, Ritual/Death,* Berkeley: University of California Press, 2000, 457.

16 See Sperber, "*Mikva Dreams*," 14–17.

17 On Weinfeld's pioneering works, see Gannit Ankori, "The Jewish Venus," in: Matthew Baigell / Milly Heyd, eds. *Complex Identities: Jewish Consciousness and Modern Art,* New Brunswick, NJ: Rutgers University Press, 2001, 247–50; David Sperber, "The Abject: Menstruation, Impurity, and Purification in Jewish Feminist Art," *Matronita: Jewish Feminist Art* [catalog, Mishkan Museum of Art, Ein Harod], curators David Sperber and Dvora Liss, Jerusalem and Tel Aviv: Mishkan Museum of Art, Ein Harod, 2012, 134–31 (reverse pagination).

18 Sperber, "The Abject," 125.

19 Ibid., 127.

20 Danya Ruttenberg, "Heaven and Earth: Some Notes on New Jewish Ritual," *Reinventing Ritual: Contemporary Art and Design for Jewish Life* [catalog, The Jewish Museum, New York], curator Daniel Belasco, New York: The Jewish Museum; New Haven: Yale University Press, 2009, 87.

21 On these approaches in postmodern and anticolonial feminist thought, see, e.g., Lila Abu-Lughod, *Do Muslim Women Need Saving?,* Cambridge, MA: Harvard University Press, 2013.

Sexuality and Gender

Ronit Irshai

A leading premise in the field of Judaic Studies asserts that Judaism embraces an affirmative attitude toward sexuality.[1] It attributes to Judaism a life-sanctifying theological stance, which, as distinct from Christianity, does not set abstinence from physical life as the spiritual ideal. This theological stance is well represented in the legal (halakhic) sphere, which for example makes it a husband's obligation to have regular sexual relations (termed *onah*) with his wife in the marital context,[2] separate from, and in addition to, the biblical obligation to "be fruitful and multiply."[3]
This article traces the emergence of new and more differentiated perspectives on sex and gender—and new approaches such as feminist critique and gender study—in the field of Judaic Studies, starting in the 1990s. Regarding sexuality and gender in modern halakhic literature and modern Jewish theological trends, scholarship is still in its early stages.

As feminist theories, cultural studies, and postmodern thinking have penetrated Judaic Studies, this has impacted the hitherto unquestioned consensus that Judaism affirms sexuality. The new scholarship challenges the ostensibly "neutral," gender-free treatment of theology and formal halakhah in classic Judaic Studies scholarship, turning attention to the practical implications of theological and halakhic viewpoints for the lives of *actual* women and men. Contemporary scholars, both male and female, have begun to question the underlying gender principles within Jewish thought, theology, and law that shape couplehood and the family as a patriarchal institution, and also the meaning of sexuality itself and its functions in Jewish tradition: the relationship between the husband's halakhic

obligation to have sex with his wife (*onah*), sexual enjoyment (of both partners), and procreation; the male sexual drive as opposed to the female one; and "solitary" sexuality (masturbation) by men and women. The emergence of queer theory has seen intensive consideration of the question of the Jewish attitude toward heteronormative sexual identities.

The new theoretical frameworks, gender and cultural studies in particular, have sparked a number of questions not addressed by traditional Judaic Studies research. Thus, feminist researchers have begun to ask how the religious laws (halakhoth) concerning women's bodies (modesty, menstrual impurity [*niddah*], procreation), especially their theological and sociological ramifications, affect women's lives today.

With what can be termed "liberal feminism," an intriguing shift in the study of gender and sexuality in ancient rabbinic literature has been initiated, with scholars addressing such questions as the attitude toward women in this literature, some underscoring its patriarchal and misogynist aspects,[4] and others citing the legislation that favors women and typical rabbinic attempts at enhancing their status.[5] Focusing on topics such as sexuality and marriage, female and male bodies, and adultery and seduction, among others, they widened and challenged existing viewpoints in Judaic Studies.

Female Sexuality and the "Problem" of Men

Feminist writings train the spotlight on the fact that it is women who are charged with taking responsibility for the ostensible "problem" of men[6] and, furthermore, that halakhic standards are usually set according to male needs. However, because masculinity is the prevailing, but "transparent," norm in halakhic rulings, it is not recognized as a problematic bias on the rabbis' part.[7] Borrowing Laura Mulvey's coinage, "to-be-looked-at-ness," E. Fisher notes that Talmudic halakhic discourse on women asserts that they "are *not* supposed to-be-looked-at" (emphasis original).[8] But here too the norms of how to avoid such observation are dictated by male inclinations and needs.

A definitive example of this issue in everyday life is the polemic in Israel surrounding the Talmudic prohibition that equates a woman's voice with nudity (*qol ba-isha ervah,* lit. "a woman's voice is nakedness"), especially in the context of women singing in the army, where men and women, both religious and secular, serve. Tamar Ross underscores the male bias inherent in this prohibition:

> Women today ask why all the anxiety about the purity of men's thoughts is not accompanied by any concern about women's experiences. This brings us back to the conclusion that the *halakhah* imposes inappropriate responsibility on women, for the traditional bounds of modesty are always formulated exclusively in terms of women's seductiveness to men.[9]

Fisher notes another problematic, conflicting message that is conveyed regarding female sexual identity.[10] The premise that women must cover themselves primarily to prevent men from having "impure thoughts," compared with the total

absence of halakhoth requiring men to cover their bodies in order to prevent women from having impure thoughts, can be interpreted as lack of recognition of women as sexual beings with sexual needs. In Hartman's view, the extreme messages of liberal culture regarding exposure of women's bodies, and of religious society that demands their maximum concealment, in actuality reflect the same notion of the woman and femininity—as a sexual object for men.[11]

Uncovering the moral paradigm underlying the exclusion of women from religious rituals is even more obvious. The primary basis for that exclusion is the image of the woman as a "ticking sexual time bomb." The idea of holiness is profoundly tied to this—the more a woman is hidden, the holier the atmosphere. In other words, the woman is equated with the unholy or even the "anti-holy"; at the same time, man is seen as a "sex-obsessed hormone dump." Halakhic genealogy can uncover this paradigm, present it to Modern Orthodox men and women, and ask whether they are prepared to look in the mirror and then buy into this image.[12]

Both feminist critique and gender analysis expose the links between the laws of modesty and theology. Women's challenge to the religious system from personal experience, their refusal to silence their voices, heightens the awareness of underlying theological assumptions regarding to what extent women are considered religious subjects and who is speaking in the name of God.

Queer Jews

Only in recent decades have Judaic Studies scholars begun to focus on questions of sexual/gender identities. If, as shown above, the discussion of gender formation in the female context has flourished, the discussion of maleness from a Jewish perspective is just beginning. Daniel Boyarin's *Unheroic Conduct: The Rise of Heterosexuality and the Invention of Jewish Men* (1997) treats, for the first time, the topic of Jewish maleness, particularly as exemplified in rabbinic literature:

> This book is intended as one small chapter [...] on rabbinic Jewish maleness [...] of the possibility of an embodied male who fully with-in the order of sexuality and even paternity, is nevertheless not "masculine" or "manly" in the terms of the dominant fiction and thus inscribes the possibility of male subjects who refuse to be men.[13]

The new perspective on "maleness" and "femaleness" as an anti-essentialist identity formed through cultural activities, and the emergence of queer theories in the 1990s sparked intense consideration of the question of gender identities within Jewish communities as well as in Jewish Studies. For generations addressed only sporadically by halakhists in the *responsa* literature activities (authoritative replies to queries on matters of Jewish law), this topic did not assume a central place on the agenda of the Jewish world for several reasons: homosexual (but not lesbian) intercourse is considered a biblical prohibition that carries the death penalty; persons with such tendencies, if they existed (such was the claim), were a small minority; and the violation of the religious *nomos* by

individuals did not challenge the religious narrative. Until the mid-1980s the question of "nonheteronormative" sexual identities was barely touched on in the various branches of Jewish literature, including halakhic literature.

As the Western social attitude toward individuals with homosexual preferences and identities changed, the painful stories of religious homosexuals (men and women) began to be heard, at first privately and then publicly. In effect, this is an instructive example of how a shift in the Western narrative regarding sexuality in general, and sexual difference in particular, also influenced liberal Western legislation and the Jewish world, respectively, both in terms of the attitude toward those with different sexual identities in the various religious branches and in scholarly writing. Thus, for example, the Reform movement was the first which saw the ripening of a respectful, legitimate attitude toward different sexual identities. The more liberal Jewish movements began to ordain rabbis with different sexual identities and even to permit same-sex marriage, providing varied religious rationales for their divergence from the traditional Jewish norm. Even in the Orthodox movement, where the prohibition against homosexuality is still in force, we find shifts in the rhetoric. A growing number of rabbis in the Orthodox wing also now feel a need to provide emotional support to homosexuals, which does not necessarily encompass an attempt to change their sexual orientation. One halakhic-legal strategy distinguishes between *orientation* and *act*: Opposed to some Orthodox rulings, the fact that a person has a homosexual orientation does not make him a criminal; his divergent orientation is not inherently incriminating. This stance is in harmony with Boyarin's study, which makes a distinction between homosexuality and the prohibition against homosexual intercourse. Boyarin argues that the strong negative reactions currently aroused by homosexuality, especially within the religious establishment, are missing from rabbinic literature, and that the attitude toward those who commit undesirable deeds never included their perception as "others." Thus, there are rabbis who suggest paying attention that biblical law mandates the death penalty for Sabbath desecrators, but the cultural attitude toward them is far removed from the emotional negativity displayed toward homosexuals. Boyarin is convinced that the biblical prohibition is grounded in the confusion of the categories of male and female, meaning putting the male as being penetrated; therefore, the real topic is gender and not the "homosexual" identity. In fact, with the exception of anal intercourse, Jewish law does not prohibit other types of homoerotic relations.
Returning to the distinction between orientation and act, some rabbis and halakhic scholars who endorse this stance continue to treat homosexuality as a disease and not as an irreversible condition. They propose that, instead of condemnation, sufferers from this disease should be directed to pharmaceutical treatment intended to return them to normative life.[14] If their orientation cannot be altered, it is then perhaps worthwhile convincing them to "lower their expectations" and aspire to the creation of a heterosexual family with a spouse who accedes after full disclosure.[15] Another viewpoint supports marriage between a gay man and a lesbian, so that, together, they can build a Jewish family. Some

apply to them the legal category of "duress" (Hebrew: *ones*), arguing, namely, that they deserve sympathetic treatment because they are impelled to their orientation by sexual desire.[16] Others maintain that this topic should not be aired in the public arena,[17] neither by the religious gay community nor in public statements by rabbis. Silence is considered the best policy in order not to grant homosexuality legitimation.[18]

With the greater public exposure of gay men and lesbians and of their personal stories—in the context of their families and communities, as well as in the media and other public forums—came their refusal to relinquish their religious worlds in spite of their exclusion by the rabbinic establishment. The tone of some modern Orthodox halakhists also shifted dramatically. First of all, halakhists began to address this matter. Second, even if this did not harbinger significant change for religious-Orthodox homosexuals, there were now calls for respect toward them, a separation of acceptance of the individual as a person and a believer from halakhic, but not social, opposition to their sexual behavior. In practical terms, this means a call not to exclude them from the community or religious educational frameworks, nor to encourage heterosexual marriage "at any cost," or to automatically direct every person struggling with their sexual identity to "conversion" therapy. This despite the fact that the religious (mainly the Orthodox) sector still retains strong principled and emotional objections to events such as Gay Pride Parades. The emerging questions touch on the level of the *nomos*—on the possibility of incorporating religious-Orthodox homosexuals, and their families, including marital and parental agreements, in religious communities, and on the widening of the scope of discussion to include issues relating to religious Jews who are transgender.[19]

In the last two decades we also see a growing interest within the Orthodox Jewish world in questions concerning transgender people and the appropriate halakhic attitude towards them. The question of gender affirmation surgeries and non-surgical gender transition has different halakhic ramifications, and this field in general is just starting to be addressed. However, not all Orthodox halakhic opinions are, as one might have thought, stringent in their position.[20]

1 See David M. Feldman, *Birth Control in Jewish Law: Marital Relations, Contraception, and Abortion as Set Forth in the Classic Texts of Jewish Law*, New York: New York University Press, 1995; David Biale, *Eros and the Jews: From Biblical Israel to Contemporary America*, New York: Basic Books, 1992; Daniel Boyarin, *Carnal Israel: Reading Sex in Talmudic Culture*, Berkeley: University of California Press, 1993, 29.

2 Maimonides, *The Code of Maimonides: Book Four: The Book of Women*, New Haven and London: Yale University Press, 1972, 14:1–7.

3 Ibid., 15:1.

4 See Blu Greenberg, *On Women and Judaism*, Philadelphia: Jewish Publication Society, 1981; Cynthia Ozick, "Notes toward Finding the Right Question," in: Susannah Heschel, ed. *On Being a Jewish Feminist: A Reader*, New York: Schocken, 1983, 120–51; Judith R. Wegner, *Chattel or Person? The Status of Women in the Mishnah*, New York: Oxford University Press, 1988; Judith Plaskow, *Standing Again at Sinai*, New York: Harper, 1991; Rachel Adler, *Engendering Judaism: An Inclusive Theology and Ethics*, Jerusalem and Philadelphia: Jewish Publication Society, 1998; Rachel Adler, "Innovation and Authority:

A Feminist Reading of the 'Women's *Minyan* Responsum,'" in Walter Jacob/Moshe Zemer, eds. *Gender Issues in Jewish Law*, New York: Berghahn, 2001, 3–32; Judith R. Baskin, *Midrashic Women: Formations of the Feminine in Rabbinic Literature*, Hanover: University Press of New England for Brandeis University Press, 2002.

5 Judith Hauptman, *Rereading the Rabbis: A Woman's Voice,* Boulder, Colo.: Westview, 1998; Lisa Aiken, *To Be a Jewish Woman,* Northvale, NJ: J. Aronson, 1992.

6 Tova Hartman, "Modesty and the Religious Male Gaze," in: Tova Hartman, *Feminism Encounters Traditional Judaism: Resistance and Accommodation,* Waltham, MA: Brandeis University Press, 2007, 45–61; Tamar Ross, "The Feminist Contribution to Halakhic Considerations: *Qol be-ishah ervah* as a Test Case," in Avinoam Rosenak, ed. *Philosphy of Halakhah: Halakhah, Meta-Halakhah and Philosophy: A Multi Disciplinary Perspective*, Jerusalem: Magnes, 2011, 35–64 (in Hebrew).

7 Ronit Irshai, "Halakhic Discretion and Gender Bias: A Conceptual Analysis," *Democratic Culture,* 2013 (in English and in Hebrew).

8 E. Fisher, "The Ethos of 'Female Modesty' in Rabbinic Literature: Between the Woman's Obligation to Conceal Her Body and the Male Prohibition against Looking," Master's thesis (Bar-Ilan University, Ramat Gan) (in Hebrew), 2009.

9 Ross, "The Feminist Contribution," 2011, 47.

10 Fischer, "The Ethos of 'Female Modesty,'" 2009.

11 Hartman, "Modesty and the Religious Male Gaze," 2007.

12 Ronit Irshai, "Toward a Gender-Critical Approach to the Philosophy of Jewish Law (Halakhah)", *Journal of Feminist Studies in Religion* 26/2 (2010), 55–77, 70.

13 Daniel Boyarin, *Unheroic Conduct: The Rise of Heterosexuality and the Invention of the Jewish Man,* Berkeley: University of California Press, 1997, 11.

14 Norman Lamm, "Judaism and the Modern Attitude to Homosexuality," in: Louis I. Rabinowitz, ed. *Encyclopedia Judaica Year Book,* Jerusalem: Keter, 1974, 194–205; Moshe Halevi Spero, "Homosexuality: Clinical and Ethical Challenge," *Tradition* 17/4 (1979), 53–73.

15 Gidon Rothstein, "Should Orthodox Homosexuals Be Encouraged to Marry?" *Hirhurim—Musings* 22 (August 2010), http://torahmusings.com/2010/08/homosexuality-and-marriage.

16 Lamm, "Judaism and the Modern Attitude," 1974; Hershel J. Matt, "Homosexual Rabbis?" *Conservative Judaism* 39/3 (1987), 29–33; Yeshayahu Leibowitz, *I Wanted to Ask You, Prof. Leibowitz: Letters to and from Yeshayahu Leibowitz,* Jerusalem: Keter, 1999, 79–178 (in Hebrew).

17 Orit Avishai, *Queer Judaism: LGBT Activism and the Remaking of Jewish Orthodoxy in Israel*, New York: NYU Press, 2023; Avishai Mizrahi (2020, in Hebrew), https://www.kamoha.org.il/?p=451694; Yoram Ettinger, "Dozens of Orthodox Rabbis Penned a Manifesto Calling for Recognition of Homosexuals and Lesbians," *Haaretz*, 29 July 2010 (in Hebrew); R. Lubitz, "The Jewish Stance on Homosexual Relations and Guidelines for Its Didactic Realization," *Mayim mi-delayav*, 233–51 (in Hebrew), 1996.

18 Lamm, "Judaism," 1974.

19 Ronit Irshai and Tanya Tzion-Waldoks, "Modern Orthodox Feminism in Israel: Between Nomos and Narrative," in *Law and Governance*, 2013 (in Hebrew).

20 Ronit Irshai, "Cross-Dressing in Jewish Law (Halakha), and the Construction of Gender Identity," *Nashim* 38 (2021), 46–68; Ronit Irshai/Ilay Avidan, "Beyond Essentialism: An against-the-grain reading of Orthodox Jewish Law (Halakhah) on Transgender People," *Nashim* (forthcoming, 2024).

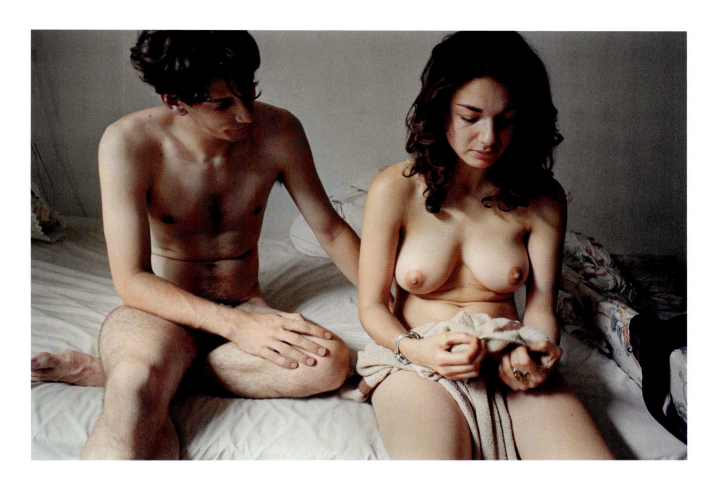

↑
PMS
Elinor Carucci
New York, 1997

Elinor Carucci shows a moment of intimacy with her husband as menstrual bleeding begins.

Separation
Desire and Control

← ↓ →
Kit for Tevilah
Inbar Erez
Israel, 2020

Even during the COVID-19 pandemic, it was important for many practicing Jewish women to purify themselves ritually. When the collective use of the mikvah became too great a risk in Israel, the Israeli artist Inbar Erez came up with an alternative as part of her design studies. It enables women to immerse themselves naked in the sea in public places. They remain modestly covered by the cloak, which keeps them afloat.

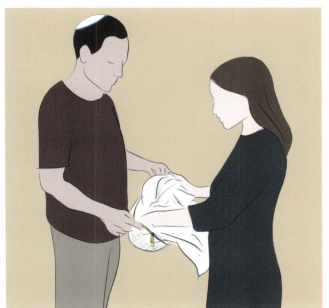
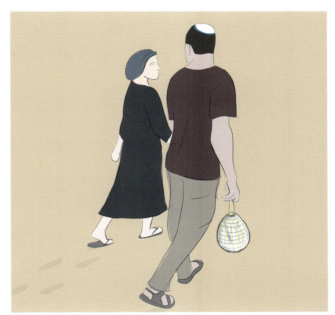

Separation
Desire and Control

93

→
Mikva Dreams: Hudson River
Mierle Laderman Ukeles
New York, 1978

Mierle Laderman Ukeles was one of the first artists to explore the mikvah ritual in her work. This photo shows the second of two performances, in which she portrays ritual immersion as a path toward feminist rebirth and liberation.

Desire and Control
Seperation

94

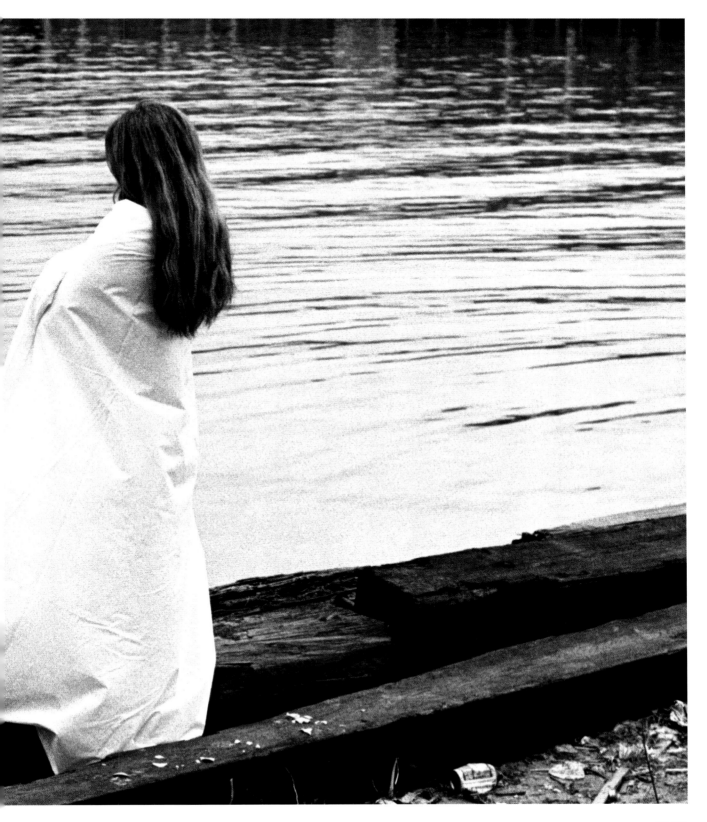

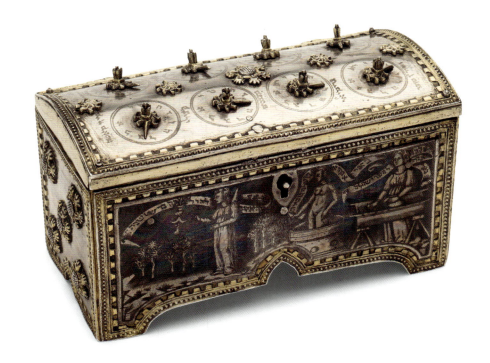

↑
Bridal Casket
Northern Italy, late 15th century

Given as a wedding gift to a bride, this richly decorated silver box depicts the essential religious duties of the Jewish woman: separating the hallah, lighting shabbat candles, and immersing as part of the monthly mikvah ritual. The perhaps unusual sight of a naked female figure foregrounds the significance of the laws of family purity to Jewish life.

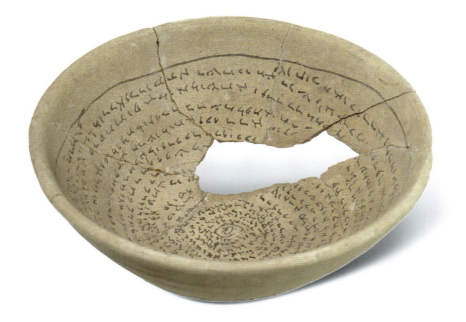

↑
Incantation bowl
Mesopotamia, after 200 CE

In the ancient cultures of the Middle East, blood was often associated with magical ideas. Persians and Jews alike saw female menstruation not only as a source of life, but also as a danger. It was in this context that the rules governing the ritual purity of Jewish women—set out in the family purity laws—emerged.

This spell bowl reflects the mutual influences between the two cultures. It is inscribed with a protective spell that invokes the Jewish name of God and the power of a bloody cloth from a menstruating woman. The Hebrew text was probably written by a Jewish scribe. The Persian customer protected himself by burying the bowl in one corner of his house with the upper part facing downward.

Separation
Desire and Control

97

→
Magen (Jewish Cut)
Ken Goldman
Kibbutz Shluchot, Israel, 2015

Using the traditional Jewish folk art of papercut, Goldman evokes the shape of the clamp used during the circumcision ceremony. As an adolescent, he was disturbed to be told by his rabbis that the purpose of circumcision was to prevent young men from sinning through masturbation or pre-marital sex. These ideas are drawn from the medieval writings of Maimonides who prioritized the procreative aspect of sex and celebrated circumcision as a means to reduce male sexual pleasure.

↑
Thumb Ring
Amsterdam, 1700–1850

It is thought that young men wore rings like this at night to protect themselves against the temptation of masturbation. Rabbinical literature rejects masturbation on the grounds that it "wastes sperm." The inscriptions on this ring are from mystical texts designed to help individuals overcome sexual desires and submit to religious rules.

↑
Kippot of the Jewish LGBTQ+ Community Germany
Keshet Deutschland e.V.
New York, 2021

Tadeo "Akiva" Berjón, a diplomat from the Mexican Embassy in Berlin, and his husband, performer Gustavo Thomas, wear these kippot that Keshet Germany made for its members and participants of Pride Shabbatot.

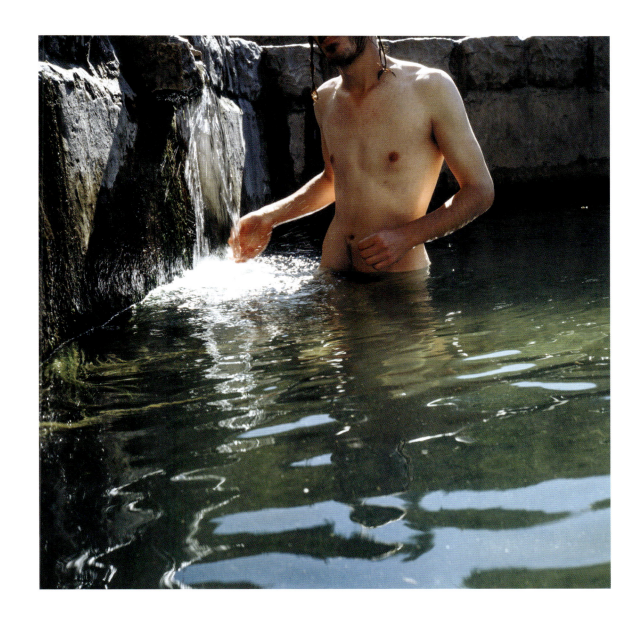

↑
From the "Friday Water" Series
Benyamin Reich
Lifta, Jerusalem, 2004–2006

Unlike women, men are not required by religious law to immerse themselves in the mikvah. Nevertheless, many strictly Orthodox Jewish men voluntarily visit the mikvah before the start of Shabbat or a holiday. Some also go to spiritually purify themselves after sexual practices that are considered forbidden, such as masturbation. Benyamin Reich's photographs convey the homoerotic nature of this custom.

→
Please Do Not Pass in Immodest Clothes
Israel, before 2021

Ultra-Orthodox communities erect prominent signs on the street instructing women to observe the rules of modest dress. In the eyes of the Orthodoxy, women are a constant source of sexual temptation and are responsible for not leading men into sin. These printed scarves are handed out to women at Jerusalem's Western Wall so they can cover their bare shoulders.

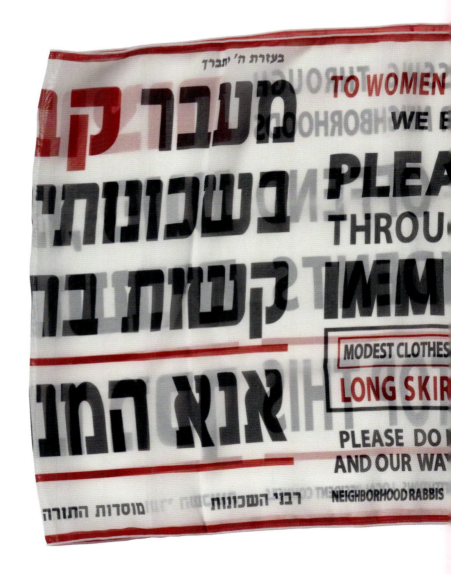

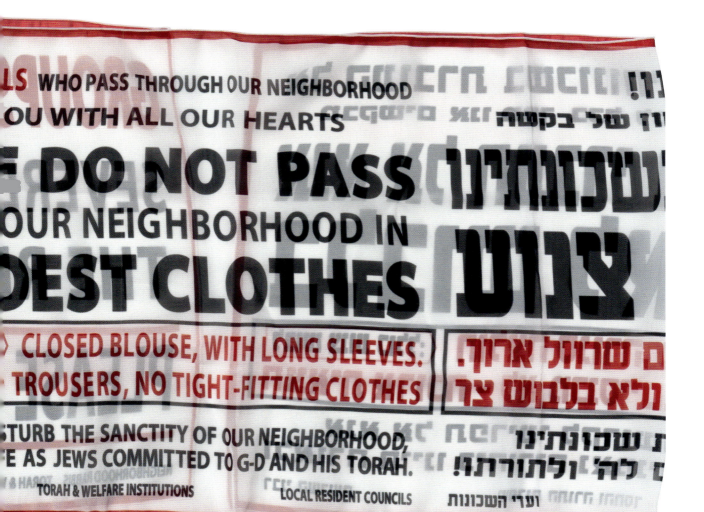

Temptation
Desire and Control

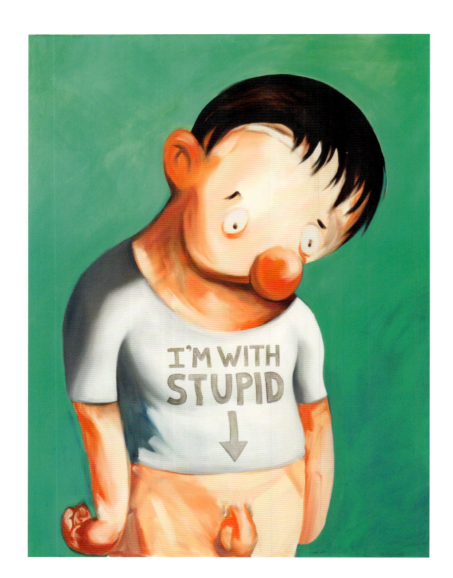

→
Monish
**Jizchak Leib Peretz,
Pinchas Shaar (illustration)**
JOINT, Paris, 1952

This epic poem by the Yiddish writer I. L. Peretz presents a pious yeshiva student's struggle with the competing desires of Torah study and the woman who has caught his eye. To mark the occasion of the author's one hundredth birthday, an illustrated version was produced, with artist Pinchas Shaar visualising the hero's dilemma as he is torn between the spiritual and the carnal.

↑
I'm With Stupid
Nicole Eisenman
USA, 2001

Eisenman uses this popular T-shirt design to comment on the fraught nature of male sexuality. With humor and irreverence, her works often present cartoon-like figures in all their failures, in reflections on sexuality and the human condition.

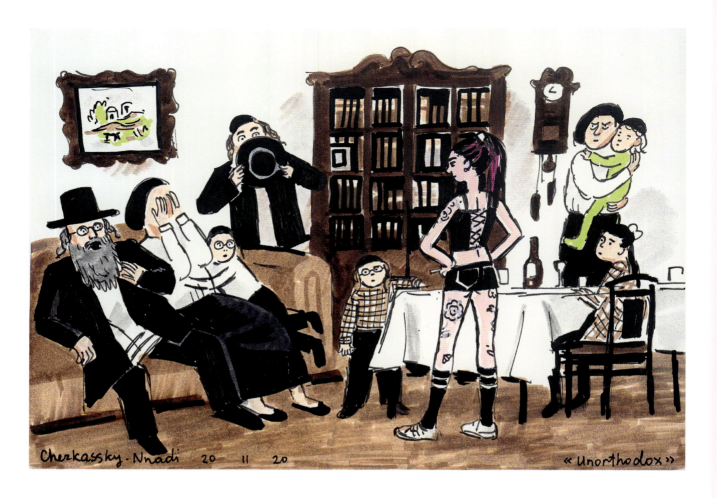

↑
Unorthodox
Zoya Cherkassky-Nnadi
Israel, 2020

This young woman looks like an alien in this Hasidic family home. Her disregard for the Orthodox rules of modesty causes two cultures to collide. Although the two men seem horrified, they cannot quite bring themselves to look away. An Israeli immigrant from Ukraine, Zoya Cherkassky-Nnadi explores the themes of religion and identity with a transgressive sense of humor.

→
Holy
Dorothea Moerman
Oakland, California, 2023

This work shows two women making love behind a *mechitza*, the partition separating men and women in Orthodox synagogues. Dorothea Moerman's imagery, inspired by medieval Jewish art, honors queer sex as a sacred act. The Hebrew word for "holy" appears above the scene: *kodesh*. This print exemplifies Moerman's artistic project to make queer Jews—long erased from history—visible once more.

Desire and Control
Temptation

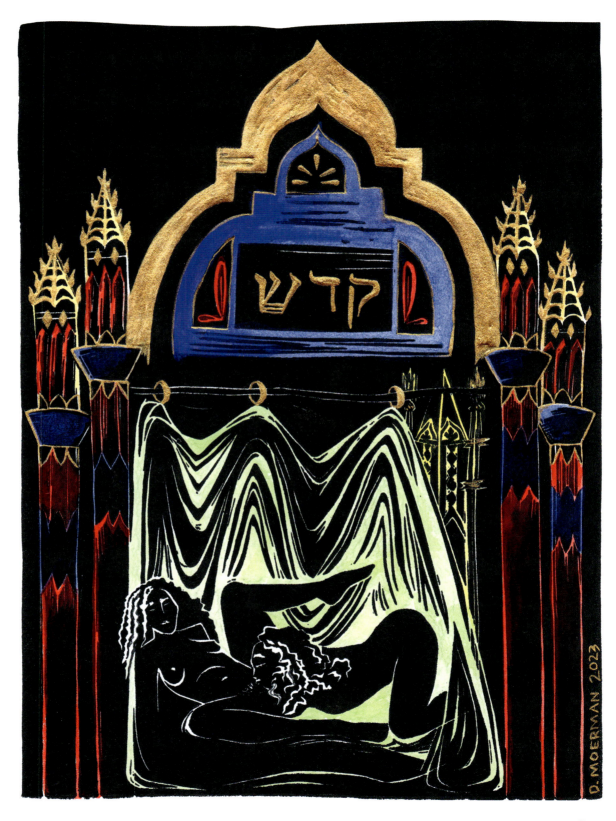

←
That Place
Naama Snitkoff-Lotan
Israel, 2013

In rabbinic literature, phrases such as "that place" which are used to describe the vulva are indicative of the early rabbis' problematic relationship with the female body. Many Orthodox codes of law even prohibit husbands from looking at their wives "down there." As a Modern Orthodox artist, Snitkoff-Lotan seems to be challenging this taboo. Although it remains unnamed, the vulva is presented for all to see.

→
Chewing Gum Sculpture
Hannah Wilke
USA, ca. 1975

The feminist artist Hannah Wilke sought to change perceptions of women through her sculptures and performances. She created a series of vulvas out of chewing gum, which she regarded as the "perfect symbol for the American woman—chew her up, get what you want out of her, throw her out, and pop in a new piece."

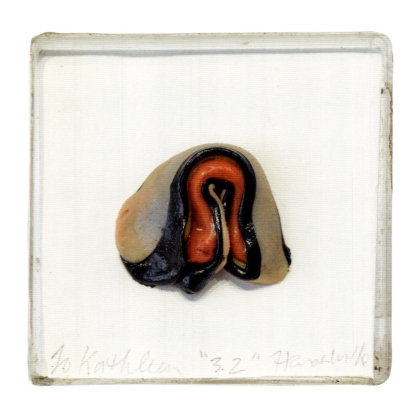

↑
The Scourge
Gabriella Boros
Skokie, Illinois, 2023

Each figurine represents a phrase used by the rabbis of the Talmud to describe the vulva: *The Grave, Teeth, The Other World, Her Other Face, That Place, Her Breath, Her Stare*. The whimsical nature of the figurines undermines the tone of religious texts, which problematize female bodies.

New Directions
Desire and Control

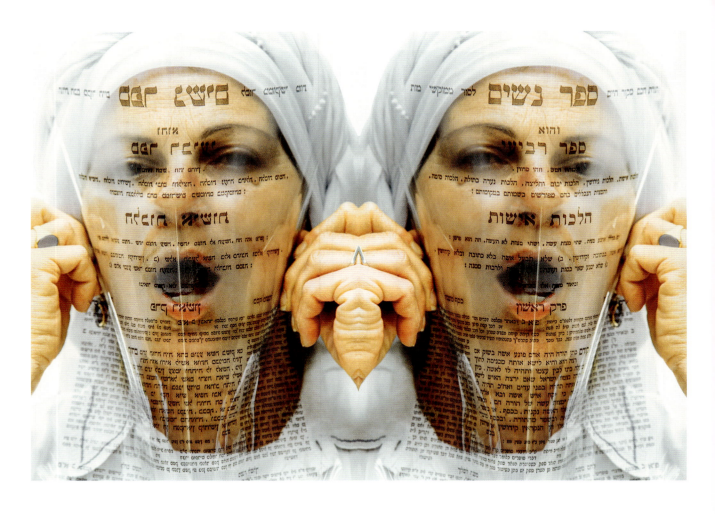

↑
Sefer Nashim
Nechama Golan
Israel, 2000

Nechama Golan presents herself being suffocated by the *Sefer Nashim,* or Book of Women. *Sefer Nashim* is part of the *Mishneh Torah*, Maimonides's twelfth-century compendium of halakhah. The text discusses marriage, divorce, and other issues affecting women in Judaism. With this arresting image Golan portrays the conflict between her Orthodox values and feminist ideals.

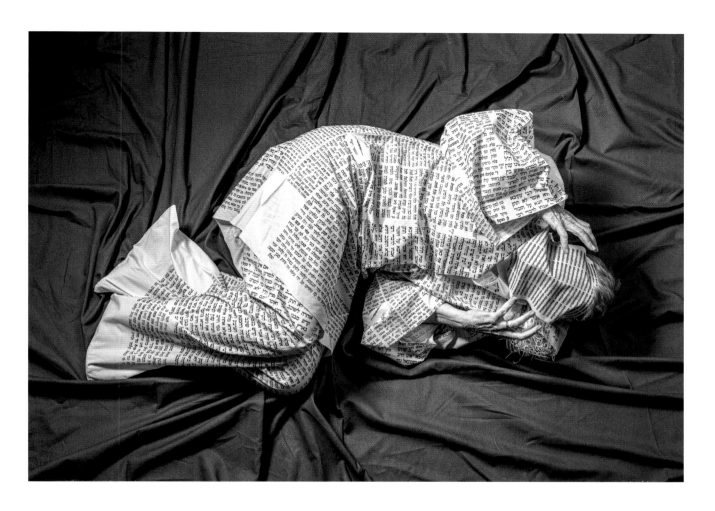

↑
Wrestling with Leviticus
Susan Kaplow
New York, 2012

Susan Kaplow confronts religious homophobia by wrapping herself in an enlarged page from the Talmud. In this page the rabbis discuss Leviticus 18:22, which condemns male homosexuality as an "abomination." Kaplow transformed the text into a death shroud, enveloping her in its rejection of her sexuality as a lesbian Jew. After the performance, she placed the shroud in a *genizah*, the traditional place for storing discarded religious texts and objects.

New Directions
Desire and Control

111

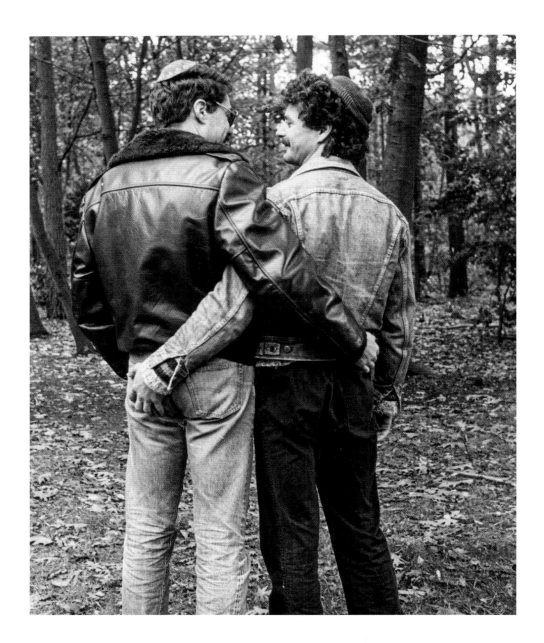

↑
Promotional Photo for Sjalhomo
Jenny E. Wesly
Amsterdam, 1980–1990

Founded in 1979, the Dutch organisation Sjalhomo fought for acceptance of homosexuality within Jewish communities and created a space for gay people to fully experience their Jewish identity.

→
#DafReactions
Miriam Anzovin
2021–2022

Miriam Anzovin has amassed a large fan base on social media with her witty and irreverent commentaries on the Talmud. Her videos are based on the tradition of *Daf Yomi,* the daily study of a Talmud page. Engaging with ancient rabbinic texts from a millennial, feminist point of view, she makes them accessible to a new generation.

New Directions
Desire and Control

113

Sexuality and Power

For better or worse, power is intimately connected to sex. Imagine a sexual fantasy, and it's likely to involve some form of dominance or submission, with one party either giving in to or wielding power. However, while power can fuel desire, in the absence of consent it can be abused as a weapon of sexual exploitation in devastating ways, as the #MeToo movement has demonstrated. Furthermore, it is power—as manifested by social structures, such as religion or the state—that determines which forms of sexuality are legitimized and which are criminalized or considered taboo.

The book of Leviticus in the Hebrew Bible is perhaps the best-known code of sexual taboos from the ancient world, featuring an extensive list of prohibited acts. Sex between men is famously decried in the original Hebrew as *toevah,* an abomination, providing a theological basis for widespread homosexual persecution over the centuries. Other prohibitions which appear include adultery, menstrual sex, bestiality, and many different kinds of incestuous relationships.

And yet, the Hebrew Bible seems to have an ambivalent relationship to sexual taboo. In spite of the unambiguous way in which these prohibitions are presented as divine law, they are frequently subverted in biblical narratives, often with surprisingly positive consequences. Lot's daughters tricking their father into an incestuous union, the marriage of Ruth and Boaz across ethnic divides, David's adulterous relationship with Batsheva—all these violations of the sexual order ultimately led to kingdoms being secured and political lineages maintained.

Taboos are by their nature culturally constructed and culturally maintained. While the taboo of incest remains deeply entrenched in many societies, contemporary attitudes towards issues such as monogamy, adultery, and homosexuality appear remarkably different to those of previous centuries. The question of what is inside or outside the bounds of acceptability changes across time, in line with prevailing social norms. And these norms are themselves shaped and transformed by new forms of knowledge and societal change.

Jewish scientists and researchers have played a major role in challenging sexual taboos, fundamentally reconfiguring how we think about human sexuality. The pioneering work of Sigmund Freud and Magnus Hirschfeld in particular established new ways of understanding the mysteries of sexual desire and destabilized fixed ideas of what is "normal" or "perverse" in relation to sexuality.

Sex was at the heart of Sigmund Freud's work. Even the harshest critics of Freudian theory would agree that Freud unquestionably revolutionized how we understand sexuality. His theories of how sexuality evolves from the earliest stages of infancy and childhood, his writings on the unconscious mind, the human sex drive, and the pleasure principle—these all provided a new language and set of foundations for thinking about sex. Freud's rejection of the idea that any form of sexuality could be said to be innate created new possibilities of acceptance for non-normative sexualities like homosexuality, which was at that point widely considered a mental illness by the medical world.

A contemporary of Sigmund Freud, Magnus Hirschfeld was one of the most important sexologists of his time and an influential campaigner for gay rights. Hirschfeld radically redefined homosexuality as a natural expression of human sexuality, rather than an illness to be stigmatized or punished. The 1919 film *Anders als die Andern* (*Different from the Others*), co-written by Hirschfeld, portrayed the plight of Paul Körner, a successful violinist whose life is ruined after being outed as a gay man. Hirschfeld appears as "The Doctor," a caring authority figure who reassures Körner that his sexuality is normal. The film hoped to win over the German public in the campaign against Paragraph 175, legislation which criminalized homosexuality in Germany. Hirschfeld was ahead of his time; the law was only repealed in 1994.

In the twenty-first century, the idea of human sexuality existing on a spectrum is now widespread. Furthermore, sex is no longer just something that we "do." Sexual desires and

behaviors carry social meanings that can define our identities and the groups to which we belong. Sexual differences, often more imagined than real, can be used to leverage power against and stigmatize particular minoritized communities. The antisemitic figures of the hypersexualized, predatory Jewish man and the *belle juive*, the alluringly exotic Jewish woman, are two notable examples of how Jews have been sexually stereotyped.

But sexuality is also central to self-definition. It has functioned as a powerful tool for constructing and reimagining collective forms of Jewish identity, often in response to antisemitic stereotyping. Zionism is a particularly strong case in point. The "Muscular Judaism"[1] envisioned by Max Nordau presented the diaspora Jew as weak and repressed, in direct opposition to the virile "new Jew" with the strength and physical prowess to partake in the building of a new homeland. As a political movement, Zionism had an interesting engagement with sexuality and identity. The early Zionists saw themselves at times as engaged in an erotic revolution of equality between the sexes and free love, but also as chaste, disciplined pioneers, pure in heart and body.

On an individual level, sexuality is a site of tremendous generative potential for creating, reinventing, and liberating the self. This potential is especially apparent in the work of artists such as Claude Cahun (1894–1972) and Gluck (1895–1978), both of whom, in very different ways, challenged rigid binaries of gender and sexuality. Their very names, a rejection of the female names they were given at birth,[2] speak to the power available to the individual in creating radically new possibilities for self-expression. With this in mind, it is perhaps unsurprising that these Jewish artists of the twentieth century have been reclaimed in recent years as queer icons for today.

1 Nordau introduced this concept in 1898 during his speech at the Second Zionist Congress in Basel.

2 Claude Cahun was born Lucy Schwob; Gluck was born Hannah Gluckstein.

Freud and His Sexual Theory

Ilka Quindeau

With his slim volume *Three Essays on the Theory of Sexuality*, published more than a century ago, Sigmund Freud presented a groundbreaking theory of sexuality and marked a milestone in psychoanalytic thought.[1] The book challenged the prevailing understanding of human sexuality, recasting sexuality from instinctive biological behaviors and outlining the author's vision of anthropology. Freud's theory of sexuality transcended the mind-body dualism that had characterized European and Western thought since the time of ancient Greece.
Even today, we commonly view bodily processes as a baseline for psychological activities, including fantasies, and as a substrate for human sexuality. In 1905, Freud completely reversed the relationship between what happens in the body and what happens in the mind. His theory of sexuality emphasizes psychological factors over physiological factors.[2]
Freud put forward desire, the pursuit of pleasure and satisfaction, as a central driving force of human behavior, stretching far beyond a narrowly defined set of sexual activities as a foundation common to human activity. Freud referred to this driving force as the "sex drive" (*Sexualtrieb*) or "libido," a term that had been coined by the sexologist Albert Moll. Unlike Moll, who saw a drive (*Trieb*) as a purely biological phenomenon, Freud treated it as a concept bridging the realms of body and mind. For Freud, a drive lacks any specific content. A drive constitutes an urgent compelling force, a form of energy, and the momentum of an engine directed toward a goal. Freud defined a drive as "a measure of the demand made upon the mind for work."[3] The drive's source, according to Freud's theory, is a state of tension in the body, and its impetus is to release that tension. Release occurs by way of an "object," which can be another person or

part of one's own body. Freud stressed that, despite common preconceptions, the drive's object is arbitrary and variable. The drive can be satisfied not only through action, as we might expect, but also through fantasy. By emphasizing fantasy, variability, and openness, Freud clearly delineated the drive (*Trieb*) from *Instinkt* (more akin to the English "reflex"), which he defined as a species's hereditary, genetically encoded, fixed, and characteristic behavior. A drive, on the other hand, changes throughout a subject's life. Beginning as an undirected, polymorphous impulse, it takes a highly personal trajectory.

In the English standard edition, the term *Trieb* (rendered here as "drive") has been translated as "instinct" and has often been misconstrued along the lines of a "steam boiler model." This misunderstanding has partly contributed to diminishing its significance in contemporary psychoanalysis. However, Freud's original concept of *Trieb* is remarkably elaborate and links the social, psychological, and somatic realms. Reimut Reiche has distilled the significance of Freud's three essays, pointing out that, unlike the numerous classic works on specific sexual questions published around the turn of the twentieth century, Freud created a "general theory of sexuality that ranges from biology and embryology to the sociology of individual development, with the unconscious sexual conflict at its core."[4]

Expanding the understanding of sexuality was vitally important to Sigmund Freud. He argued that sexuality could not be reduced merely to adulthood or to genitalia, but encompasses broad-ranging modalities of pleasure and gratification. In other words, it manifests "polymorphous perversity" and begins with a child's earliest life expressions, specifically, that is, with the act of nursing. The phrase "polymorphously perverse" may sound disapproving, but Freud's use of "perverse" is quite broad and does not necessarily pass judgment. In reference to both children and adults, he uses the term "perversions" to describe forms of sexuality that do not serve reproductive purposes. Meanwhile, he applies the word "polymorphous" to describe the many expressions of childhood sexuality. Hence, sexuality is not limited to a reproductive function but is expressed in a variety of psychologically equivalent forms. This pertains to heterosexuality and homosexuality alike, as well as what he terms "perversions."

Fantasy plays a central role in sexual experience. According to Freud, it is composed of "traces in memory" (*Erinnerungsspuren*), as real as memories experienced in conscious life. It follows that fantasy is neither random nor arbitrary but evolves uniquely over each person's lifetime. Sexual fantasies serve a dual function, contributing to both arousal and gratification.

Freud's unconventionally expansive, non-judgmental, and non-hierarchical concept of sexuality, which is particularly evident in the first of his three essays, offers several advantages. Notably, it avoids constructing a normative hierarchy of sexual experiences and behaviors. For a concept of sexuality to encompass psychologically equivalent sexual forms, it must begin before adulthood, even before the onset of puberty and sexual maturity. Elevating genitality above all would inherently prioritize reproductive functions over other aspects of sexuality. By acknowledging psychological equivalence, we can also reexamine our approach to the pathologization of sexual behavior and experiences. In the broader

context of the psychoanalytic model of illness, a specific behavior is not inherently pathological, but rather its function indicates the presence or absence of a disorder. Consequently, the distinction between normative and deviant or pathological behavior becomes a complex, case-by-case assessment rather than a rigid categorization.

The nonnormative aspect of Freud's theory of sexuality is evident in various passages throughout the three essays. Freud takes great care to avoid normative language. However, in revising his work for later editions, he also qualifies some of his initial statements and relates them to the prevalent ideas of his era. For example, the first essay begins with a discussion of "sexual aberrations," but does so without displaying any clinical interest. Instead, Freud aims to highlight these behaviors relative to "normal" sexuality. The core of his argument is the idea that the drive is independent of the object. He thus challenged the seemingly unbreakable link between the two, a connection that persists in the discourse to this day. This biological premise is often found in discussions of homosexuality, essentially attributing desire to an individual's "nature." By severing this connection, Freud avoids defining what is "normal." Freud also articulates another groundbreaking thesis by treating psychological symptoms as a form of sexual activity. For example, hysteria is characterized by the presence of both excessive sexual desire and a simultaneous strong sexual defense.

The second essay is devoted to "infantile sexuality," which Freud uses in a broader sense than merely sexuality during childhood and addresses the core of adult sexuality as well. Even today, sexual expressions among children often go overlooked. According to Freud, "infantile amnesia," which largely erases our memories of the first years of life, contributes to repressing memories of childhood sexual impulses. Child sexual development, on the other hand, experiences "efflorescences" in infancy and between ages four and five, and is followed by a return during puberty. No additional sexual forms develop during the intervening latent stage, yet sexuality remains significant throughout. This notion of a "two-phase sexual development" is of particular importance: "This appears to be one of the factors underlying humans' aptitude for developing higher civilization, but also for their tendency toward neurosis."[5]

In Freud's view, sexual development is mediated through association of sexual drive with satiation of vital bodily needs: initially nursing and later the processes of excreting. Subsequently, sexuality gains independence from these needs and differentiates itself. Freud describes this process via different psychosexual modalities: the oral, anal, phallic, and genital levels. These modalities do not follow a linear sequence of developmental stages; instead, they represent distinct avenues for pleasure and gratification. They evolve alongside vital bodily needs and emerge in conjunction with specific developmental functions. However, as time progresses, they disentangle from these functions and persist throughout a person's life, whether in conscious or unconscious forms.

Freud articulates this consequential thesis as follows: "There are thus good reasons why a child sucking at his mother's breast has become the prototype of every relation of love. The finding of an object is in fact a refinding of it."[6]

The third essay shifts the focus to the changes that occur during puberty, marking the passage from infantile sexual life into its ultimate, adult form: the sexual drive, which has hitherto been predominantly autoerotic, now seeks an object. The erogenous (or "erotogenic") zones become subservient to the primacy of the genital zone, and the partial drives coalesce into a new sexual target. By emphasizing the primacy of the genitalia in the service of reproduction, Freud presents a rather conventional image of adult sexuality, distinct from the multifaceted and indirected nature of infantile sexuality. Thus, during adolescent development, the predominance of heterosexuality is reestablished and the conceptual foundations of a gender binary and hierarchy are laid. Freud asserts that "it is not until puberty that the sharp distinction is established between the masculine and feminine characters. From that time on, this contrast has a more decisive influence than any other upon the shaping of human life."[7]

Freud's theory of sexuality remains groundbreaking for (at least) three important reasons. First, it offers a nonnormative conceptualization of human sexuality, rejecting the tendency to pathologize and categorically differentiate between "normal, healthy" and "problematic, deviant" sexualities. Instead, it emphasizes commonalities and outlines a broad spectrum of sexuality with nuanced variations. Second, it stresses the existence of an infantile, polymorphous sexuality that constitutes the foundation of genital sexuality in adulthood. And third, it does not perceive sexuality as an innate, genetically preprogrammed phenomenon. Rather, Freud locates the origins of human sexuality in the realms of interpersonal dynamics. Fantasies and memories play formative roles. Freud's presentation of sexuality is rooted not in instinct but in desire, emerging through the relationship between the child and the adult and inscribed into the body.

1 Sigmund Freud, "Three Essays on the Theory of Sexuality," in: *The Standard Edition of the Complete Psychological Works of Sigmund Freud,* trans. James Strachey, VII:123–246, London: Hogarth, 1953, 123–246.

2 Unfortunately, this shift in perspective was incomplete, and Freud repeatedly reverted to the traditional viewpoint in his reasoning. For example, throughout his life, he sought the origin of sexuality in endogenous, somatic processes—to no avail—instead of abandoning the notion of an "origin" altogether.

3 Freud, "Three Essays," 168.

4 Reimut Reiche, "Nachwort" (Afterword) to *Drei Abhandlungen zur Sexualtheorie* [Three Essays on the Theory of Sexuality] by Sigmund Freud, reprint of the first edition of 1905, Frankfurt a. M.: Fischer, 2005, 105.

5 Wolfgang Berner, *Perversion*, Giessen, Germany: Psychosozial-Verlag, 2011, 136. Quotation translated for this essay.

6 Freud, "Three Essays," 222.

7 Freud, "Three Essays," 219.

Jewish Sexuality on Film

Nathan Abrams

A book on Jewish sexuality on film should be titled "And…cut!" It cunningly plays on the term yelled by a director when they are ready to stop recording a scene but is also the primary signifier of Jewish masculinity: circumcision. One could write a whole book about the portrayal of the Jewish penis on film.[1] Take *An American Werewolf in London* (1981), when a nurse states that she believes the main character is Jewish because he is circumcised, or how in the Holocaust film *Hitlerjunge Salomon/Europa Europa* (1990) a Jew passing as a gentile in Nazi-occupied Europe spends much time trying to hide his penis. While much of cinema's representation of Jewish sexuality has been reduced to the male member, there is a larger story to tell of how its representation has evolved as public sexual mores, and their depiction, have loosened and widened.

Jewish sexuality has always been there on film but not necessarily discernible to the untutored eye as Jewish characters—especially female ones—weren't always obvious to spot. During the silent era, for example, Jewish actress Theda Bara (born Theodosia Goodman) was typecast as a heartless man-eating succubus in nearly all of her silent-era films including such movies as *Cleopatra* (1917) and *Salomé* (1918). The type of role she was assigned over and over again was called "the vampire," a woman who sapped men of their vitality. She served as the celluloid personification of the dangers and pleasures of sex. Her unwholesome image was embodied in the publicity shots for *Cleopatra* in which she was photographed topless, save for a skimpy coiled-snake bra that would not look out of place on a contemporary pop star.

Whereas non-Jews had often been sexualized, the representation of Jewish sexuality on film changed with what was known as "the great coming out," especially from the 1960s onward when the door was cracked open for a wider variety of sexual and sexualized Jews to appear. When Dustin Hoffman played Benjamin Braddock in *The Graduate* (1968) and Barbra Streisand featured as Fanny Brice in *Funny Girl* (1968), the Jewish body not only came to be recognized as sexually appealing, but it also helped redefine sexual attractiveness more generally and in US culture in particular. Woody Allen took full advantage of this over decades of filmmaking in which he placed himself front and center as the focus of female attraction.

In images of Jewish sexuality on film, typically men swing between two poles. They have had to navigate between outside images of Jewish men as hypersexual predators such as Joseph Süss Oppenheimer in the notorious Nazi propaganda film *Jud Süss* (1940) or as neurotics whose angst stands in the way of their success as exemplified by the films of Woody Allen. Somewhere in between, they have near-superhuman physical prowess and attractiveness to the opposite, usually non-Jewish, sex. They share an obsession with sex. Woody Allen plays on both, but it was an interesting decision by Stanley Kubrick to make the sexually dubious Sydney Pollack as Victor Ziegler Jewish in his final film *Eyes Wide Shut* (1999). In line with this trend, the younger generation of Jewish filmmakers is also producing more sex-obsessed Jews. This is especially true of Adam Sandler's various Jewish characters or those in Judd Apatow's ensemble—including Seth Rogen and Jonah Hill, among others—known as the Jew Tang Clan. The *American Pie* trilogy follows the hapless Jim Levenstein on his journey from high-school virgin to married man and his various attempts, both successful and otherwise, to get laid.

Likewise, Jewish women are often represented as either frigidly unattractive or extraordinarily exotic (otherwise known as *la belle juive*), and often appear only to be rejected in favor of the *shiksa* (a non-Jewish female). This is changing as Jewish women are shown unabashedly and without remorse making love. Their bodies are revealed by a hitherto rare nudity. In so doing, such depictions mimic, mock, and reverse some of the worst antisemitic tropes of the Jewess as a wanton, manipulative, deviant, hypersexual, and incestuous prostitute.

Jewish women are also becoming more sex-obsessed on film. "Finally: Jewish women have sex on the screen," Aviva Kempner triumphantly called out in 1999.[2] However, reflecting the increased visibility of Jewish women writers, directors, performers, filmmakers, and other industry personnel, female Jewish desire is central to many contemporary films, which often feature young, free-spirited, and liberated women who express their sexual selves in increasingly (verbally and visually) explicit terms. The title of *Amy's O* (2001), for example, foregrounds her sexual pleasure (the "O" standing for orgasm). Highly sexed, desirable, and erotically magnetic Jewish women occur across many films, often set during the Holocaust, including *Schindler's List* (1993), *Black Book* (2006), and *Inglourious Basterds* (2009). *Shiva Baby* (2020) opens with the sounds of an approaching orgasm followed by the words "Fuck, yeah daddy, keep going" before

we have even seen anything on screen. The British film *The Governess* (1998) certainly presents an alternative model of Jewish sexuality to the mainstream American fare mentioned previously.

Diaspora Jews were rarely found coupling with each other cinematically, in contrast to Israeli cinema where they are rarely not. In diaspora movies, Jewish men were always chasing non-Jewish women, rejecting and stigmatizing female Jews as Jewish American Princesses (JAPs) who are then blamed. While this continues, the variety of partners of different ethnic and faith groups is growing. At the same time, more and more Jews are shown making love with each other. The sex sequences in Steven Spielberg's *Munich* (2005) are striking for their almost idealized portrayal of two beautiful bodies.

While Jewish cinema still overwhelmingly focuses on the heterosexual male experience, the representation of women and LGBTQ+ has blossomed. Another sign of increased confidence is the growth in the number of nonnormative Jewish sexualities across the spectrum of gender, sexual preference, religious identity, and age. It points to a greater inclusiveness by representing those "outside" normative Judaism. Jews in contemporary cinema are increasingly outing themselves as gay. There have been many films featuring gay characters, such as *Torch Song Trilogy* (1988), *Sunday Bloody Sunday* (1971), or *The Boys in the Band* (1970) where Harold says, "What I am, Michael, is a 32-year-old, ugly, pock-marked Jew fairy." Israeli cinema has seen many films, in particular *Amazing Grace* (2006), *Yossi and Jagger* (2002), *Walk on Water* (2004), *The Bubble* (2006) and *Eyes Wide Open* (2009). Several documentaries on the subject were released, including *Treyf* (1988) and *Trembling Before G-d* (2001). *Keep Not Silent* in 2004 was the first film to focus on Jewish lesbians in Israel. There are more films about Jewish lesbians including *Aimée & Jaguar* (1999), *Kissing Jessica Stein* (2001), *Disobedience* (2017), and *Shiva Baby* (2020).

More recently, there have been two short films about nonbinary Jews, *Jude* (2020) and *Make Me a King* (2021). The former film depicts how its protagonist was born into an Orthodox family and coerced into marriage at a young age but has since transformed from a Jewish rebbetzin to a single, nonbinary person. Here, they speak candidly about their religious, gender, and sexual identities. That transgender Jews, Jews of color, disabled Jews, and many other marginalized groups have all recently found space in the film industry has allowed the evolution of Jewish sexuality to gain momentum particularly in the past decade with such movies as *Tahara* (2020) and *Fig Tree* (2018).

These Jews are not just secular but cover a spectrum of beliefs from overwhelmingly secular Jews through Reform, Liberal, and Conservative. Even Haredim have come in for similar treatment, leading to an unprecedented eroticization of ultra-Orthodox Jews. The Israeli film *Kadosh* (Sacred, 1999) supplies a representation of the marital and sexual lives of Haredim in Jerusalem, including a disturbing scene of marital rape. It is not the only example. In doing so, Haredim are increasingly humanized and represented less as cyphers or symbols. They are depicted as having the same sexual drives and needs as their more secular co-religionists. In this way, contemporary filmmakers are depicting their willingness

to transgress previously held boundaries and move into new territory that previously had not been extensively explored in such depth.

Increased exposure of Jewish body parts in sexual and erotic conditions, outside hardcore pornography, stands for a significant departure from a mainstream cinematic tradition that tended to shy away from graphic displays of Jewish sexuality and nudity, preferring suggestiveness, innuendo, double entendre, and outrageousness, as typically represented by Woody Allen. Thus, in this new guise, the Jewish body is presented as both spectacle and erotic. The Jewish body is fetishized through overt sexual engagement with it.

The display of sexual, eroticized Jewish bodies stands for a clear cinematic shift. One of the reasons for this is surely propelled by the increasing seepage of pornography into mainstream culture and hence cinema in general. Indeed, a sexually explicitly Jewish porn film, *Nice Jewish Girls,* was released in 2009, mocking the stereotype of JAP frigidity. And this doesn't even take into account the role both in front of and behind the camera of Jews in the adult film industry in California and elsewhere.

The other reason is attributable to Jewish sexual confidence, extending to a spectrum of sexually defined and erotic Jews in terms of gender, sexual preference, age, and religious identification. Contemporary cinema, therefore, reverses many of the sexual stereotypes of the Jew/ess. The older anxieties, while not disappearing completely, are being coupled with a new confidence. Jewish neo-Nazi Danny Balint may ask his fellow antisemites in *The Believer* (2001), "Do we hate 'em [...] cos they have the most active sex lives?" But Jews are clearly taking pride in, as well as mocking, their hypersexual reputations.

Overall, then, over the course of the twentieth and twenty-first centuries, cinema not only recycles but reverses many of these sexual stereotypes, and also begins to introduce a spectrum of sexually defined and sexually active Jews that challenges earlier binaries. Jewish filmmakers are unafraid to touch what could be perceived as potentially troubling subject matter, including representing the Jewish body more explicitly than hitherto. Although progress is not always linear, especially when depicting Jewishness and sexuality on film, as the relationship between the two is winding and labyrinthine, there is hope that in the future representations of Jewish sexuality on film will be more textured and nuanced and less subject to stereotypes.

1 Thus far, I've only written a chapter, entitled "Circumcised Cinema: Representing Jewishness on Film through Circumcision," in: Monika Kopytowska, Artur Gałkowski, and Massimo Leone eds. *Thought-Sign-Symbol*, Berlin: Peter Lang, 2022.

2 Aviva Kempner, 1999, "Finally Jewish Women Have Sex on the Screen," *Lilith*, March 25, lilith.org/articles/finally-jewish-women-have-sex-on-the-screen.

Magnus Hirschfeld and the Birth of Sexual Science as an Emancipatory Discipline

Rainer Herrn

In the latter half of the nineteenth century, Berlin experienced a population boom, a substantial densification of housing, widespread industrial expansion, and advancements in transport and media technologies. Meanwhile, the city was also witnessing cultural diversification, challenges to conventional gender norms, and the emergence of new ways of life.[1] These complex changes prompted the rise of "life reform" (*Lebensreform*) movements, notably the sexual reform movement, which sought major changes to prevailing policies regarding sexuality and gender. The reformists stood against what they deemed "inhumane, freedom-restricting, or unnatural" discrimination against minoritized social groups, gender identities, and sexualities.[2] The dawn of the twentieth century brought the birth of organizations supporting these causes, which in turn sought scientific and theoretical rationales to back up their claims. This gap was filled by the nascent discipline that became known as sexual science[3] (*Sexualwissenschaft*), which synthesized discourses around sexual pathology, sex and gender, and population planning.

Magnus Hirschfeld's (1868–1935) affinity as a practicing physician for naturopathy, coupled with his involvement in the temperance movement, marked him as an exponent of the *Lebensreform* movement.[4] In 1897, he was the initiator of the Scientific-Humanitarian Committee (Wissenschaftlich-humanitäres Komitee, WhK), the first organization to advocate for the rights of homosexuals. With a petition authored by Hirschfeld, the committee fought for the repeal of Paragraph 175 of the German Reich Penal Code, introduced with the founding of the Empire in 1871, which criminalized certain sexual acts between men. Members

of the German Empire's artistic, academic, and political elites were among the petition's signatories. In 1898, Hirschfeld's party colleague, Social Democrat chairman August Bebel, made a case for it before the Reichstag, the German parliament.

Another notable organization of this period was the Society to Combat Venereal Diseases (Gesellschaft zur Bekämpfung der Geschlechtskrankheiten), cofounded in 1902 by Alfred Blaschko, a Berlin venereologist, and Albert Neisser, a dermatology professor from Breslau. This society advocated for a more progressive approach to managing sexually transmitted infections (STIs) and prostitution while calling for public education around preventing infections, albeit within the restrictive legal parameters in place.

In 1904, under the leadership of Helene Stöcker, Maria Lischnewska, and Max Marcuse, the League for the Protection of Mothers (Bund für Mutterschutz) emerged as the third significant reformist group. The league championed the rights of women, especially those of unmarried mothers, promoting women's education and sexual self-fulfillment. In 1908, it was renamed the League for the Protection of Mothers and for Sexual Reform (Bund für Mutterschutz und Sexualreform).

The fourth organization was the Society for Sexual Reform (Gesellschaft für Sexualreform), initiated in 1913 by the dermatologist and venereologist Felix Theilhaber. It primarily campaigned for legalizing abortion and spreading awareness and knowledge about birth control. Numerous non-medical organizations founded in the 1920s were dedicated to these causes.

The overall movement's central figures—Hirschfeld, Blaschko, Neisser, Marcuse, and Theilhaber, but also other prominent players such as Iwan Bloch, Albert Eulenburg, Albert Moll, and Max Hirsch—mostly came from "minor" and less-prestigious medical fields, including dermatology, venereology, urology, gynecology, and psychiatry. Most of them also came from assimilated, Reform Jewish families.

About half of all doctors were Jewish in turn-of-the-century Berlin, even though Jews accounted for just under 4% of the city's overall population. The medical field, as one of Germany's few designated "liberal," or independent, professions (Freie Berufe), not only offered financial stability but also opportunities for social mobility and recognition. Nonetheless, opportunities for distinction in prestigious fields such as anatomy, internal medicine, or surgery were limited due to the antisemitic climate coupled with fierce competition. Until 1848, besides being banned from becoming military officers or civil servants, Jews (and Jewish-born converts) were also prohibited from holding teaching positions at a university. Even after this legal impediment was lifted, the glass ceiling keeping Jews from rising in the academic ranks remained in place. Jewish scholars and scientists thus tried to break new ground in smaller, peripheral, and less prestigious fields. Sexuality was considered an unworthy subject of scientific investigation in academia, and thus sexual science was held in low regard. A similar situation can be observed in other specialized disciplines, such as psychoanalysis, which, like sexual science, was considered a "Jewish branch of knowledge"; the two fields shared many other similarities.[5]

Another significant factor underlying the preponderance of Jews in these niche fields was their shared experience of societal stigmatization and persecution. Jewish sexologists and reformists had this in common with the people they championed, who were also outsiders.[6] These included women, some of them single mothers; people with STIs; sex workers; and homosexuals. Thus, on both "internal and external grounds," they fought "for human rights, personal freedoms, enlightenment, decriminalization, and emancipation."[7]

These mostly Berlin-based organizations supported one another and published journals with scientific ambitions. One early coalition of reformist medical professionals was the Medical Society for Sexual Science and Eugenics (Ärztliche Gesellschaft für Sexualwissenschaft und Eugenik), cofounded in 1913 by Magnus Hirschfeld, Iwan Bloch, and Albert Eulenburg. Its rival organization, the International Society for Sexual Science (Internationale Gesellschaft für Sexualforschung), established in the same year by Albert Moll and Max Marcuse, insisted that science was apolitical and explicitly rejected reformist aspirations.

Albert Eulenburg's initiative to introduce academic lectures on sexual pathology at the Friedrich Wilhelm University of Berlin in 1913 did not outlast the First World War.[8] However, this postwar period brought a general climate of change and upheaval. As an active campaigner for the Social Democratic Party in the election, Magnus Hirschfeld perceived the emerging era as "the dawn of socialism" and held up hopes that the young Weimar Republic would thoroughly reform sex-related criminal laws.[9] Although he continued to lament the exclusion of sexual science from the ranks of canonically established fields, he noted that

> just because "some other discipline" looks condescendingly upon sexual science, which a university has yet to deem worthy of including in its curriculum [...] we consider it felicitous that in 1919 we were granted the opportunity at the Institute for Sexual Science not only to release the textbook on sexual pathology but to establish a training program for doctors and medical students.[10]

He wrote these words in his three-volume treatise on sexual pathology. With its publication, Hirschfeld sought to establish himself as a leading representative of the field, a position he underscored with the foundation of the Institute, bankrolled by his personal fortune, and notably located in a grand villa in Berlin's affluent Tiergarten district.[11]

Hirschfeld had envisioned the Institute as a "site of research, teaching, treatment, and refuge."[12] His aspirations to secure state funding for the Institute, or even to transform it into an official state institution, were shattered in 1924, partly due to changed political circumstances, requiring the Institute to be financially self-sustaining until its forced closure in 1933.

The Institute encompassed a variety of facilities: apartments as well as treatment and consultation rooms, laboratories, and the office of the WhK. After acquiring an adjacent property in 1921, it expanded to include a lecture hall that doubled as a cinema as well as exhibition spaces and a library.[13]

Alongside trainee doctors and doctoral candidates, the staff primarily consisted of Jewish physicians, with notable figures such as psychiatrists Arthur Kronfeld and Berndt Götz, venereologist Friedrich Wertheim, radiologist August Bessunger, ENT specialist Eugen Littaur, anthropologist Hans Friedenthal, "social hygiene" specialist Max Hodann, and gynecologists Bernhard Schapiro and Ludwig Levy-Lenz. Felix Abraham, a promising young psychiatrist, joined the team in 1928. The Institute also employed several legal professionals, most of them likewise Jewish. These included homosexual rights activist Kurt Hiller and attorneys Arthur Brandt, Erich Frey, and Sidney Mendel, who provided legal expertise in various cases. The staff also included non-Jewish patients and activists, such as Dora Richter, who worked as a cleaner and was designated at the time as a "transvestite," Erich Amborn,[14] who worked as an assistant archivist and was intersex, and the homosexual writer Bruno Vogel. Karl Giese, Hirschfeld's life partner and an authority in the field, guided visitors through the Institute's extensive sexology-related collections.

Hirschfeld maintained the conviction that "if something is natural, it must not be penalized," and around the turn of the century he decided to use modern natural science research to advocate for the emancipation of "sexual intermediaries," his term at the time encompassing homosexuals, intersex people, and transgender people. This academic approach, the "theory of sexual intermediaries," dominated the Institute's scientific work in its early years. In Hirschfeld's understanding, sexual and gender diversity resulted from individuals' inherited disposition and their production of male or female hormones. To prove this, he initiated research into his patients' family trees, examined homosexuals' testicular tissue, and took measurements of their bodies. For those homosexuals who reported that their inclinations brought them particular suffering, he transplanted testes from heterosexuals to "cure" them.

However, the matter proved to be more complicated, the causations less clear, and the investigations more costly than anticipated. Even his attempts at a cure were futile. Therefore, and due to the consequences of hyperinflation, this research was discontinued in the mid-1920s.

Still, the Institute maintained its key role in medical practice and sexual reform: justified by eugenics, its (at times free-of-charge) counseling about marriage and sex thrived, as did its treatment of STIs. As advocates of sexual reform intensified their efforts in the mid- to late 1920s, educational programs for the general public were expanded and a spate of popular science journals, brochures, and books were released on these themes.

From an early stage, Hirschfeld developed an attitude toward "sexual intermediaries" that prioritized personal self-identification, what we would call today sexual or gender identity. This position was first explicitly articulated in Hirschfeld's afterword to N. O. Body's memoir [Karl/Martha Baer] *Aus eines Mannes Mädchenjahren* (From a Man's Girlhood), in which he asserted: "The gender of a person rests much more in their soul than in their body, or, in medical terms, more in the brain than in the genitals."[15] In a medical report on another intersexual person, written during the period of the Institute, he added,

> The determining factor in the event of a discrepancy between the two is not the opinion of an expert, but a person's own feelings. [...] We have no right to tell a person who wants to be a woman "You are a man," or to command someone who wants to be a man "Remain a woman."[16]

Hirschfeld's radically subjective approach was singular at the time; he pursued the goal of legally validating individuals' desired gender identity, that is, enabling people to change their own gender markers under civil status law, a practice that would not be codified in Germany until the passage of the Self-Determination Act (*Selbstbestimmungsgesetz*) a full century later. In addition to this, he conceived a type of therapy, which he termed "adaptation therapy" and later "milieu therapy," to help homosexuals, transgender people, and intersex people better adapt to the subcultural conditions and social circumstances that matched their inclinations. This approach is also found in Felix Abraham, who addressed the difficult living situation of "transvestites" | see page 152 |. "Transvestite passes," a form of identification initiated by Hirschfeld and issued and authenticated by police headquarters starting in 1909, had the aim of protecting their bearers from arrest and prosecution when presented. In 1931, Felix Abraham published the first scientific paper describing the techniques for gender-affirming surgeries that trans individuals received at the Institute.

In 1920, the WhK (which had its offices at the Institute) spearheaded the "Action League" (Aktionsausschuss) for the repeal of Paragraph 175—an alliance of organizations fighting for the decriminalization of homosexuality. In addition to WhK, the alliance included two other homosexual organizations, the Community of the Self-Owned (Gemeinschaft der Eigenen, founded in 1903) and the German Friendship League (Deutscher Freundschaftsverband, founded in 1919, later Bund für Menschenrecht, or League for Human Rights). When it disbanded in 1924, the Cartel for the Reform of Penal Law (Kartell für Reform des Sexualstrafrechts), led by Kurt Hiller, took its place—after new draft legislation about sexual crimes had been announced in 1925. As the first thematically broad coalition of leftist sexual reform forces advocating for the easing of divorce laws, education on contraceptive methods, the legalization of abortion on social grounds, and the decriminalization of homosexuality, the Cartel presented a "counter-draft" of a new law on sexual crimes. In 1928, continuing this big-tent policy, Hirschfeld initiated the first international coalition in a World League for Sexual Reform—with an office in the Institute and national chapters in many countries. Until 1932, the League gathered in various European cities for conferences at which motions regarding policies on sexual matters were raised and resolutions adopted.

In 1929, a vote was held in the Reichstag's Criminal Law Committee on the future of Paragraph 175, Hirschfeld's core issue. The committee, including its conservative chair Wilhelm Kahl, voted in favor of its abolishment, and this recommendation was passed on to the full Reichstag, but then ignored as a result of the political turmoil in the late Weimar era. Subsequently, Hirschfeld resigned as

chair of the WhK after thirty-two years, following various accusations; the Committee then moved to its own premises.

Having received an invitation to the United States, Magnus Hirschfeld embarked on a world tour in October 1930. In 1932, heeding warnings from his staff, he refrained from returning to Germany. However, he did send rare ethnological objects from various places around the world to Berlin for his sexual science collection. This included a box from Japan containing penis prostheses made of horn, one of the few artifacts from the Institute's collections that still survives today | see page 153 |. On his world tour, he was celebrated as a leading representative of German sexual science, while in Germany he was vilified as a corrupter of morals.

But this was not new to him. The antisemitic attacks against Hirschfeld and the sexual science he shaped began in 1898 with the founding of the WhK and his demand for the decriminalization of homosexuality, which Eugen Dühring vilified as "Jewish uncleanliness" and a "motion to promote Jewish lust."[17] The sexual reform movement's political demands were greeted by antisemitic stereotypes from the beginning, often invoked whenever Hirschfeld stepped into the public spotlight as a political figure (on sexual matters or otherwise).

It would be an oversimplification to say that the antisemitic image of Hirschfeld as villain, constructed from the 1920s onward, was the sole work of nationalist groups alone. Numerous pamphlets, writings, and press campaigns to this end were also issued by conservative Christians (both Protestant and Catholic), moral and alliance organizations, and even rival associations within the homosexual movement.[18] Nevertheless, this essay will only make reference to those in the Nazi press. The looting of the Institute on May 6, 1933, in the run-up to the book burning; the instrumentalization of Hirschfeld as a symbol of the liberal Weimar spirit to be eradicated; and the Institute's ultimate closure by the Berlin police in July 1933 were just following up on steps announced by leading Nazis back in the late 1920s. In a concerted campaign against Hirschfeld, defamatory articles appeared in the three most important Nazi newspapers, Joseph Goebbels's *Der Angriff*, Julius Streicher's *Der Stürmer*, and Hitler's *Völkischer Beobachter*. Around twenty articles were published between April 1928 and May 1931 gradually constructing an image of Magnus Hirschfeld as an "archetypical villain." The German Student Union took advantage of this image of him during the "Action against the Un-German Spirit" (Aktion wider den undeutschen Geist) when they vandalized the Institute.[19]

By then, however, Hirschfeld was already living in exile in Paris, where his attempt to establish a new institute failed. In poor health, he proceeded to Nice, where he died on May 14, 1935, his sixty-seventh birthday. His Institute's staff nearly all went into hiding, were persecuted and imprisoned, went into exile, or committed suicide. Only a few adapted to the new regime. With that, Hirschfeld's approach to sexual science was snuffed out in Germany. Sexology as a discipline would not re-emerge with open support for sexual liberalization in Germany until the 1970s.

1. Gottfried Korff, "Mentalität und Kommunikation in der Großstadt. Berliner Notizen zur 'inneren' Urbanisierung," in: Theodor Kohlmann and Hermann Bausinger, eds. *Großstadt. Aspekte empirischer Kulturforschung*, Berlin: Staatliche Museen Preussischer Kultur, 1985, 343–61.

2. Wolfgang Krabbe, "Die Lebensreformbewegung," in: Kai Buchholz et al., eds. *Die Lebensreform. Entwürfe zur Neugestaltung von Leben und Kunst um 1900*, vol. 1, Darmstadt: Institut Mathildenhöhe, 2001, 25–29, here 25.

3. Translator's note: The German discipline *Sexualwissenschaft* (literally "sexual science" or "sexual studies") is generally translated as sexology in the contemporary context, but for this early period the translations vary. The English version of this essay will use the literal translation "sexual science."

4. For more on the life of Magnus Hirschfeld and the history of his Institute for Sexual Science, see Ralf Dose, *Magnus Hirschfeld: Deutscher, Jude, Weltbürger* (Jüdische Miniaturen, vol. 15), Teetz: Hentrich & Hentrich, 2005; Manfred Herzer, *Magnus Hirschfeld und seine Zeit*, Berlin: De Gruyter, 2017; Rainer Herrn, *Der Liebe und dem Leid: Das Institut für Sexualwissenschaft 1919–1933*, Berlin: Suhrkamp, 2022.

5. See the chapter by Ilka Quindeau on page 121.

6. Christina von Braun suggests, "We cannot rule out the possibility the profusion of antisemitic sexual imagery contributed to Jews' own interest in sexology, […] [in order to] fend off the sexual defamations of antisemitism." Christina von Braun, "Ist die Sexualwissenschaft eine 'jüdische Wissenschaft'?" *Zeitschrift für Sexualforschung* 14, no. 1 (2001), 3, original translation from the German.

7. Volkmar Sigusch, *Geschichte der Sexualwissenschaft*, Frankfurt a. M.: Campus Verlag, 2008, 374. See also John M. Efron, *Defenders of the Race. Jewish Doctors and Race Science in Fin-de-Siècle Europe*, New Haven, CT: Yale University Press, 1994, 143.

8. Albert Eulenburg died in 1917. It is not possible to date the first Chair for Sexual Science at the University of Königsberg due to lack of documentation. Samuel Jessner was first mentioned as its representative in 1921, at a conference organized by Hirschfeld. Arthur Weil, *Sexualreform und Sexualwissenschaft. Vorträge gehalten auf der I. Internationalen Tagung für Sexualreform auf sexualwissenschaftlicher Grundlage in Berlin*, Stuttgart: Julius Püttmann, 1922, 8.

9. Magnus Hirschfeld, *Die Verstaatlichung des Gesundheitswesens*, Berlin: Verlag Neues Vaterland, 1919, 3.

10. Magnus Hirschfeld, *Sexualpathologie*, vol. III, Bonn: Marcus & Weber, 1920, 327, emphasis in the original. In his opening speech, Arthur Kronfeld also emphasized that "traditional academia" exhibits "a certain reserve" towards sexual science. Arthur Kronfeld, "Gegenwärtige Probleme und Ziele der Sexuologie," *Deutsche Medizinische Wochenschrift* 45, no. 41 (1919), 1140, original translation from the German.

11. Hirschfeld's understanding of sexual science was indeed controversial. When one of his coeditors of the *Zeitschrift für Sexualwissenschaft* in 1908, Hermann Rohleder from Leipzig, tried to establish an Institute for Sexual Science in 1923, the Dean of the Medical Faculty, Karl Sudhoff, rejected the proposal with the following reasoning: "I am decidedly against the establishment of an institute for sexual science. I know of no sexual science as such. What passes for it is either a highly questionable pseudoscience, as practiced by Mr. Magnus Hirschfeld and Ministerial Director Dr. Wulffen, for example, each in a different way; or a misleading name for very necessary and appropriate educational work, which, however, has nothing to do with science." Quoted in Volkmar Sigusch, *Geschichte der Sexualwissenschaft*, Frankfurt a. M.: Campus Verlag, 2008, 71, original translation from the German.

12. From Magnus Hirschfeld's opening speech; see Magnus Hirschfeld, "Das Institut für Sexualwissenschaft," *Jahrbuch für sexuelle Zwischenstufen* 19, no. 1/2 (1919), 54.

13. Magnus Hirschfeld, *Unsere Arbeit*, 2nd report, Berlin: Institut für Sexualwissenschaft, 1924, 10.

14. See Erich Amborn, *Und dennoch ja zum Leben. Die Jugend eines Intersexuellen in den Jahren 1915–1933*, Schaffhausen: Meier, 1981.

15. Magnus Hirschfeld, "Nachwort" [Afterword], in N. O. Body, *Aus eines Mannes Mädchenjahren*, Berlin: Gustav Rieckes Buchhandlung, 1907, original pagi-

nation 214, in the reprint edited by Hermann Simon, Berlin: Edition Hentrich, 1993, 163f.

16 Magnus Hirschfeld, *Geschlechtskunde*, vol. 1, Stuttgart: Meier, 1926, 552–53.

17 Eugen Dühring, "Moralischer Irrsinn und Unzuchtbeschönigung," *Der moderne Völkergeist* 5, no. 8 (1898), 63.

18 See Sabine Zur Nieden, "'Heroische Freundesliebe' ist 'dem Judengeiste fremd'. Antisemitismus und Maskulinismus," in: Julius Schoeps and Elke-Vera Kotowski, eds. *Magnus Hirschfeld. Ein Leben im Spannungsfeld von Wissenschaft, Politik und Gesellschaft*, Brandenburg: Be.bra Wissenschaft, 2004, 329–42.

19 For a detailed account, see Rainer Herrn, "Magnus Hirschfeld, sein Institut für Sexualwissenschaft und die Bücherverbrennung," in: Julius H. Schoeps and Werner Treß, eds. *Verfemt und Verboten. Vorgeschichte und Folgen der Bücherverbrennungen 1933*, Hildesheim: Olms, 2010, 97–152.

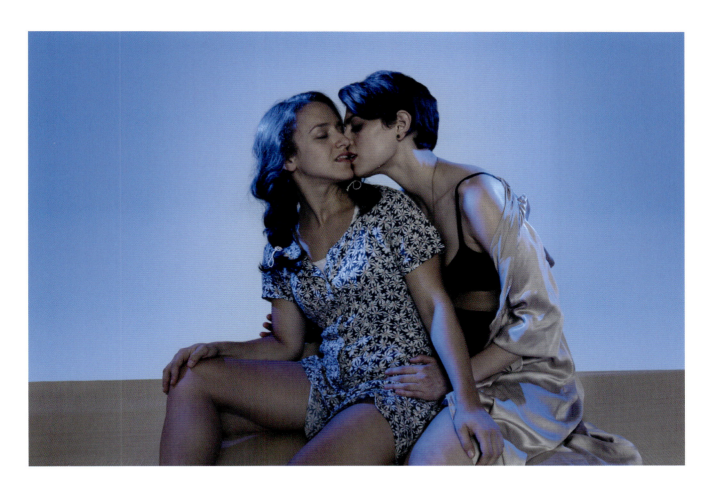

↑
Lesbian Kiss
Ronald L. Glassman
New Yiddish Rep,
USA, 2017

In the scandalous play *God of Vengeance* by Sholem Asch (1880–1957), the daughter of a Jewish brothel owner falls in love with a sex worker. During a New York production in 1923, this scene made history as the first lesbian kiss on Broadway. But the play was ultimately too much for the American public. The actors were arrested and tried on obscenity charges.

Taboo
Sexuality and Power

141

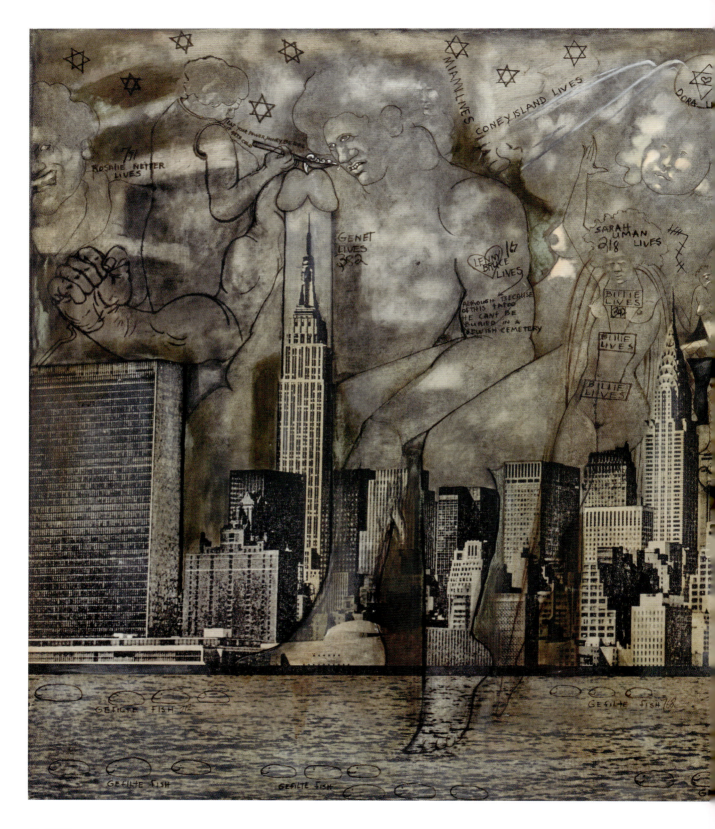

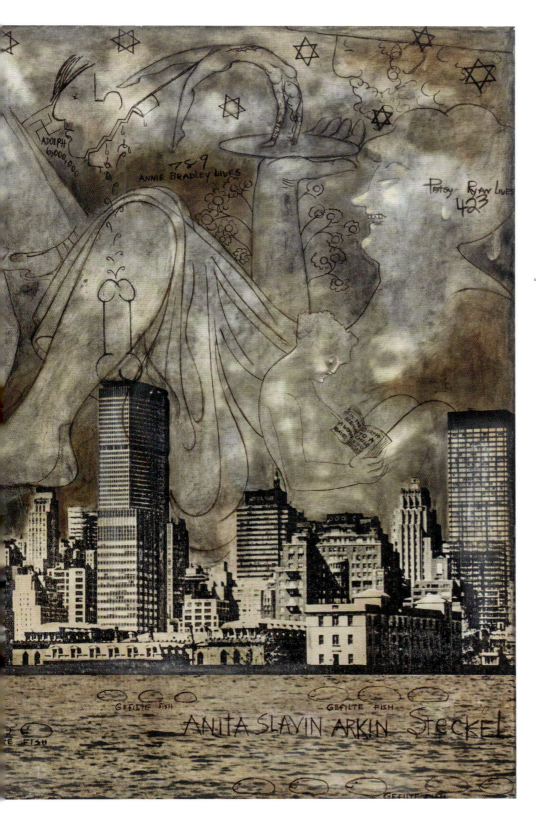

Eat Your Power, Honey, Before It Grows Cold
Anita Steckel
New York, ca. 1970 / 1972

In her New York Skyline series, Anita Steckel superimposes sexually explicit imagery onto the city's skyline. She shows how eroticism and desire drive urban living. Steckel's work raises questions concerning lust, politics, and misogyny, especially in the art world. She founded the Fight Censorship Group with other female artists. In their joint press release Steckel wrote: "If the erect penis is wholesome enough to go into women, then it is more than wholesome enough to go into the greatest art museums."

Taboo
Sexuality and Power

143

Immigrant's NO Suitcase (Anti-Pop)
Boris Lurie
New York, 1963

Boris Lurie often placed sexuality and violence in uncomfortable proximity. In this artwork a glamor model is presented alongside naked corpses. Stars of David appear frequently as an element in his art. Lurie survived the Riga ghetto and three concentration camps together with his father. The rest of his family were murdered. Lurie used his art to criticize the commercialization of public life, which reduced even the Shoah to a media product. He was one of the initiators of the NO!art movement, which distanced itself from pop art. The movement protested manipulations of the art scene, conservatism, war, and prudery in the US.

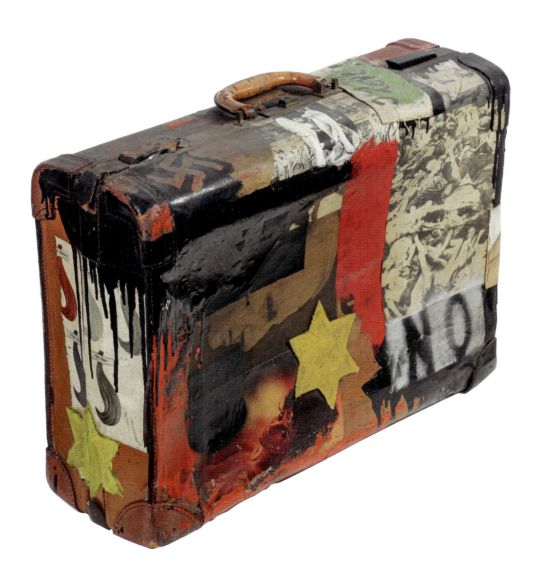

Sexuality and Power
Taboo

144

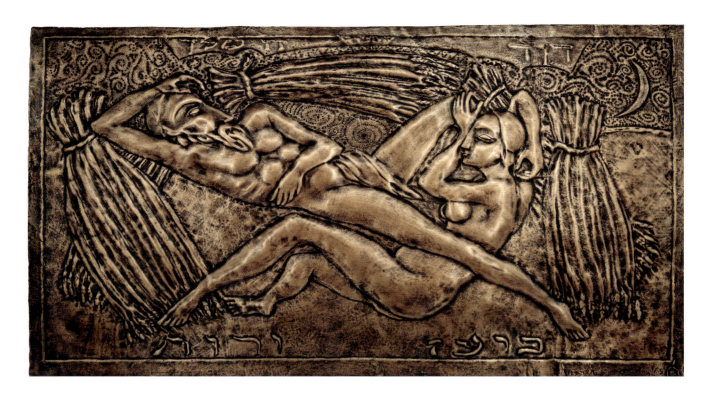

↑
Ruth et Boaz
Marek Szwarc
Paris, ca. 1920

After her husband dies, Ruth the Moabite follows her mother-in-law Naomi home. Boaz, a relative of the deceased, appreciates Ruth's loyalty as a foreigner. On Naomi's suggestion, Ruth seduces the Israelite Boaz. The two get married and Ruth ultimately gives birth to King David's grandfather.

Taboo
Sexuality and Power

145

←
Stalag 217
Victor Bolder
Israel, 1961

Stalags, short for *Stammlager* (main camp), were a genre of pornographic novels set in Nazi concentration camps, popular in Israel in the 1950s. They focus on the sexual violence of female SS guards abusing Allied prisoners of war and the prisoners' later revenge. These Hebrew-language bestsellers reached their peak circulation during the 1961 Eichmann trial in Jerusalem, helping Israeli society to confront the horrors of the Shoah. The Stalag series shows how sexual fantasies often take uncomfortable, transgressive forms.

→
Picture Postcard of the Maison Weinthal Brothel Protesting the New Police Ordinance
Amsterdam, ca. 1900

"Madam" Jurjentje Rauwerda ran the largest brothel in Amsterdam in the nineteenth century, named after her husband Benjamin Weinthal. The luxurious Maison Weinthal had to close its doors in 1902 after the police imposed a brothel ban.

→
Lot and His Daughters
Abraham Lozoff
England, 1926

Lot's two daughters seduce their clueless father into an incestuous union—with the aim of preserving humankind, believing the entire world had been destroyed. Without Lot's knowledge, his daughters have sex with him on two consecutive nights, each one giving birth to a son: Moab and Ammon.

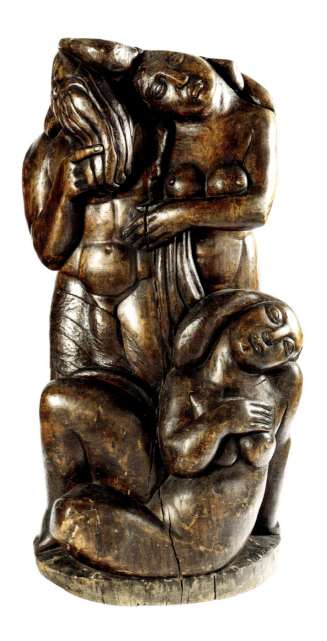

Taboo
Sexuality and Power

147

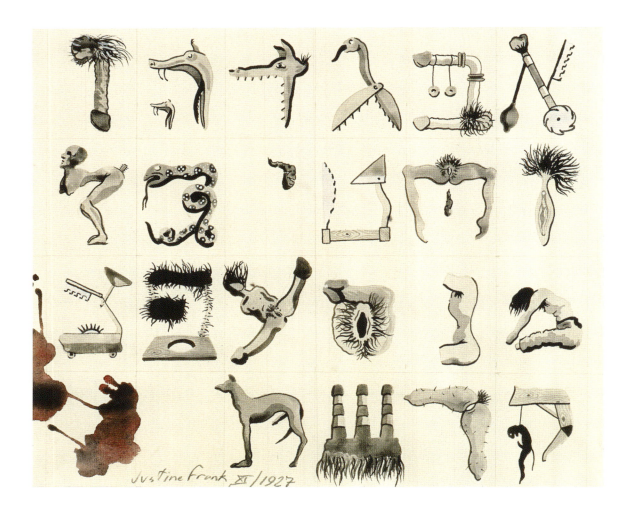

↑
The Stained Portfolio by Justine Frank (56)
Roee Rosen
1927–1928

Invented by Israeli artist Roee Rosen, Justine Frank (1900–1943) is a fictitious Belgian-Jewish surrealist and pornographer whose art melds Jewish iconography with erotica and obscenity. This work indicates Frank's hostility to Zionism: she presents the Hebrew alphabet as a grotesque index of fornication and genitalia.

Lekythos with Oedipus and the Sphinx
Copy of an original from 550

Sigmund Freud was a passionate collector of antiquities, which he brought with him to London after fleeing Vienna in 1938. These antiquities had a significant influence on the development of his theories. Freud viewed psychoanalysis, the excavating of buried memories, as a kind of archaeology of the mind. The Greek myth of Oedipus and his encounter with the Sphinx occupied a central place in Freud's thinking, symbolizing the mystery of being human. He famously named his theory of the Oedipus complex after him.

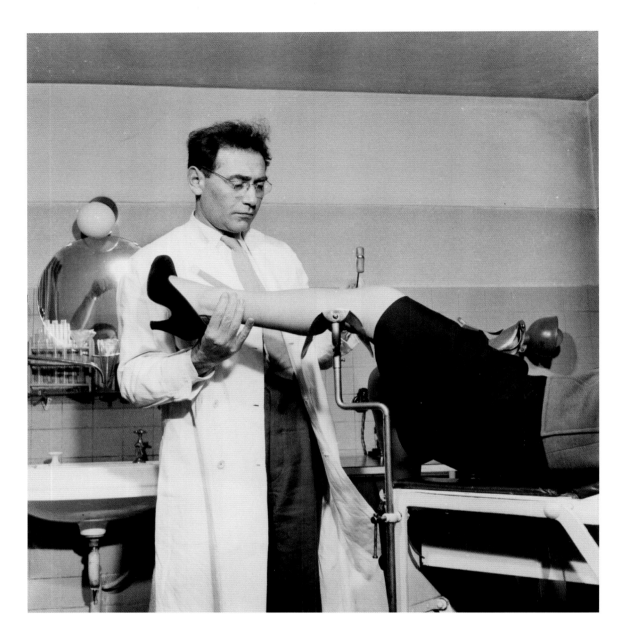

↑
Sexologist Herman Musaph Examining a Patient
ca. 1953

Dutch psychiatrist and sexologist Prof. Herman Musaph (1915–1992) fought against the cultural and religious prejudices that plagued society. Striving for sexual liberation he was involved in the founding of Dutch sexual advocacy organizations.

↑
Anders als die Andern
Richard Oswald
Germany, 1919

This feature-length film was the first to deal openly with homosexuality. It portrayed the plight of a man whose life is ruined on being outed as gay. Magnus Hirschfeld, who co-wrote the film, appears in the role of the sympathetic doctor and therapist, here seen on the right. The film hoped to win over the German public in a campaign against legislation which criminalized homosexuality. When it was aired, it triggered a scandal, with conservatives demanding the reintroduction of censorship.

↑
Felix Abraham in Conversation
Berlin, 1929

This photograph was taken in the Institute for Sexual Research in Berlin-Tiergarten in 1929, the tenth anniversary of the Institute's founding. It shows the physician Felix Abraham conversing with a transgender patient. Abraham was the director of the Institute's sexual-forensic department and the first to publish reports on the gender reassignment surgery conducted there.

Sexuality and Power
Sexology

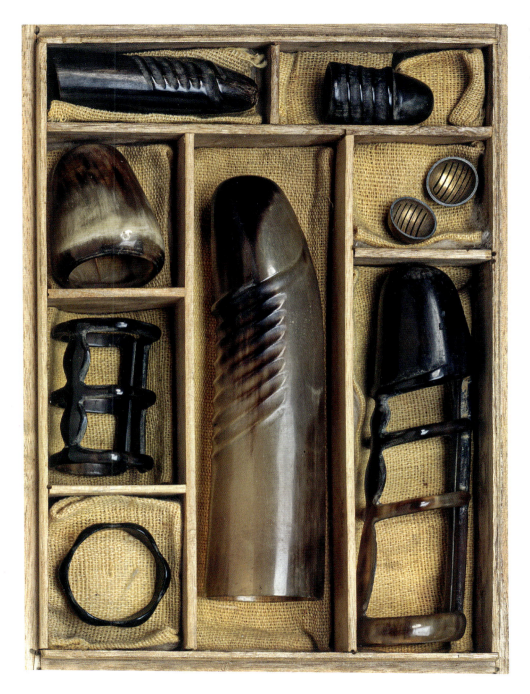

Box with Penis Prostheses
Japan, before 1928

This small collection of prostheses made of jade and horn is one of the few items from the Institut für Sexualwissenschaft that has survived. Founded in 1919 by Magnus Hirschfeld, this interdisciplinary research institute was the first of its kind globally. The Nazis vilified sexology as "Jewish science" and plundered the Institute in May 1933, burning tens of thousands of books and objects.

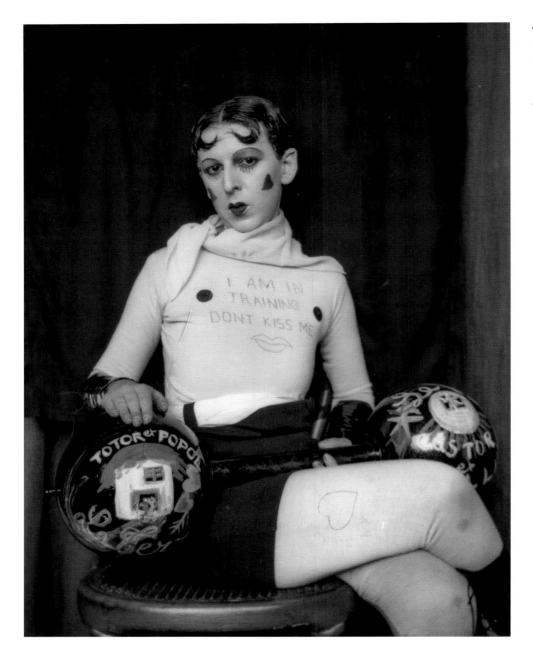

←
I Am in Training Don't Kiss Me
Claude Cahun
France (presumed), 1927

This iconic self-portrait by Claude Cahun, born Lucy Schwob, presents a contradictory mix of male and female forms of expression. Part body builder, part seductress, the ambiguous image challenges the idea of gender identity as stable. Cahun's exploration into gender, sexuality, and the self resonate today in a time of increasingly fluid identities.

→
Gluck
Howard Coster
England, 1926

Born Hannah Gluckstein, Gluck insisted on this shortened name and rejected any titles or forenames that indicated a specific gender. Gluck lived openly as a lesbian and subversively challenged the gender binary. Gluck's masculine identity is evident in this portrait by Howard Coster, who was known as the "Photographer of Men."

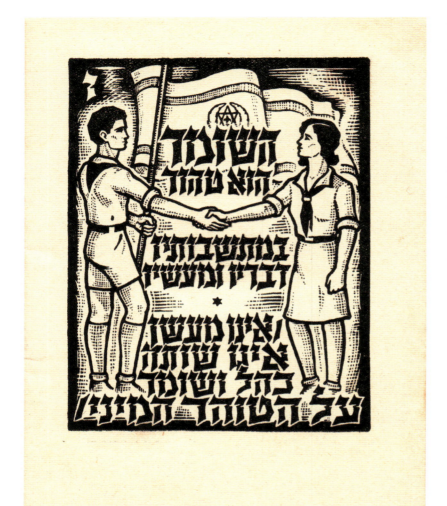

←
The Tenth Commandment
Shraga Weil
Hungary (presumed), 1946

As a teenager in Czechoslovakia, Shraga Weil belonged to the socialist-Zionist youth movement Hashomer Hatzair. This poster is part of a series in which Weil illustrated the movement's ten secular "commandments." The text emphasizes the importance of sexual purity for Zionist youth: "The Shomer is pure in thought, word, and deed. He does not smoke, nor drink alcohol, and practices sexual chastity."

→
Let Me Work!
Palestine, 1930s

A muscular industrial worker operates a machine with the headline: "Let me work! Buy locally made products!" The man is depicted as a model of masculinity, embodying the image of the so-called muscle Jew. Muscular Judaism rejected the antisemitic idea of the ghetto Jew, arguing that Jews must be strong and fit in order to build a national homeland in Palestine.

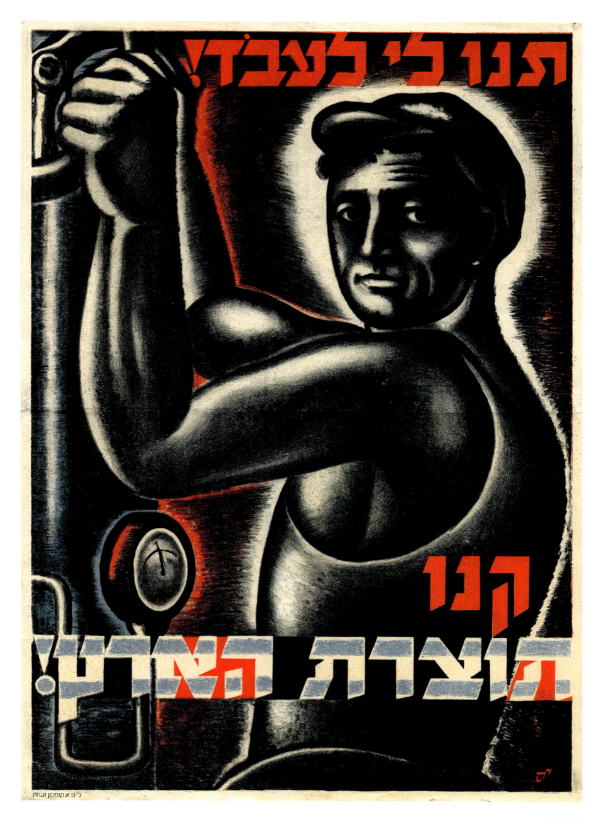

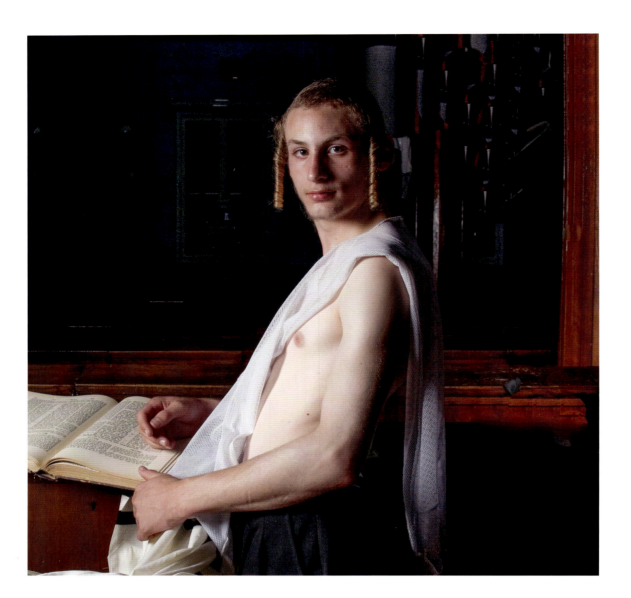

↑
Orthodox Eros
G. L. H.
Israel, 2010

This carefully composed image of an ultra-Orthodox young man is part of a series by the Israeli photographer G. L. H. The images offer an intimate look at masculinity and religion, presenting the sensuality and eroticism of Hasidic life.

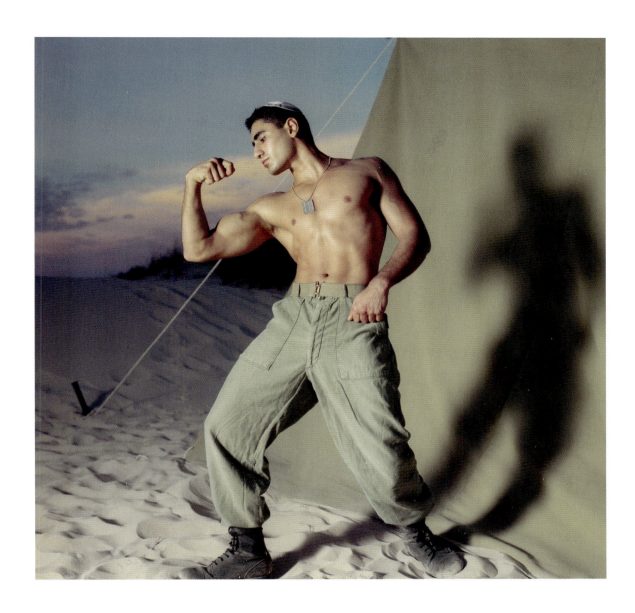

↑
Untitled (Soldiers Series)
Adi Nes
Israel, 1996

This photograph is characteristic of Adi Nes's work on the figure of the Israeli soldier, combining hypermasculinity and homoeroticism to challenge normative Israeli constructions of the ideal Jewish man.

Identities
Sexuality and Power

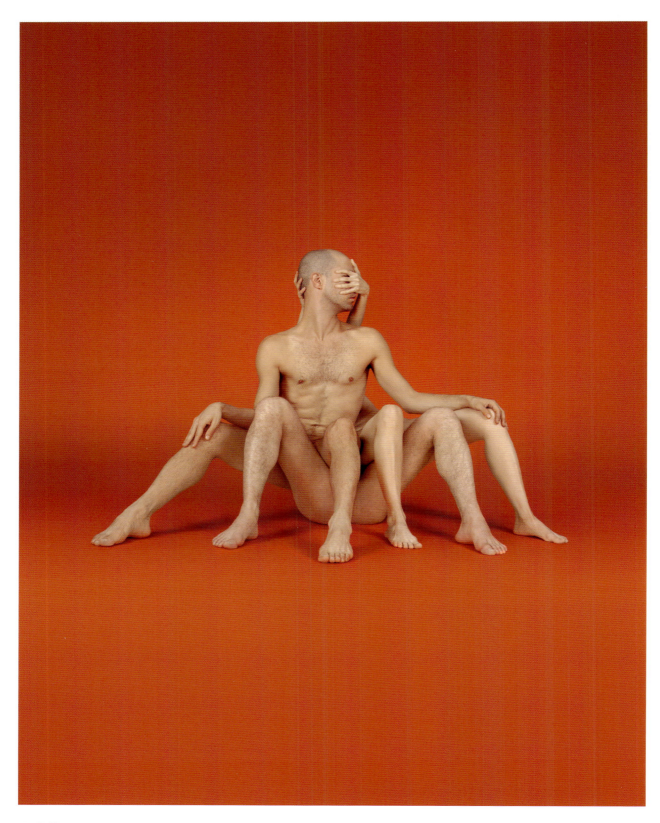

←
Body Piece II
Guy Aon
Israel, 2021

Six legs, four arms, and one head—several bodies merge to form a new being. Guy Aon's photography takes a close look at human bodies, which he stages sculpturally. His pictures are created in consultation with actual couples that live together, in this case a polyamorous love triangle.

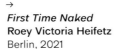

→
First Time Naked
Roey Victoria Heifetz
Berlin, 2021

With this self-portrait, Roey Victoria Heifetz documents a particular moment in her gender transition. The scale and detail of the drawing bring the artist and viewer into an intimate encounter. Heifetz views this work as a way to express her own vulnerability and embrace her changing body as a transgender woman.

161

Thank God I'm Gay
Jean-Baptiste Carhaix
San Francisco, 1983

The photograph shows *Sadie, Sadie, the Rabbi Lady,* born Gilbert Block. Sadie was a Jewish member of the Sisters of Perpetual Indulgence, a queer protest and performance group formed in San Francisco in 1979. As "queer nuns" they staged theatrical protests against homophobia and religious hypocrisy. This image captures the joyful, irreverent nature of Sadie's activism.

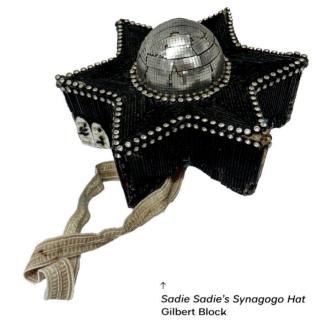

Sadie Sadie's Synagogo Hat
Gilbert Block

Made by Block in the shape of a Star of David, the hat playfully combines Sadie's Jewish and queer identities. A mirror ball tops the head covering, with the Ten Commandments adorning the side.

Yehuda Amichai
We Did it
1971

We did it in front of the mirror
And in the light. We did it in darkness,
In water, and in the high grass.

We did it in honour of man
And in honour of beast and in honour of God.
But they didn't want to know about us,
They'd already seen our sort.

We did it with imagination and colours,
With confusion of reddish hair and brown
And with difficult gladdening
Exercises. We did it
Like wheels and holy creatures
And with chariot-feats of prophets.
We did it six wings
And six legs

 But the heavens
Were hard above us
Like the earth of the summer beneath.

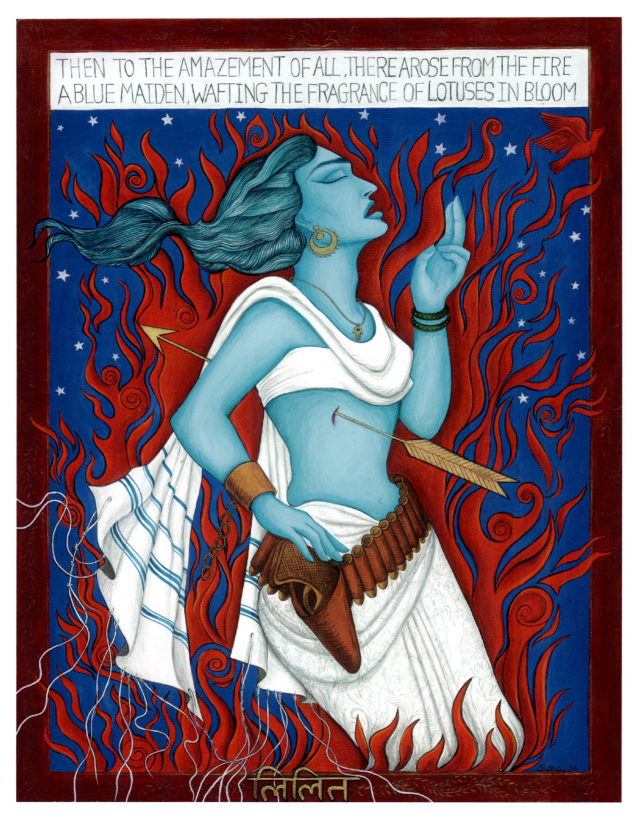

→
The Last of the Red Hot Mamas: Sophie Tucker's Greatest Hits
Sophie Tucker
USA, 1967

Sophie Tucker, born Sonya Kalish, was an internationally successful singer, actor, and comedian. Also known as *The Last of The Red Hot Mamas*, she challenged gender stereotypes with bold songs that celebrated her libido. Joan Rivers and Bette Midler are prime examples of Tucker's influence on later generations of Jewish entertainers.

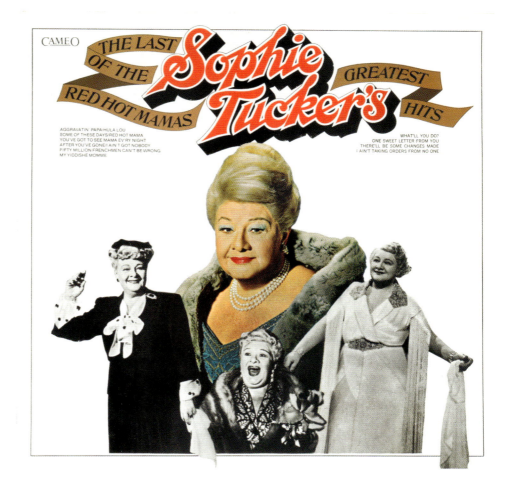

←
Lilith
Siona Benjamin
USA, 2006

Lilith is traditionally known as a dangerous seductress, but here she appears as a symbol of female defiance. Siona Benjamin sees Lilith as the first feminist, who was demonized for demanding sexual equality with Adam. Her paintings are a fusion of cultures, combining American pop art with the imagery of the artist's Indian and Jewish heritage.

IV

Eroticism and the Divine

*Oh, give me the kisses of your mouth,
For your love is more delightful than wine.*

These words of desire open the Song of Songs, setting the tone for what is to come. The Song of Songs is somewhat of an anomaly in the Hebrew Bible. A collection of erotic love poetry, it features no religious or legal instruction, and God is completely absent. Written in explicitly erotic language, it is a sensual celebration of bodily pleasure—and yet it is part of the biblical canon, read publicly in the synagogue during the annual Passover service.

The rapturous passions of these ancient love poems have inspired artists such as Judy Chicago, Marc Chagall, and Jacques Lipchitz, but the rabbinic tradition has had an uneasy relationship with their erotic nature. Religious commentators have instead tended to read the book as an allegory, presenting the desire of the two lovers at its heart as a symbol of God's love for the people of Israel. Indeed, the biblical prophets themselves frequently employed the same symbolic device, presenting the relationship between God and Israel as that of married partners, engaged in a turbulent love affair.

But the allegorical turn of the rabbis in response to the eroticism of the Song of Songs reflects a deeply held value found in the religious tradition itself, namely that sexuality must be elevated into the spiritual realm in order to become truly legitimate. By this logic, the carnal is by no means automatically opposed to the spiritual. What is to be rejected more precisely is a sexuality that represents nothing more than self-gratification: eroticism which is devoid of the spiritual dimension. Instead, God must be part of the equation. Sex itself is generally seen in rabbinic literature as a divine gift, an embodied form of religious worship. The Talmud even specifies that it is the Sabbath, the holiest day of the week, which is the optimal time for couples to engage in sex.[1]

With the evolution of Kabbalah, Judaism developed an erotic theology, which laid the foundations for sex to be elevated

from a base, physical act and transported it into the spiritual, theological realm. The medieval mystics of the Kabbalah conceived of God as metaphysically comprising multiple *sefirot*, or emanations, which are male and female. The sexual union of man and woman on Earth was understood to be not just a holy mirror of the divine but moreover an act of cosmic implications, capable of restoring the divine order by reuniting the "male" and "female" aspects of the Godhead. With this cosmological framing, the Kabbalists revolutionized the religious meanings which could be attached to sex. Much more than merely a physical act, sex had now become something sacred and transcendent, with profound heavenly implications.

Indeed, even in Judaism's most ancient texts, far from being a barrier to a spiritual life, sex was seen as a necessary part of being human. One of the few issues on which the Talmudic sages achieved consensus was the question of celibacy, a practice which was unanimously condemned. Even the most devoted Torah scholar was tasked with the duty to serve God with the body as well as the mind. The most prominent bachelor of the Talmud, Shimon Ben Azzai, is a notable exception; he was harshly rebuked by his peers for prioritizing Torah study over marriage. In defending his unorthodox choice of a celibate life, Ben Azzai's words are revealing: "What shall I do, my soul yearns for the Torah?"[2] Sex for him seemed to hold no allure; it was a distraction from the true object of his lust: divine worship.

The line between spiritual and carnal is far from clear. As the case of Ben Azzai demonstrates, devotion to God and religious worship can be experienced as manifestations of intense desire and even romantic love. The notion of God and the Torah as objects of desire appears in certain strands of mystical thought and throughout religious liturgy, where Godly devotion is often expressed in language that is erotically charged. The unbridled passion found in the liturgical poem *Yedid Nefesh* is just one example. Popularly sung on the Sabbath, it narrates the relationship between God and the Jewish

people with language more commonly found in erotic poetry: *Nafshi holat ahavatekha*, which literally translates as "My soul is sick for your love."

And if the soul aches for Godly love, religious rituals offer the body a useful vehicle for attaining it. For while rituals may be spiritual acts, they are enacted and experienced through the body, with all the senses. Whether kissing a mezuzah,[3] adorning the Torah scroll in layers of sumptuous fabrics, or binding the tefillin[4] around one's arm, Judaism incorporates a menu of everyday rituals which carry decidedly erotic undertones.

The example of the tefillin offers an interesting insight into the permeable nature of whatever boundary may exist between spiritual and carnal. With its black leather straps ritualistically bound around the body, the tefillin can easily be recast—albeit through a less religious lens—as an item of fetish or bondage. In her poem "Tefillin," Yona Wallach transgressively reimagined this sacred object as a sex toy for fulfilling a violent sexual fantasy |see page 194|. The poem caused outrage in Israeli society when it was first published in 1982. And tefillin remain the site of creative exploration for many queer artists today, including Berlin-based photographer Benyamin Reich, whose work has drawn heavily on the erotically charged power of this particular ritual object |see page 192|.

But for those in search of authentic communion with the divine, ritual objects are not the only route.

Prayer itself—the most direct, unmediated act of communing with God—has its own erotic potential. For proof we need look no further than the sight of ultra-Orthodox men vigorously rocking their bodies back and forth in private rapture, whether in the synagogue or at home. The founder of the Hasidic movement, the Baal Shem Tov, made explicit the connection between prayer and eroticized spirituality in his teachings. In an extraordinary passage which makes clear the Kabbalistic origins of Hasidic thought, he writes that "prayer is a form of intercourse with the Shekhinah" (the Shekhinah

being God's female presence) and refers to the "arousal" that comes from moving one's body during prayer.[5] Whether the arousal in question is physical or spiritual—or more likely both—the inference is clear: sexuality is an intrinsic part of divine worship.

1 Babylonian Talmud, Tractate Ketubot 62b.

2 Babylonian Talmud, Tractate Yevamot 63b.

3 Literally meaning "doorpost," the mezuzah refers to a parchment scroll containing verses from the Hebrew Bible which, according to Rabbinic Judaism, must be fixed to every doorpost in each home or building. There is a popular custom when passing through the doorway to touch the mezuzah and then kiss one's hand.

4 Tefillin are small black leather boxes, attached to leather straps, containing parchment scrolls with biblical scriptures. Worn as part of the morning prayer ritual, the leather straps serve to secure the tefillin to the body.

5 Baal Shem Tov, *Tzavaat ha-Rivash*.

The Eruption of Eros in Jewish Messianic Heresies

Jay Michaelson

"With this deed we go to the naked thing, therefore it is necessary to go naked." So said the heresiarch Jacob Frank (1726–1791) at the culmination of a sexual ritual conducted on the eve of his sect's conversion to Christianity in 1759. According to §46 of the Frankist chronicle, Frank

> stripped naked and ordered all those gathered [to do likewise]. Then he took a small bench, drove a nail into the center and set two burning candles on it and hung his cross from the nail. He kneeled before it, and took the cross, bowed in four directions, and kissed it. Then he ordered Her Highness [Frank's wife] and everyone else to do likewise. After that, sexual relations took place according to his determination.

What were the meanings ascribed to such sexually transgressive acts by those who engaged in them? Engaging with that question is a fraught endeavor. There are few records of the Sabbatean messianic movement from which Frank's sect sprang; most accounts come from the movement's opponents, and are replete with hyperbole.[1] Even the most notorious episode in Frankist history, an alleged sexual ritual conducted in 1757, is only recorded in rabbinic polemics; the sect said they were merely "singing songs," which indeed Sabbateans often did.[2] Meanwhile, among heresiologists, popularizers, and even many scholars, sexual antinomianism—that is, the intentional transgression of sexual mores[3]—assumes an outsized role in accounts of Sabbateanism and Frankism,[4] as is often the case with non-orthodox religious movements, often reducing these movements to mere rationalizations for licentious behavior.[5] Yet surely these heresies

were not mere pretexts—there are far easier ways to engage in sexual acts than creating heretical movements which were persecuted with threats of violence and death. So what were they? As I have argued in more detail elsewhere,[6] the messianic heresies of Sabbetai Zevi (1626–1676) and Jacob Frank built on Kabbalistic foundations and understood sexual liberation as being an enactment of the messianic age. Having failed to bring about historical, collective redemption, these movements cultivated a new, messianic consciousness among their believers that shifted messianism from the public and historical to the private and experiential. Sexual antinomianism demarcated and enacted a new social, theological, and perhaps psychological reality: a messianic ecstasy which would later become domesticated under the vague rubric of "spirituality." As such, though the available evidence suggests that sexual ritual was rare, it was imbued with theological and social meanings. And while these heretical sects eventually died out, the logic of eroticized messianic mysticism was eventually sublimated and domesticated by Hasidism into ecstatic prayer, to the point where, in the twenty-first century, seemingly innocuous practices like ecstatic chanting, swaying, and dance are common in contemporary synagogues. But the genealogy of this Jewish spirituality leads back to the eroticized messianism of Sabbateanism.

To begin with a short historical sketch, Sabbetai Zevi was a messianic figure who briefly, in 1665–66, attracted a mass following of Jews who believed him to be the redeemer. This mass movement ended in 1666, when the Ottoman Sultan Mehmet IV gave Sabbetai the choice of conversion or death—and the messiah converted to Islam.[7] Some of Sabbetai's most devoted followers, however, did not abandon the new messiah. In the Ottoman Empire, they outwardly converted to Islam while maintaining Sabbatean rites and beliefs in secret, becoming known as the Doenmeh, and, remarkably, they have endured until the present day. In European Jewish communities, some Sabbateans publicly renounced their messianic beliefs but secretly maintained them; these crypto-Sabbateans included prominent rabbis such as Rabbi Jonathan Eibeschütz and figures in the Haskalah (the Jewish Enlightenment).

Jacob Frank was active in both worlds: he was born into a Sabbatean family in Podolia (part of present-day Ukraine), was initiated into the Doenmeh in Salonica, and was then active in Poland from 1757 to 1759, at which time his sect converted en masse to Christianity. When this conversion was found to be false, Frank was imprisoned for over twelve years, but from 1772 until his death in 1791, he established himself as a kind of faux-noble charlatan, attaining social mobility through a combination of grift, mystery, Masonic political networks, and rumors of hedonistic excess.[8] As I have remarked elsewhere, the truth of Frank's life is often stranger than his fantastic tales and theologies.[9]

Kabbalah forms the primary ideological context for Sabbateanism/Frankism in general, and their attitudes towards eros in particular. While it is impossible to summarize Kabbalistic doctrines on eros here, sexuality is central to Kabbalistic theologies, particularly in the theosophical system of the *sefirot*, the Divine emanations or aspects. The Divine creative process is analogized and embodied in

the procreative sexual act, and conversely, religious acts are understood as enacting sexual union (*yihud*) both between the mystic and God and within the sefirot, which are variously male, female, nonbinary, and plurally gendered. Kabbalah's erotic speculation does not lead to libertinism—on the contrary, it leads to greater repression and anxiety, particularly around non-procreative sexual acts (many of Judaism's most extreme restrictions on masturbation, for example, derive from Kabbalistic traditions). Yet by eroticizing God and religious practice, theosophical Kabbalah created a tension that the heretics would later exploit. Sometimes, the tension is explicit: some texts state that in the messianic age, the restrictions on sexual behavior would be lifted, while others state that while incest is prohibited to human beings, "above there are no laws of incest," and that incest is the "scepter of the king."[10] Even absent such explicit doctrines, though, Kabbalah's eroticization of everything and gendering of the Godhead created a powerful eroto-spiritual tension.

The Sabbatean movement exploited it, annulling sexual restrictions (*arayot*) as a sign of the messianic age,[11] adapting secular love songs for use in religious liturgy, creating numerous eroticized (and homoeroticized) hymns about Sabbetai himself, and creating a shockingly eroto-spiritual theology in texts such as *And I Came This Day unto the Fountain*.[12] Sabbateanism took what Moshe Idel calls a "non-metaphorical" interpretation of Kabbalistic understandings of eros[13] and what Ada Rapoport-Albert calls "the concrete substantiation of the spirit, including the full physical materialization of the divine."[14] The Doenmeh rejected customs of modesty and sexual propriety, and instituted sexual ritual as part of the springtime Festival of the Lamb, at which, after the festive meal, the lights were extinguished and sect members had sexual relations with one another.[15] As Cengiz Şişman describes,

> Such "strange acts" were justified by the postmessianic Dönme Kabbalah, which professed that the messiah had already come and abolished the rulings of the Torah of Beri'ah (this world) and initiated the Torah of the 'Azilut (world-to-come) in its place. In order to penetrate into the 'Azilut world fully, a believer was supposed to transgress the rulings belonging to this world.[16]

Presumably, such practices, in addition to their conceptual or symbolic meanings, also were profoundly decentering, creating a rupture that actualizes the messianic promise of the movement itself; if conventional nomic order is founded upon the subjugation of eros, the messianic ritual unleashes it.[17]

Notably, these liberalizations were accompanied by the increased power of women in the Sabbatean movement, with leaders such as Sarah Ashkenazi (Sabbetai's wife), Chaya Shorr, and Eve Frank wielding unprecedented communal and ritual authority.[18] Indeed, Rapoport-Albert argues that the leadership of women was one reason Sabbateanism became associated with licentiousness:

> The sexual depravity imputed to their women was inextricably linked to their full engagement with the failed messianic project.

> It was an untimely eruption of female spirituality—a powerful force prematurely unleashed which was now to be stowed away, kept out of sight, and securely contained until the appointed time for its discharge.[19]

Sabbateanism is also one of the few places in Jewish mystical history in which queer sexuality and gendering appears to have been significant. Homoerotic liturgy praised the beauty of Sabbetai Zevi and one of his successors, Beruchia Russo; texts depict Sabbetai as a woman in the guise of a man, or identify him with the divine androgyne and with the biblical Esther, while others describe his penis having been wounded, leading to years of non-marriage, and two marriages annulled prior to that to Sarah Ashkenazi. Even if we discount anti-Sabbatean rumors of Russo having been a male sex worker and Sabbetai having had liaisons with young male servants, the non-normativity of Sabbetai's gender and sexuality within Sabbatean sources themselves is remarkably striking.[20]

Frankism builds upon these themes, while also seeking to overturn others. As with the Doenmeh, Frankist sexual ritual appears to have been quite rare and carefully choreographed, quite unlike the fevered dreams of the sect's opponents. For example, the ritual described at the beginning of this essay was conducted in July, 1759, on the eve of the sect's baptism, as a kind of initiation rite, directed by Frank, in which the Brethren confirm that they are not becoming Christian, but are bound to one another. It confirms the group identity and, as with Sabbatean ritual, provides a taste of the transgressive millennial reality. As Ada Rapoport-Albert put it,

> The apparent licentiousness of the Frankist court should not be viewed as wanton anarchy, unregulated and unchecked. On the contrary, the sexual contraventions practiced there, which Frank endowed with symbolic, sacramental meanings, were always performed at his own dictate, in carefully prescribed manners, and at particular times and places. They bore the hallmarks of antinomian activity—meaningful precisely because it recognizes the authority of the laws it sets out to violate.[21]

Frankism also builds new structures atop its Sabbatean foundations. Frank depicts sexual liberation in terms of liberating the Maiden (*panna*), a messianic figure who may be understood as the principle of material, embodied sensuality, incarnated in many women over time; she is the gateway to eschatological redemption and personal transformation. In contrast, the repression of sexuality is a trap of the "Foreign Woman," who in Kabbalistic tradition is associated with licentiousness but here is associated with sexual repression. In § 2183 of Frank's oral teachings, Frank says that the "concealment" of Eve behind veils of modesty and subjugation was only due to Adam's sin, a situation to be rectified by the liberation of the "feminine" principle of sensuality.[22] Sexual shame has caused this concealment; sexual freedom will end it. Yet this "liberation" is at once proto-

feminist and misogynistic. In contrast to the "effeminate" Sabbetai Zevi, Frank sets himself up as a powerful, priapic male hero. Sabbetai was a secret woman, but the messiah, i.e., the Maiden, will be an actual woman, and Frank will be her redeemer. And yet, in the end, this masculine quest is undertaken so that the feminine can rule over the masculine: so that liberation rules over repression.

The heresies of Sabbateanism and Frankism died out, though they did not entirely disappear. In the Ottoman context, Doenmeh made up large parts of the leadership of the "Young Turks" that would eventually bring about the modern Turkish state.[23] And in Europe, Sabbateanism paved the way for Hasidism, which arose in the same geographical and social locations, and which domesticated Sabbatean mystical ecstasy in ecstatic prayer, which was often described in erotic terms and was seen as an immediate experience of messianic reality.[24] Hasidism, like Sabbateanism, replaced public messianism with private, eroticized spiritual practice; it maintained, in Haviva Pedaya's words, "structural continuity with the former experiences of revelation and messianism."[25] But unlike Frankism, Hasidism succeeded in integrating this eroticized, de-historicized messianism into normative Jewish life. As benign as the chanting of a Hasidic *niggun* may seem today, it was, at its inception, understood as an ecstatic, (spiritually) erotic ritual, a new, normative translation of the Sabbatean religious grammar. The logic of eroticized mysticism remains, but sublimated into spiritual practices that are today so commonplace as to be scarcely recognizable.

1 See Paweł Maciejko, *The Mixed Multitude: Jacob Frank and the Frankist Movement, 1755–1816*, Philadelphia: Univ. of Pennsylvania Press, 2011, 32–33 (recording accusations of "'sexual hospitality,' masturbation, sex with menstruant women, and incest").

2 See Jay Michaelson, *The Heresy of Jacob Frank: From Jewish Messianism to Esoteric Myth*, New York: Oxford University Press, 2022, 17–20, 116–18, 192–93; Hadar Samet, "Ottoman Songs in Sabbatian Manuscripts," *Jewish Quarterly Review* 109/4 (2019), 567–97.

3 See Michaelson, *The Heresy*, 114–51; Shaul Magid, *Hasidim Incarnate*, Stanford: Stanford University Press, 2014, 208–15.

4 See Rachel Elior, "Jacob Frank and His Book The Sayings of the Lord: Anarchism as a Restoration of Myth and Metaphor" [Hebrew], in: Rachel Elior, ed. *Ha-Halom v'Shivro*, Jerusalem: Hebrew University, 2001, 524–32; Chone Shmeruk, "The Frankist Novels of Isaac Bashevis Singer," in: Ezra Mendelsohn, ed. *Literary Strategies: Jewish Texts and Contexts*, Oxford: Oxford University Press, 1996, 118–27; Arthur Mandel, *The Militant Messiah or the Flight from the Ghetto*, Atlantic Highlands: Humanties Press, 1979, 39–44; Gershom Scholem, *The Messianic Idea in Judaism and Other Essays on Jewish Spirituality*, New York: Schocken, 1988, 126–27; Shmuel Feiner, *Origins of Jewish Secularization in Eighteenth-Century Europe*, Philadelphia: Univ. of Pennsylvania Press, 2010, 74–78 (claiming that "libertine behavior was justified by the claim that the transgressions have a secret religious meaning").

5 See Hugh Urban, *Magia Sexualis,* Berkeley: Univ. of California Press, 2006, 33–35; Arthur Versluis, *Secret History of Western Sexual Mysticism*, Merrimac: Destiny Books, 2008, 57–58; Norman Cohn, *Pursuit of the Millennium*, London: Pimlico, 1993, 150–51; Robert E. Lerner, *Heresy of the Free Spirit in the Later Middle Ages*, Notre Dame: Notre Dame Press, 1972, 20–22, 239–40 (noting how the Free Spirit was said to possess "religious doctrines that are merely pretenses for fornication").

6 Michaelson, *Jacob Frank*, 138–41.

7 See Cengiz Şişman, *The Burden of Silence: Sabbatai Sevi and the Evolution of the Ottoman-Turkish Dönmes*, Oxford: Oxford University Press, 2015, 63–69; Matt Goldish, *The Sabbatean Prophets*, Cambridge: Harvard Univ. Press, 2004, 131–51; Gershom Scholem, *Sabbatai Sevi: The Mystical Messiah 1626–1676*, R. J. Z. Werblowsky, trans. Princeton: Princeton University Press, 1973, 861.

8 See Maciejko, *Mixed Multitude*, 199–231; Jonatan Meir, "Jacob Frank: The Wondrous Charlatan" [Hebrew], *Tarbiz* 80/3 (2012), 463–74.

9 Michaelson, *The Heresy*, 13–45.

10 Tikkunei Zohar 69. See Moshe Idel, "The Interpretations of the Secret of Incest in Early Kabbalah" [Hebrew], *Kabbalah* 12 (2004), 89–199.

11 Elliot Wolfson, "'Tiqqun ha-Shekhinah': Redemption and the Overcoming of Gender Dimorphism in the Messianic Kabbalah of Moses Hayyim Luzzatto," *History of Religions* 36/4 (1997), 289–332, 292–99.

12 See Paweł Maciejko, "Coitus interruptus," in: Paweł Maciejko ed. *And I Came This Day unto the Fountain*, Los Angeles: Cherub Press, 2016, xxv–xxxii (discussing text's descriptions of "supernal" masturbation, homosexuality, anal sex, and oral sex).

13 Moshe Idel, *Kabbalah and Eros*, New Haven: Yale University Press, 2005, 202.

14 Ada Rapoport-Albert and Cesar Merchan Hamánn, "Something for the Female Sex: A Call for the Liberation of Women, and the Release of the Female Libido from the 'Shackles of Shame,'" in an Anonymous Frankist Manuscript from Prague c. 1800." in: Joseph Dan, ed. *Gershom Scholem (1897–1982): In Memoriam*, vol. 2, Jerusalem: Hebrew University, 2007, 77–135.

15 See Ada Rapoport-Albert, *Women and the Messianic Heresy of Sabbatai Zevi, 1666–1816*, London: Littman Library of Jewish Civilization, 2011, 85–89; Şişman, *Burden of Silence*, 150–88.

16 Cengiz Şişman, "The Redemptive Power of Sexual Anarchy," *AJS Perspectives* (Spring 2017), http://perspectives.ajsnet.org/transgression-issue/the-redemptive-power-of-sexual-anarchy/.

17 Herbert Marcuse, *Eros and Civilization: A Philosophical Inquiry into Freud*, Boston: Beacon Press, 1974, 55–105; Dominic Pettman, *After the Orgy: Toward a Politics of Exhaustion*, Albany: State Univ. of New York Press, 2002, 51.

18 Rapoport-Albert, *Women and the Messianic Heresy*, 171–74; Alexander van der Haven, *From Lowly Metaphor to Divine Flesh: Sarah the Ashkenazi, Sabbatai Tsevi's Messianic Queen and the Sabbatian Movement*, Amsterdam: Menasseh ben Israel Instituut, 2012, 9–11, 38.

19 Rapoport-Albert, *Women and the Messianic Heresy*, 296.

20 Idel, *Kabbalah and Eros*, 232–33; Yehuda Liebes, *The Secret of the Sabbatean Faith: Collected Papers* [Hebrew], Jerusalem: Mosad Bialik, 1995, 107–9; Avraham Elqayam, "To Know the Messiah: The Dialectics of the Sexual Discourse in the Messianic Thought of Nathan of Gaza," *Tarbiz* 65 (1996), 637–70; Eli Shai, *Messiah of Incest*, Tel Aviv: Yediot Ahronot, 2002, 138–39, 260–61; Elior, "Jacob Frank," 471–547; Scholem, *Sabbatai Sevi*, 434; Van der Haven, *From Lowly Metaphor*, 34; Elliot Wolfson, "The Engenderment of Messianic Politics: Symbolic Significance of Sabbatai Sevi's Coronation," in: Peter Schäfer and Mark R. Cohen, eds. *Toward the Millennium: Messianic Expectations from the Bible to Waco*, Leiden: Brill, 1998, 203–58, 246; Rachel Elior, *The Mystical Origins of Hasidism*, Portland: Littman Library of Jewish Civilization, 2006, 189–90.

21 Rapoport-Albert, *Women and the Messianic Heresy*, 166–67.

22 Ibid., 258–60.

23 Şişman, *Burden of Silence*, 241–50.

24 See Arthur Green and Barry Holtz, *Your Word Is Fire: Hasidic Masters on Contemplative Prayer*, Woodstock: Jewish Lights, 1993; Idel, *Messianic Mystics*, New Haven: Yale University Press, 1998, 235.

25 Haviva Pedaya, "The Iggeret HaKodesh of the Baal Shem Tov: The Style of the Text and Its Worldview—Messianism, Revelation, Ecstasy, and Sabbateanism" [Hebrew], *Zion* 70/3 (2005), 311–54, 348–49. See Idel, *Messianic Mystics*, 3–16, 212–14.

The Song of Songs: Between Literal and Allegorical Loves

Ilana Pardes

The Song of Songs opens with a craving to be kissed: "Let him kiss me with the kisses of his mouth,/for your loving is better than wine.../poured oil is your name" (Song 1:2–3).[1] The beloved craves not just kisses, but luscious kisses. The kisses she longs for hover between intoxicating wine and perfumed oil, embodying an exhilarating welter of senses—taste, touch, and smell. Sound, too, joins this sensual celebration: a repeated "sh" rustle begins with the title of the Song of Songs, *shir ha-shirim*, and flows onto many of the words that follow, among them *neshikot*, "kisses."[2]

The bulk of this ancient love poem revolves around a dialogue between two young lovers: the Shulamite, as the beloved is called, and her nameless lover.[3] There is something utterly refreshing in the frank celebration of love that is found in the passionate exchanges of the two. Nowhere else in the Bible are bodily parts—mouth, lips, tongue, hair, nose, eyes, breasts, thighs—set on a pedestal; nowhere else are the sensual pleasures of love relished with such joy; nowhere else is sexual desire spelled out with utmost verve. And yet sexuality is never blatant in the Song. Instead we find a nuanced combination of audacity, innocence, and decorum, made possible by a spectacular metaphoric web which allows the two lovers to be direct and indirect at once.

Both lovers are masters of metaphor. If in much of the love poetry of antiquity (and beyond) male lovers are set on stage as the agents of courting, here we find a strikingly egalitarian amorous dialogue between two virtuoso speakers, who woo each other while juggling a plethora of metaphors and similes from different realms.[4] They liken each other to wine, perfumes, roses, trees, gazelles,

doves, the moon, the sun, a crimson thread, gold, precious stones, locks, walls, and towers. No figure of speech seems to suffice in depicting love.

The primary enigma of the story of the Song's reception is: Why was a daringly sensual poem of love with no reference whatsoever to God or national history included in the Bible? There was apparently a rabbinic dispute regarding the canonicity of the Song. The account of this dispute, however, is sparse and does not spell out the official criteria used to determine canonicity. The one remnant of this debate is Rabbi Akiva's (50–ca. 135 CE) memorable declaration that the "whole world is not worth the day on which the Song of Songs was given to Israel for all the Writings are holy and the Song of Songs is the Holy of Holies" (Mishnah Yadayim 3.5). In a striking rhetorical move, Rabbi Akiva, one of the founding sages of rabbinic Judaism, draws on the superlative structure of the phrase "Song of Songs" (*shir ha-shirim*) to turn the text whose holiness was called into question into none other than the "Holy of Holies" (*kodesh kodashim*).

Rabbi Akiva's affirmation of the Song's sanctity played a pivotal role in shaping the allegorical reading of the ancient love poem. For many centuries the predominant tendency in Jewish exegesis was to regard the Song as an allegorical poem whose primary objective was to celebrate divine love. The rabbinic commentary on Song 7:4 is exemplary:

> "Your two breasts are like two fawns" This refers to Moses and Aaron. Just as a woman's breasts are her glory and her ornament, so Moses and Aaron are the glory and the ornament of Israel. Just as a woman's breasts are her charm, so Moses and Aaron are the charm of Israel (*Song of Songs Rabba* 4:5).[5]

To modern readers, any attempt to regard the Song as pertinent to sacred history or divine love seems astonishingly detached from its literal sense. But from the point of view of the rabbis of late antiquity, the possibility of interpreting the Song as anything but divine would have been unthinkable: Why else was the Song included in Scripture if not to serve as a key to the mysteries of the human-divine bond?

A dramatic shift—one of the most dramatic exegetical shifts of all times—took place in the context of European Enlightenment with the rise of a new reading of the Song as an exquisite earthly dialogue between human lovers.[6] There were various advocates of the literalist Song in eighteenth-century Germany, but Johann Gottfried Herder was undoubtedly the most fervent and famous of them. In his *Lieder der Liebe* (1778)—a German translation of the Song and a verse-by-verse commentary—he attacks traditional allegorical readings of the ancient love poem.[7] After centuries of distorted readings, he writes, the time has come to admit the obvious: "What then is the content? What does it treat from beginning to end? ... *Love, love*. It is simply ... what it is and with every word suggests: a love song."[8] The literal character of the poem, its original meaning, was obfuscated by Jewish and Christian exegesis and concealed by mystical allegories of divine love. "I read the book and can find in it not the tiniest sign,

not the smallest hint that any other meaning is...the purpose of the book."[9] Herder's literalist approach is inextricably connected to an endorsement of the ancient love song as an aesthetic touchstone. He regards the Song as a superb product of the Bible's unparalleled oriental imagination, a text whose subtle meanings are best understood in light of the culture and customs of the Orient. The first shock waves of the literalist readings of the Song made their way to the intellectual circles of Jewish Enlightenment in the late eighteenth and early nineteenth centuries. The scholar and poet Shlomo Löwisohn (1789–1821) provided the most substantive introduction to the literalist-aesthetic reading of the Song within the framework of the Jewish Enlightenment. His most renowned book *The Rhetoric of Israel* (1816), written in flowery biblical Hebrew, includes extensive adaptations of Herder's commentaries on the Song. Löwisohn construes the Song as a passionate, triangular drama involving the Shulamite, the king, and the shepherd. King Solomon, who forces the Shulamite to reside in his harem, wooing her fervently, does not succeed in preventing the chaste maiden from running off to meet her rustic lover in the fields. Spurning every royal allurement, she ignores Solomon's call for her to return to the harem—"Turn back, turn back, O Shulamite!" (Song 7:1)—and remains faithful to her humble shepherd.[10]

With the rise of Zionism, the Enlightenment Song was embraced with utmost enthusiasm. What made the Song a privileged text for secular Zionism was the fact that it required no de-theologizing, given the absence of God in these amorous dialogues. Zionist readers set out to remove the allegorical layers that had been piled upon the Song and to restore its original, literal grandeur. The biblical love poem appeared in different forms in early Zionist culture—from the many musical adaptations of the Song, to numerous artworks, folk dances, the Haggadot of the kibbutzim.[11] The most elaborate visual interpretation of the Song in the Bezalel School of Arts and Crafts was provided by Zeev Raban (1890–1970) in an illuminated edition of the Song of Songs, published in 1922. In Raban's illustrations of the Song, the lovers are positioned in highly sensuous scenes against the backdrop of oriental settings (both pastoral and urban) and the Shulamite oscillates between being covered, semi-bare, and bare. Raban's oriental Shulamite is somehow innocent and voluptuous at once.

The Song continues to be a key text in Israeli culture. It continues to hold a privileged position in modern Israeli poetry—from Haviva Pedaya's *From a Sealed Ark* to Yehuda Amichai's *Bible, Bible, with You, with You, and other Midrashim* (1998); it continues to be (even more than before) an indispensable part of wedding ceremonies, and it still thrives in popular music. One of the most fascinating features of contemporary adaptations of the Song is the renewal of traditional *piyyutim* (liturgical poems), among them poems of the great medieval poets Solomon ibn Gabirol and Yehuda Halevi, where the ancient love poem is evoked both as earthly and divine. This contemporary mélange of literal and liturgical renditions of the Song is evident in the work of the vocal artist Victoria Hanna.

Her adaptation of the dream sequence of the Song of Songs *I Sleep and My Heart Is Awake I Sleep and My Heart Is Awake* allows the mystical and the sensual to blend in unprecedented ways.

No interpreter of the Song can remain indifferent to its wonders. The opening scene in the long story of the Song's reception—its puzzling inclusion in the canon—is a prelude to much that lies ahead. Rabbi Akiva does not merely insist, dryly, that the Song needs to be canonized but rather endorses it with much fervor. Modern readers are no less passionate. Even those readers who have no interest whatsoever in searching for sanctity in the Song regard the poem's exquisitely profound exploration of human love and bold celebration of the human body as absolutely vital to their lives. For all readers of the Song—whether modern or premodern—the ancient love poem offers much more than a springboard to reflect on love and sexuality. It entails an urgent invitation to sense the unformulated reaches of amorous pursuits.

1 Biblical citations here are from Robert Alter's translation, *The Hebrew Bible*, New York: W. W. Norton, 2018.

2 The sound pattern of the "sh" rustle also includes the following words: *Shelomo* (Solomon), *asher* (which), *yishakeni* (let him kiss me), *shemen* (oil), and *shimkha* (your name). Note that there is a pun in Song 1:2 that highlights the fluidity of the kisses: "Let him kiss me," *yishakeni*, is phonetically similar to the verb *yashkeni*, "let him make me drink."

3 The meaning of the name Shulamite has been disputed. The most probable derivation is from Shalem, a shortened form of Jerusalem, though it is linked by punning with Solomon, Shelomo, and wholeness, *shalem*.

4 For more on the Song's egalitarian stance, see Ilana Pardes, *Countertraditions in the Bible: A Feminist Approach*, Cambridge: Harvard University Press, 1992, Chapter 7.

5 *Song of Songs rabbah: An Analytical Translation*, trans. Jacob Neusner, Atlanta Georgia: Scholars Press, 1989, 48.

6 For an extensive consideration of the twists and turns in the Song's exegetical history, see Ilana Pardes, *The Song of Songs: A Biography*, Princeton: Princeton University Press, 2019.

7 Johann Gottfried Herder, *Lieder der Liebe: die ältesten und schönsten aus Morgenlande, Nebst vier und vierzig alten Minneliedern*, 1778, printed in: *Sämmtliche Werke*, VIII, 485–588.

8 Quoted in Samuel Moyn's "Divine and Human Love," 200. Moyn's translation of Herder refers to the 1781 reprint of *Lieder der Liebe*.

9 Ibid., 200.

10 See Tova Cohen, *Melitzat yeshurun li-Shlomo Levisohn: Ha-yetzira ve-yotzra* [Melitzat Yeshurun by Shlomo Levisohn: The Work and its Author], Jerusalem: Bar Ilan University Press, 1988, 219.

11 For an extensive consideration of the reception of the Song in the Israeli context see Ilana Pardes, *Agnon's Moonstruck Lovers: The Song of Songs in Israeli Culture*, Seattle: Washington University Press, 2013.

→
Scroll with Kabbalistic Amulets and Texts
18th century

This scroll features an *Ilan* (literally: tree), a Kabbalistic visualisation of God's essence. In the complex diagram we see the heavenly spheres and divine emanations, which are conceived of as both male and female. These mystical ideas laid the foundation for human sexuality to take on a spiritual, transcendent dimension, capable of influencing divine harmony.

185

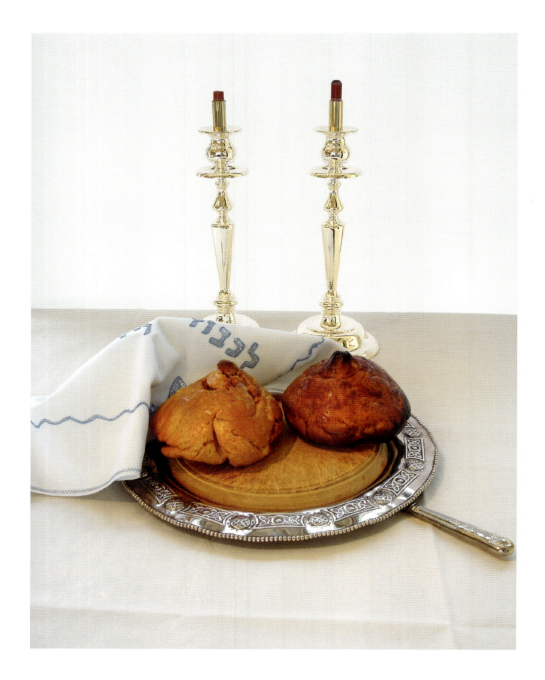

↑
Mizvah Night I
Ruth Schreiber
2011

In this playful installation Schreiber references the hidden, sexual agenda of Friday night, often half-jokingly called "mitzvah night." The Shabbat table is transformed into a scene of seduction, suggesting marital sex as a religious duty.

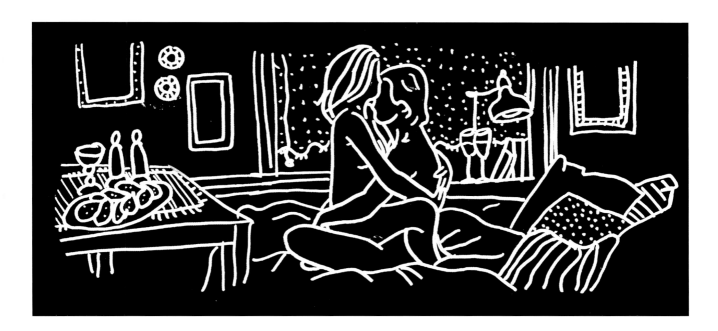

↑
*Challah Back Girl
(from the series "Shabbat
Sex Positions to Get
Your Double Mitzvah On")*
Melissa Cetlin
2017

These illustrations are based on the idea that sex on Shabbat is doubly encouraged on religious grounds and is thus a "double mitzvah." Shabbat bread and candles provide a Jewish backdrop to the erotic scenes. The series was designed for "At the Well," an online community whose mission is "to enhance women's well-being through ancient Jewish practices."

Holy Sex
Eroticism and the Divine

↑
Kosher Sex
1999

In 1999, the Orthodox American rabbi Shmuley Boteach published the international bestseller *Kosher Sex: A Recipe for Passion and Intimacy*. When excerpts from his book were printed in *Playboy* magazine, conservative figures in the Jewish world condemned Boteach's "unorthodox" promotional strategy, and Boteach lost his job as a community rabbi.

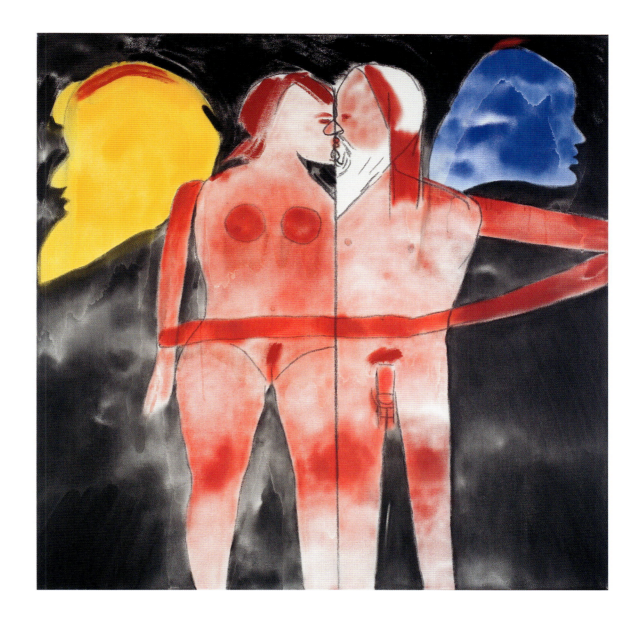

↑
Nose to Nose
R. B. Kitaj
Los Angeles, 2003

This work by R. B. Kitaj shows the artist in an erotic reunion with his wife Sandra Fisher. In the Los Angeles series, Kitaj expresses his longing for Fisher, who died unexpectedly in 1994. The painting reveals how Jewish mysticism influenced Kitaj's work during this period. Sandra takes the form of the Shekhinah with its characteristic wings, representing the female presence of God.

→
Allegorical Marriage Contract for Shavuot
Gibralter (presumed), 1830–1840

This illustrated ketubbah is part of a curious genre of Jewish art: mystical marriage contracts documenting the symbolic betrothal of God and the people of Israel. Particularly popular in Sephardi communities, it was customary to read out the text of these contracts in the synagogue during the festival of Shavuot, which traditionally commemorates God giving the Torah to the Israelites.

↑
Touching Mezuzah
Sari Srulovitch
Jerusalem, 2011

The mezuzah is a piece of parchment inscribed with biblical verses that is placed in a holder on the doorpost of a house. Out of respect or even superstition, many Jews touch the mezuzah and often kiss their fingers as they pass through. The three indentations in this mezuzah holder suggest the traces of this touch. Additionally, they stand for *shin*, the first letter of God's name.

Eroticism and the Divine
Devotion

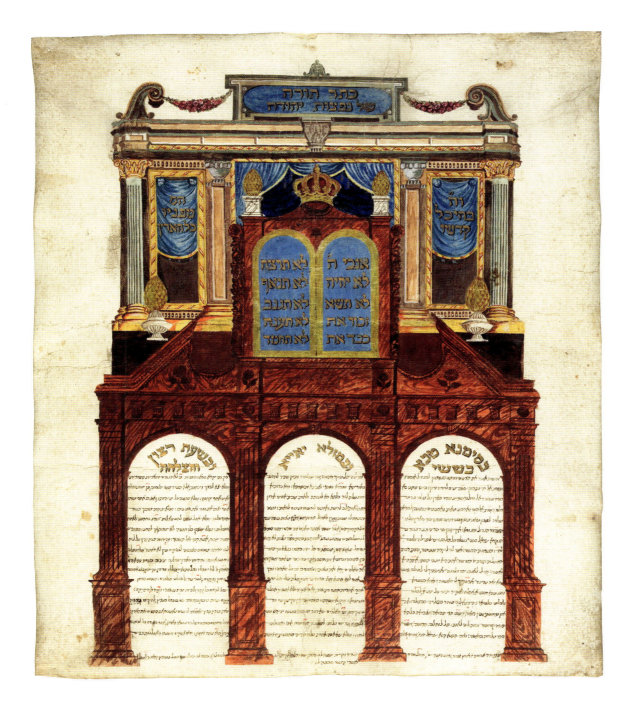

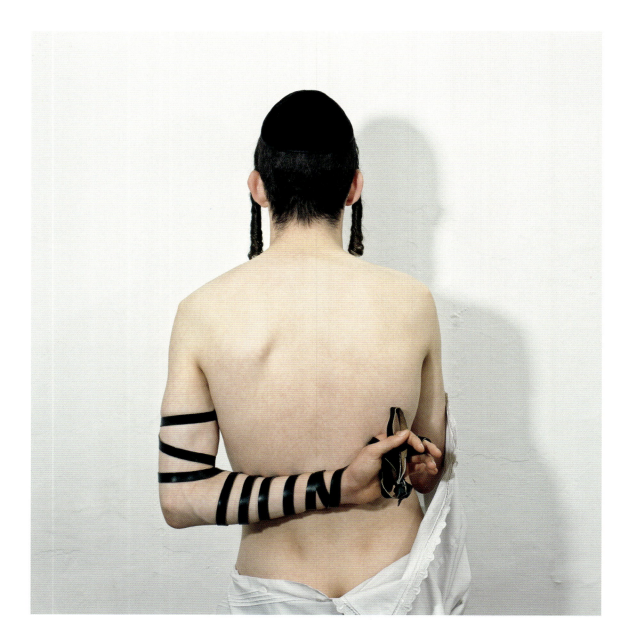

Eroticism and the Divine — Devotion

↑
Tefillin Schel Jad
Benyamin Reich
2005

By focusing on tefillin, or phylacteries, Benyamin Reich highlights the erotic aspect of prayer. Here the ritual object is both an integral part of prayer and a sex toy.

The young man's arm, wrapped in a leather strap, underscores the nakedness of his body and serves as a symbol of bondage and fetish.

→
Carrying the Scrolls of the Law
Simeon Solomon
England, 1867

The young man holds a Torah scroll in his arms and tenderly slips his hand under its velvet cover. In this affectionate portrait, Simeon Solomon elevates the Torah to an object of near erotic desire. This echoes the view of Rabbinic Judaism that scholars are drawn to study the Torah by a longing that can compete with marriage.

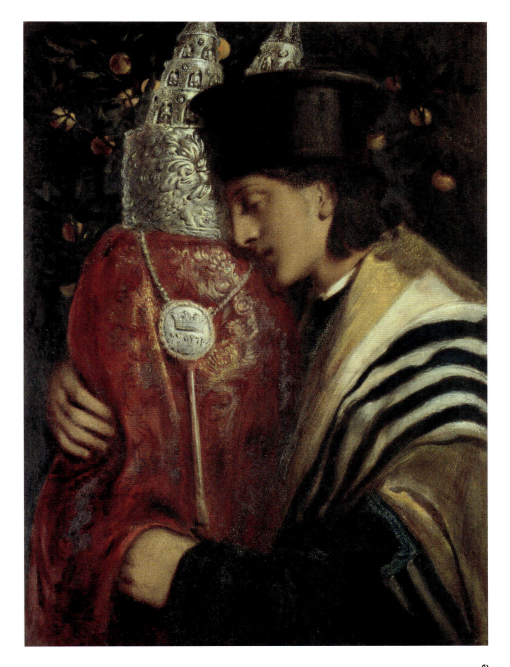

Devotion
Eroticism and the Divine

193

Yona Wallach
Tefillin
1982

Come to me
don't let me do a thing
do everything for me
everything that I'll begin to do
you'll do instead
I'll put Tefillin
will pray
you'll put the Tefillin for me
wrap them on my hands
play them in me
pass them delicately over my body
rub them well in me
everywhere arouse me
make me faint in the sensations
pass them on my clitoris
tie my waist with them
so that I'd come fast
play them in me
tie my hands and feet
do anything with me
despite my will

turn me on my stomach
and put the Tefillin in my mouth a
restraining bit
ride on me I'm a female horse
pull my head backwards
until I scream of pain
and you delighted
afterwards I'll pass them on your body
not hiding my intentions
oh how mean my face will be
I'll pass them slowly over your body
slowly slowly slowly
around your neck I'll pass them
I'll turn them a few times around
your neck, on one side
and on the other side I'll tie them
to something steady
particularly very heavy maybe spinning
I'll pull and pull
until you expire
until I strangle you
totally with the Tefillin
that string along the stage
and among the startled audience

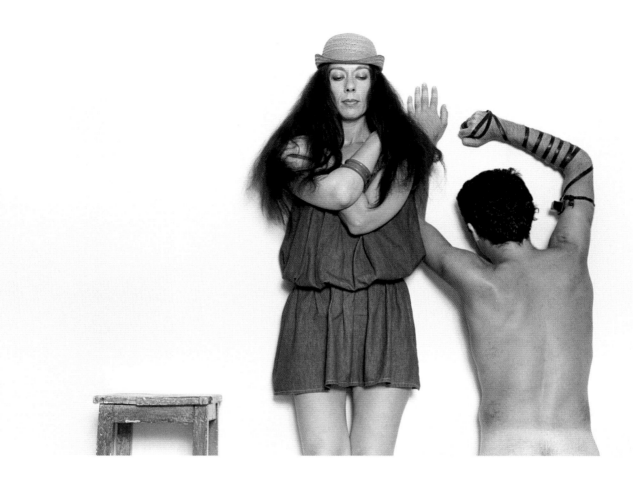

↑
Yona Wallach
Micha Kirshner
Israel, 1982

"Tefillin" is the title of one of the most famous poems by the Israeli poet Yona Wallach. It focuses on the sacred phylacteries traditionally worn by men for prayer, transforming them into a BDSM toy. The poem caused a storm of indignation, and this photograph was taken in its wake. Addressing the same subject, it shows a portrait of the poet herself. The photograph and poem illustrate how Wallach's work transgressed norms of gender and sexuality.

→
Untitled (Species)
Leor Grady
Israel, 2019

In the Sukkot harvest festival, the "four species" seen here—palm branch, citron fruit, myrtle, and willow branches—are united and shaken together. Leor Grady emphasizes the sensuousness of these ritual objects, portraying them as symbols of fertility and abundance. In Hebrew, the artwork's title means both "species" and "sex", pointing to the male and female symbolism of this festive bouquet.

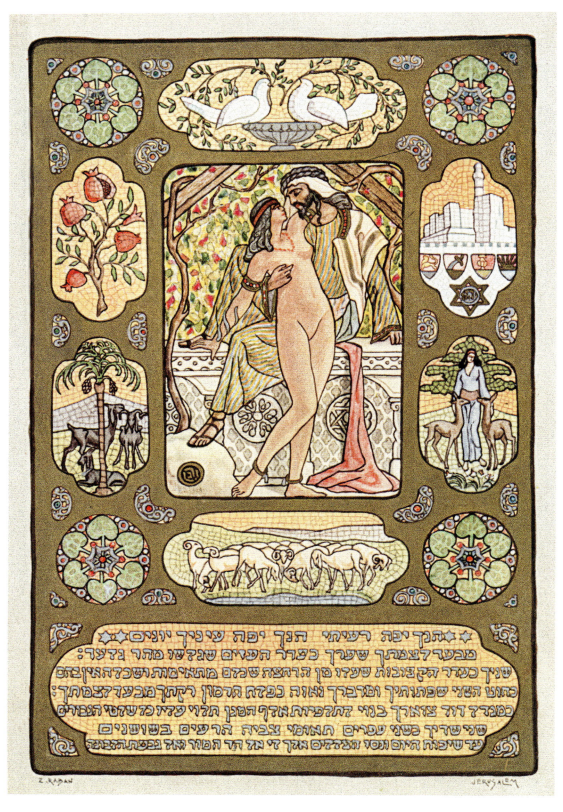

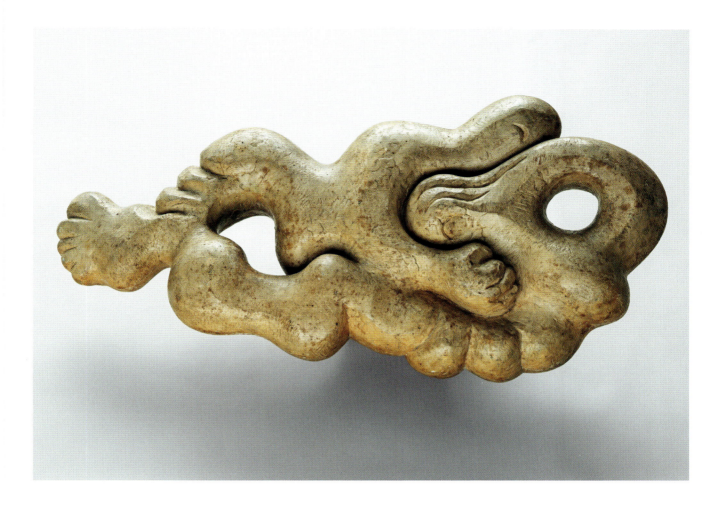

←
The Song of Solomon
Zeev Raban
Jerusalem, ca. 1949

Zeev Raban's illustrations for the Song of Songs show an eroticized and idealized vision of female beauty. This was the style favored by the Bezalel School of Art in Jerusalem, where Raban taught. He combined Art Nouveau and Orientalist motifs to produce a visual language that celebrates sensuality and the Land of Israel.

↑
Le Cantique des cantiques
Jacques Lipchitz
London, 1946

Jacques Lipchitz drew inspiration from the Song of Songs with this sculpture of a couple embracing. Lipchitz was asked by a friend to create a gift for the man's wife. This is one of several versions he produced on the theme.

←
Voices from the Song of Songs
Judy Chicago
New York, after 1998

In this series of six illustrations, Judy Chicago embraces the eroticism of the biblical Song of Songs. Through the balance and symmetry of her compositions, she suggests lust and desire that are equally shared by the male and female lovers. Their faces are noticeably absent of any obvious gender.

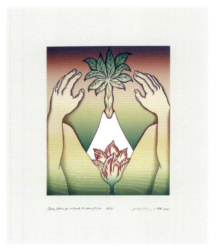

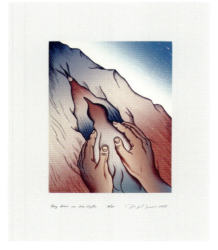

→
In My Mother's House
Judy Chicago
ca. 1962–1964

For the title of this work, Judy Chicago chose a sexually suggestive phrase from the Song of Songs in which a woman describes bringing her male lover into "her mother's house." It is here that she invites him to drink from her "pomegranate juice."

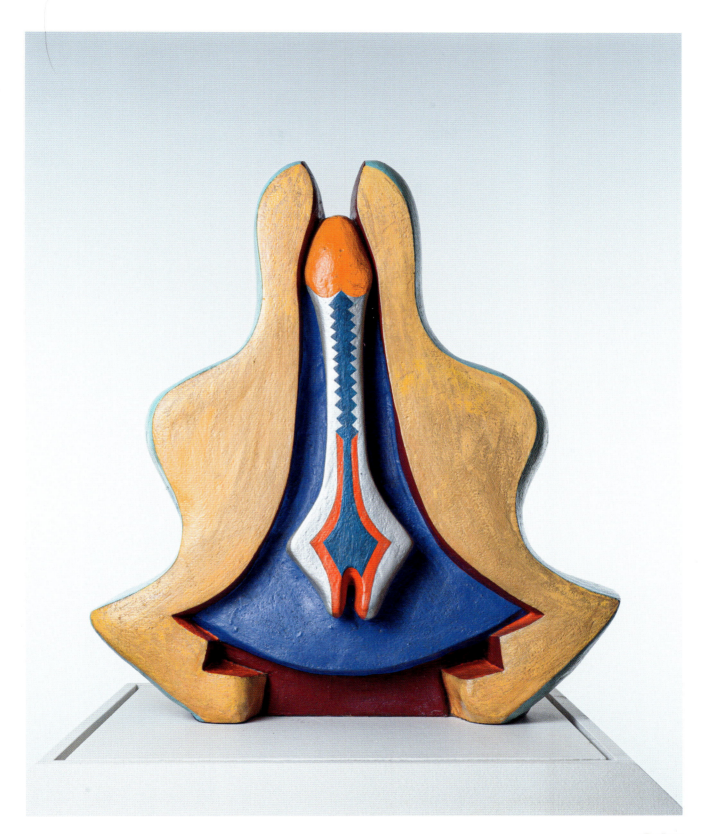

Appendix

Authors

Nathan Abrams is Professor of Film at Bangor University and Executive Director of the Centre for Film, Television and Screen Studies. He is also co-founder of the British Jewish Contemporary Cultures Network and the international journal *Jewish Film and New Media.* He lectures, writes, and broadcasts widely on British and American popular culture, film history, and intellectual culture.

Rainer Herrn worked as a medical historian at the Institute for the History of Medicine and Ethics in Medicine at Charité Berlin until 2023 and has been working at the Research Center for the History of Sexual Science at the Magnus Hirschfeld Society since 1990. His research topics include the establishment, functions, and practices of sexology and psychiatry as ways of interpreting and dealing with psychological, gender, and sexual diversity in urban modernity.

Ronit Irshai is Associate Professor and head of the gender studies department at Bar Ilan University in Israel and research fellow at the Shalom Hartman Institute in Jerusalem. She published a series of articles on halakhah (Jewish law), theology and gender, Jewish sexual ethics, and Jewish religious feminism. Her first book *Fertility and Jewish Law: Feminist Perspectives on Orthodox Responsa Literature* was published by Brandeis University Press in 2012. Her second book on abortion was published in Hebrew by Magness Press in 2022. *Holy Rebellion* (together with Tanya Zion-Waldoks) on modern Orthodox feminism in Israel will be published by Brandeis University Press in spring 2024.

Gail Levin is Distinguished Professor of Art History, Fine & Performing Arts, American Studies, and Women's Studies at Baruch College and the Graduate Center of the City University of New York. Her frequent focus on women artists and Jewish Studies led to biographies of Judy Chicago and Lee Krasner and a major study of Theresa Bernstein.

Evyatar Marienberg is Professor in the Department of Religious Studies at the University of North Carolina at Chapel Hill. He is a historian of religions, having a particular focus on the study of beliefs and practices of lay Jews and Christians from various periods. Dealing with more than one religious culture, regardless of whether a comparison is intended or not, is an important part of his research.

Jay Michaelson is a fellow at American Jewish University. His 2022 book *The Heresy of Jacob Frank: From Jewish Messianism to Esoteric Myth* won the National Jewish Book Award for Scholarship. Michaelson holds a PhD in Jewish Thought from Hebrew University, a JD from Yale Law School, and nondenominational rabbinic ordination. He has written widely on the intersections of Kabbalah, hermeneutics, and queer theology. His most recent book is *The Secret That Is Not a Secret,* a collection of ten interlocking tales of mysticism, queerness, and magic.

Ilana Pardes is the Katharine Cornell Professor of Comparative Literature at the Hebrew University of Jerusalem and the Director of the Center for Literary Studies and of the Institute of Literatures. She has taught at Princeton University, UC Berkeley, and Harvard. During the fall of 2009 she was a fellow at the Katz Center for Advanced Judaic

Studies at Penn and in fall 2017 she was a fellow at the Humanities Council at Princeton University. Her work focuses on the nexus of the Bible, literature, and culture, as well as on questions of gender, aesthetics, and hermeneutics.

Ilka Quindeau is a practitioning psychoanalyst and Professor of Clinical Psychology and Psychoanalysis at the Frankfurt University of Applied Sciences. She is currently working at the Center for Research on Antisemitism at TU Berlin. From 2018 to 2020 she was President of the International Psychoanalytic University in Berlin. Her research focuses on gender, biography and trauma research, the genealogy of sexuality, and the consequences of National Socialism.

Michal Raucher is Associate Professor of Jewish Studies at Rutgers, The State University of New Jersey. Her research lies at the intersection of the anthropology of women in Judaism, reproductive ethics, and religious authority. Raucher's first book, an ethnography of Israeli ultra-Orthodox Jewish women's reproductive ethics, titled, *Conceiving Agency: Reproductive Authority among Haredi Women,* was published by Indiana University Press in 2020.

Talli Yehuda Rosenbaum is an individual and couples therapist and certified sex therapist and supervisor in Israel. Her research addresses the psychosocial and cultural aspects of sexuality and relationships as well as the intersection of trauma with intimacy and sexuality. In the podcast *Intimate Judaism,* Talli Rosenbaum and Rabbi Scott Kahn explore a wide range of questions around lived sexuality in harmony with the Torah and halakhah.

David Sperber is an art historian, curator, and art critic. In 2018/19 he was a Postdoctoral Associate at the Institute of Sacred Music, Yale University, and taught there in the art history department. He also served as a David Hartman Center for Intellectual Leadership research fellow at the Shalom Hartman Institute, Jerusalem, and was the head of the Curatorial Studies Program at the Schechter Institutes, Jerusalem. Currently, he is a student in the Israeli Rabbinical Studies Program at the Hebrew Union College, Jerusalem. In 2012, he co-curated the international exhibition *Matronita: Jewish Feminist Art* at the Mishkan Le'Omanut, Museum of Art, Ein Harod in Israel.

Gil Yefman was born in Kibbutz Ramat Yohanan, Israel, graduated from Bezalel Academy for Art and Design, Jerusalem, in 2003, and received a two-year fellowship at the Alma program for Jewish culture studies as well as numerous residency programs. Yefman is the 2017 Rappaport Prize laureate for young Israeli artists, and was awarded The Young Artist Prize by the Israeli Ministry of Culture and Science, 2010. Yefman currently lives and works in Tel Aviv.

Index of Exhibited Works

|B| Presentation in Berlin
|BA| Presentation in Berlin and Amsterdam
|A| Presentation in Amsterdam

The order of the objects corresponds to the presentation at the Jewish Museum Berlin.

1. Procreation and Pleasure

1.1 COUPLES

Eran and I (Midlife Series) |BA|
Elinor Carucci (b. 1971)
New York, 2016
Exhibition print
57 × 85.5 cm
Courtesy of the artist, Edwynn Houk Gallery

Meine Eltern I |BA|
Issai Kulvianski (1892–1970)
Berlin, 1925
Oil on canvas
150 × 125 cm
BG-M 0093/75
Berlinische Galerie – State Museum of Modern Art, Photography and Architecture

Joodse Bruiloft |B|
Jozef Israëls (1824–1911)
The Hague, 1903
Oil on canvas
137 × 148 cm
MB01835
Jewish Museum, Amsterdam. Loan from Rijksmuseum, Amsterdam, Gift from Mr. and Mrs. Drucker-Fraser Montreux
→ p. 42

A Jewish Wedding |BA|
Yitzchak Woolf (b. 1975)
Jerusalem, 2008
Exhibition print
80 × 86 cm
Courtesy of the artist
→ p. 43

Adam und Eva mit ihrem Erstgeborenen |BA|
Lesser Ury (1861–1931)
Berlin, 1896
Oil on canvas
86.4 × 124.1 × 2.1 cm
2001/227/0
Jewish Museum Berlin, photo: Jens Ziehe
→ p. 41

Coffee Service Given as Wedding Gift |BA|
Staffordshire, England, 1769
Stoneware
Ø 34.3 cm (tablet)
22.9 × 20.3 × 11.4 cm (coffee pot)
14 × 10.2 cm (jug)
7 × 14.6 cm (sugar jar)
6.4 × 10.2 cm (waste container)
JM 26-59a-e
The Jewish Museum, New York
Gift of the Felix M. and Frieda Schiff Warburg Foundation
→ p. 47

Roman Marriage Contract |B|
Rome, 1763
Parchment, ink
84 × 46.5 cm
BCK44
Braginsky Collection, Zurich, Switzerland, photo: Ardon Bar-Hama, Ra'anana, Israel
→ p. 48

A Recontextualized Ketubbah |BA|
Gay Block (b. 1942),
Malka Drucker (b. 1945)
USA, 1994
Exhibition copy
59.7 × 46.5 cm
1994-58
The Jewish Museum, New York, courtesy of the artists
→ p. 49

Brit Ahuvim |BA|
Producer: Ketubata
Israel, 2023
Graphic watercolor print
50.6 × 50.6 cm
Jewish Museum Berlin, photo: Roman März
→ p. 46

Ketubbah for Samuel Senior Teixeira and Rachel de Mattos Senior |A|
Hamburg, 1690
Ink and paint on parchment
60.6 × 54.0 cm
M010382
Jewish Museum, Amsterdam

Ketubbah with Image of the Bridal Chamber |A|
Padua, 1750–1828
Ink and paint on parchment
78.6 × 53.2 cm
76
Braginsky Collection, Zurich, photo: Ardon Bar-Hama, Ra'anana, Israel
→ pp. 44–45

Wedding Ring |A|
Italy (possibly Venice),
19th century
Gold and enamel
M005751
Jewish Museum, Amsterdam

1.2 CHILDREN

Bag with Earth |BA|
Israel, before 1980
Textile, soil
5 × 18.5 × 5 cm
M002185
Jewish Museum, Amsterdam

Glass for the Bride |BA|
Austria-Hungary, ca. 1790
Glass
12 × Ø 8 cm
8007
Jewish Museum Vienna
→ p. 52

Fertility Figurine |B|
Syria, Bronze Age
Terracotta
12.8 cm
MAA3908
National Maritime Museum, Haifa
→ p. 50

Body Piece I |B|
Guy Aon (b. 1986)
Tel Aviv, 2021
150 × 100 cm
Courtesy of the artist

Be Fruitful and Multiply |BA|
Andi LaVine Arnovitz
(b. 1959)
Jerusalem, 2019
Paper, watercolor, textile
103 × 77.5 × 7 cm
Courtesy of the artist
© Andi Arnovitz, photo: Issac Fisch
→ p. 53

Incantation Bowl |B|
Mesopotamia, ca. year 0
Clay
6 × Ø 15 cm
HS 3034
Friedrich Schiller University Jena | Hilprecht Collection

Incantation Bowl with Image of a Demon |A|
Mesopotamia, 6th–7th century
Pottery
11 × 21 cm
6266/6267 - JIB 3
Collection of Dr. David and Jemima Jeselsohn, Zurich

Recipes for Love |BA|
Found in Cairo, before 1899
Paper
17.4 × 26 cm
T-S K1.132
Cambridge University Library; reproduction with kind permission of the Syndics of Cambridge University Library
→ p. 51

Cloth for Newborn |BA|
Niva Sharon (b. 1944)
New York, 2011
Textile, plastic, metal
112 × 112 cm
Collection of Mayanne Sion, Switzerland

Gräfenberg Rings |BA|
Ernst Gräfenberg
(1881–1957)
1925–1935
Gold, silver alloy
1866
Museum for Contraception and Abortion, Vienna
→ p. 52

Reproductive Freedom Kit |BA|
National Council of Jewish Women
USA, 2022
Magnet, paper, plastic, wax, spices
Jewish Museum Berlin, photo: Roman März
→ p. 54

Emma Goldman in Union Square |BA|
Unknown photographer
New York, 1916
Reproduction
26 × 21 cm
Pictorial Press Ltd, Alamy Stock Photo

One Family |BA|
Vardi Kahana (b. 1959)
1993–2007
Courtesy of the artist

From the series:
Grandchild of cousin Hannan
Kiryat Sefer, Modiin Ilit, Israel, 2005

Grandchild of cousin Shmuel
Copenhagen, Denmark, 2004

Barak family: Cousin Libi with husband Naftali and their ten children: Yair, Asher, Hagit, Tehila, David, Netanel, Hillel, Shilo, Rachel, and Yinon
Petach Tikva, Israel, 1993

Moria, daughter of cousin Yaki, with husband Amikam
Southern highlands of Hebron, West Bank, 2004

Cousin Rina with her daughters
Groningen, Netherlands, 2004

Shmulik, son of cousin Miki, with his wife Daphna and their children Michaela and Adam
Neve Tsedek, Tel Aviv, Israel, 2005

Ayelet, daughter of cousin Yaki, with husband Eliyahu and their children Tehila, Shahar, Maoz, Tal, and Avraham
Susiya, West Bank, 2004

Ari, son of cousin Shmuel, with wife Hagit and son Noam
Copenhagen, Denmark, 2004

Rachel, cousin Hannan's daughter with husband Yehuda and their children Nechama and Zvi
Kiryat Sefer, Modiin Ilit, Israel, 2005

Cousin Benny's grandchildren in a leaf hut, the sukkah
Bnei Brak, Israel, 2003

Cousin Alik with his wife, cousin Atara, and their children Noa, Itai, Maya, and Neta
Moshav Chagor, Israel, 2005

Yael, daughter of cousin Erela, with husband Eldar and their children Hadas, Ofer, and Amit
Kibbutz Kabri, Israel, 2007

Yehuda, son of cousin Eta, with his wife Rinat and their children Uri, Hallel, and Adi
Alonei Habashan
Golan Heights, 2007

My mother Rivka and my children Gil and Roni
Studio of the artist, 2003

Adam en Eve |A|
Eli Content (1943–2022)
Amsterdam, 2018
Acrylic on canvas
75 × 166 cm
M015665-b
Jewish Museum, Amsterdam.
Courtesy of Peter Cox
© Heirs of Eli Content, photo: Peter Cox
Purchased with the support of Vrienden-Loterij (formerly BankGiro Loterij)
→ p. 55

1.3 LUST

Yentl |BA|
Director, co-writer, producer, leading role:
Barbra Streisand (b. 1942)
USA, 1983
Film, approx. 1 min.
Yentl © 1983 Ladbroke Entertainments Limited. All Rights Reserved.
Courtesy of MGM Media Licensing
photo: picture alliance/United Archives / IFTN
→ p. 56

The Honeymoon Suite |BA|
Director: Sam Leifer (b. 1980)
UK, 2010
Film, 2:33 min.
Rise Films
→ p. 56

Untitled (from the series Divine Connection) |BA|
Benyamin Reich (b. 1976)
Mea Shearim, Jerusalem, 2005
Photo
110 × 110 cm
Courtesy of the artist

Signs of Time (Midlife Series) |BA|
Elinor Carucci (b. 1971)
New York, 2017
Exhibition print

207

57 × 85.5 cm
Courtesy of the artist,
Edwynn Houk Gallery
→ p. 57

It Is So |B|
Nicole Eisenman (b. 1965)
USA, 2014
Oil on canvas
165 × 208 cm
EISENNI14.05
Hall Collection
© Nicole Eisenman
→ p. 58

Hold (Erotic Series) |B|
Joan Semmel (b. 1932)
New York, 1972
Oil on canvas
173 × 244.8 × 3.2 cm
Lent by the Minneapolis Institute of Art, Gift of Mary and Bob Mersky
© VG Bild-Kunst, Bonn, 2024
→ p. 59

WaterSlyde™ |BA|
Maureen Pollack (b. 1985)
The Pleasure Parlor
USA, 2014
Plastic, textile
39 × 17 × 6 cm
Jewish Museum Berlin,
photo: Roman März
→ p. 60

Dr. Ruth's Game of Good Sex |BA|
Ruth Westheimer (b. 1928)
Victory Games Inc.,
New York, 1985
Cardboard, wood, plastic
29 × 21 × 5.5 cm
Jewish Museum Berlin,
photo: Roman März
→ p. 61

The Feminine Mystique |B|
Betty Friedan (1921–2006)
Penguin Books, USA, 2010
Jewish Museum Berlin

Iggeret ha-Kodesh |BA|
Editor: Seymour J. Cohen
Ktav Publishing House Inc.,
New York, 1976
Jewish Museum Berlin

*The Marriage Covenant:
A Guide to Jewish
Marriage* |B|
Rabbi Elyashiv Knohl
(1948–2018)
Leshmon Limudim Ltd.,
Israel, 2021
Jewish Museum Berlin

*The Newlywed's Guide to
Physical Intimacy* |BA|
David S. Ribner, Jennie
Rosenfeld
Gefen Publishing House,
Jerusalem, 2011
Jewish Museum Berlin

Ecstasy |BA|
Director: Gustav Machatý
(1901–1963)
Actress: Hedy Lamarr
(1914–2000)
Czechoslovakia, 1933
Film, 2:06 min.
Thomas Sessler Verlag

Tumtum |BA|
Gil Yefman (born 1979)
Installation, 2023
Yarn, textiles, knitting
300 × 200 × 200 cm
USA, Ron Feldman Gallery, NYC,
© Gil Yelman
Supported by Artis (www.artis.art),
and Asylum Arts at The Neighborhood, photo: Elad Sarig
→ p. 62

2. Desire and Control

2.1 SEPARATION

PMS |BA|
Elinor Carucci (b. 1971)
New York, 1997
Exhibition print
40 × 58 cm
Courtesy of the artist, Edwynn Houk Gallery
→ p. 91

Five Plus Seven |BA|
Hagit Molgan (b. 1972)
Kibbuz Saad and Kibbuz
Beeri, Israel, 2001
Film, 2:25 min.
Courtesy of the artist

Bridal Casket |BA|
North of Italy, second
half of the 15th century
Silver
6.6 × 13 × 6 cm
B 51.04.0207, 131/030
The Israel Museum, Jerusalem; gifted by Astorre Mayer, Milan
Photo © Israel Museum, Jerusalem,
by Laura Lachman
→ p. 96

He Loves Me |BA|
Andi LaVine Arnovitz
(b. 1959)
Israel, 2011
Paper, textile
25 × 25 cm (opened)
Courtesy of the artist

Siman Heker |B|
Ken Goldman (b. 1960)
Israel, 2012
Paper, metal
24 × 50 × 20 cm
Courtesy of the artist

A Hedge of Roses |B|
Norman Lamm (1927–2020)
First published 1966
Philip Feldheim Inc., USA,
Feldheim Publishers, 1987
Jüdisches Museum Berlin

Incantation Bowl |B|
Mesopotamia, after 200 CE
Clay
6 × Ø 14.9 cm
VA 2452

Staatliche Museen zu Berlin, Vorderasiatisches Museum; photo: Olaf M.
Teßmer; CC-BY-SA 4.0
→ p. 97

Mikvah Model |B|
Jerusalem, beginning of
the 20th century
Plaster
16.8 × 13.2 × 7.3 cm
184
Jewish Museum Vienna

*Mikva Dreams:
Hudson River* |BA|
Mierle Laderman Ukeles
(b. 1939)
New York, 1978
Performance photography:
Deborah Freedman
60 × 78.6 cm
© Mierle Laderman Ukeles. Courtesy of the artist and Ronald Feldman Gallery, New York
→ pp. 94–95

Kit for Tevilah |BA|
Inbar Erez (b. 1994)
Israel, 2020
Draft drawing
Inbar Erez, supervised by Eran Lederman, Bezalel Academy of Arts and Design
→ pp. 92–93

*Seder Birkat ha-Mazon
(Grace after Meals) and
Other Prayers and Blessings* |A|
Possibly Aaron Wolf
Herlingen (ca. 1700–1757)
Deutschkreutz, 1751
Ink and watercolor on
parchment
9.5 × 5.2 cm
217
Braginsky Collection, Zurich

208

2.2 TEMPTATION

Kitzur Schulchan Aruch |B|
Josef Karo (1488–1575),
Schelomo Ganzfried
(1804–1886)
Translation: Selig Bamberger
(1872–1936)
Victor Goldschmidt Verlag,
Basel, ca. 1970
Jewish Museum Berlin

Mishneh Torah |B|
Moses Maimonindes
(d. 1204)
Editor: Leon Nemoy
(1901–1997)
Volume 5, Yale Judaica
Series 16
Yale University Press, USA,
1965
Jewish Museum Berlin

Thumb Ring |BA|
Amsterdam, 1700–1850
Silver
3.7 × 2.1 cm
MB02189
Jewish Museum, Amsterdam.
Loan from Bibliotheca Rosenthaliana,
Allard Pierson, University of
Amsterdam
→ p. 98

Sacred Sperm |BA|
Director: Ori Gruder (b. 1970)
Israel, 2014
Film, 1:15 min.
Courtesy of Go2Films

Magen (Jewish Cut) |BA|
Ken Goldman (b. 1960)
Kibbutz Shluchot, Israel,
2015
Reproduction
184 × 145 cm
Courtesy of the artist
→ p. 99

Tallit Katan |B|
Bnei Brak, Israel, 2001
Wool, cotton, synthetic
textile
48 × 40 cm
Jewish Museum Berlin

Gartl |B|
Chacham Judaica
Ashdod, Israel, 2023
Textile
315 × 5 cm
Jewish Museum Berlin

Gartl |A|
1990–2010
Textile
315 × 5 cm
M012850
Jewish Museum, Amsterdam

Tallit Katan |A|
1990–2013
Wool, textile
60 × 140 cm
M012849
Jewish Museum, Amsterdam

Please Do Not Pass in Immodest Clothes |BA|
Israel, before 2021
Textile
40 × 178 cm
Jewish Museum Berlin,
photo: Roman März
→ pp. 102/103

Unorthodox |BA|
Zoya Cherkassky-Nnadi
(b. 1976)
Israel, 2020
Felt marker on paper
18.5 × 27.5 cm
Haya Heichal
→ p. 106

I'm With Stupid |B|
Nicole Eisenman (b. 1965)
USA, 2001
Oil on canvas
129.5 × 99 cm
EISENNI06.04
© Nicole Eisenman, Hall Collection
→ p. 104

Friday Water Series |BA|
Benyamin Reich (b. 1976)
Lifta, Israel 2004–2006
Photographs
Courtesy of the artist
From the series:

Untitled, 2004
35 × 35 cm

Untitled, 2005
35 × 35 cm
→ p. 101

Untitled, 2006
230 × 160 cm

Untitled, 2006
35 × 35 cm

Monish |BA|
Jizchak Leib Peretz
(1851–1915)
Pinchas Shaar (1923–1996)
JOINT, Paris, 1952
Courtesy of the David Mazower
Collection
→ p. 105

Moses Maimonides' Halakhic Codex Mishneh Torah |A|
Immanuel Athias
(ca. 1664–1714)
Amsterdam, 1702
Printed book
EH 1 A 19
Ets Haim – Livraria Montezinos,
Amsterdam

Yosef Karo's Code of Jewish Law Shulkhan Arukh, Section 3 |A|
Joseph Athias
(ca. 1635–1700)
Amsterdam, 1697
Printed book
ROK A-83
Bibliotheca Rosenthaliana, Allard
Pierson, Universiteit van Amsterdam

2.3 NEW DIRECTIONS

Holy |BA|
Dorothea Moerman (b. 1998)
Oakland, California, USA,
2023
Linoprint
22.86 × 30.48 cm
Courtesy of the artist
→ p. 107

Feygeles |BA|
Shterna Goldbloom (b. 1992)
USA, 2019
Paper
32 × 40 cm
Courtesy of the artist

#DafReactions |BA|
Miriam Anzovin (b. 1985)
Videos, 3:48 min.,
2:44 min., 3:18 min.
USA, 2021–2022
Courtesy of the artist
→ p. 113

Poetry Fragment from the Tahkemoni |BA|
Judah b. Solomon Al-Harizi
(1166–1225)
Spain, 13th century
Paper
13.8 × 12 cm
Cambridge University Library

Wrestling with Leviticus |BA|
Susan Kaplow (b. 1943)
New York, 2012
Exhibition print
61 × 86 cm
Courtesy of the artist.
No reproduction without express
permission from Susan Kaplow.
→ p. 111

Sefer Nashim |BA|
Nechama Golan (b. 1947)
Israel, 2000
Exhibition print
54 × 74 cm
Courtesy of the artist
→ p. 110

The Scourge |BA|
 The Grave
 Teeth
 The Other World
 Her Other Face
 That Place
 Her Stare
 Her Breath
Gabriella Boros (b. 1961)
Skokie, Illinois, USA, 2023
Latex
each 38 × 14 × 14 cm
Courtesy of the artist,
photo: Jack Kraig
→ p. 109

209

Chewing Gum Sculpture |B|
Hannah Wilke (1940–1993)
USA, ca. 1975
Chewing gum, plexiglas box
6 × 6 × 2 cm
WILKEHA11.01
© Marsie, Emanuelle, Damon, and Andrew Scharlatt, Hannah Wilke Collection & Archive Los Angeles / Hall Collection. Courtesy Hall Art Foundation. Photo: Adam Reich
© VG Bild-Kunst, Bonn, 2024
→ p. 108

That Place |BA|
Naama Snitkoff-Lotan (b. 1984)
Israel, 2013
Mixed media
13 × 13 cm
Courtesy of the artist
→ p. 108

Kippot of the Jewish LGBTQ+ Community Germany |B|
Keshet Deutschland e.V.
New York City, July 2021
Textile
Ø 23 cm
Tadeo "Akiva" Berjón and Gustavo Thomas,
photo: Roman März
→ p. 100

Promotional Photo for Sjalhomo |A|
Jenny E. Wesly (1948–2016)
Amsterdam, 1980–1990
Photograph
25.3 × 20.3 cm
M013645
Jewish Museum, Amsterdam
→ p. 112

3. Sexuality and Power

3.1 TABOO

Lot and His Daughters |BA|
Abraham Lozoff (1887–1936)
England, 1926
Wood
109 × 43 × 45 cm
1987-261
Ben Uri Collection. Presented by Lord Sieff 1936
© Ben Uri Collection / Bridgeman Images
→ p. 147

Ruth et Boaz |BA|
Marek Szwarc (1892–1958)
Paris, ca. 1920
Bronze
39 × 68.5 × 3.5 cm
Musée d'art et d'histoire du Judaïsme, Paris, photo: © mahJ / Niels Forg;
© VG Bild-Kunst, Bonn, 2024
→ p. 145

King David and Bathsheba |BA|
Meir Gur-Arie (1891–1951), after E. M. Lilien (1874–1925)
Bezalel School of Arts and Crafts, Jerusalem
1913–1929
Plaster
8.1 × 12.4 × 1.63 cm
B09.1146 and 174/271
The Israel Museum, Jerusalem; The Alan and Riva Slifka Collection in the Israel Museum

Everything Forbidden Is Sought After |BA|
Lenore Mizrachi-Cohen (b. 1990)
USA, 2016
Exhibition print
101.6 × 68.8 cm
Courtesy of the artist

Eat Your Power, Honey, Before It Grows Cold |B|
Anita Steckel (1930–2012)
USA, ca. 1970–1972
Oil and screen print on canvas
160 × 251.3 × 7.4 cm
© Estate of Anita Steckel. Courtesy of the Estate of Anita Steckel, Ortuzar Projects, New York, and Hannah Hoffman, Los Angeles, photo: Paul Salveson
→ pp. 142/143

The Stained Portfolio by Justine Frank |BA|
nos. 45, 46, 56, 60, 62–64, 80, 81
1927–1928
Roee Rosen (b. 1963)
Israel, 1998/2001
Gouache and pencil on paper
38 × 33 cm
Courtesy of the artist and Rosenfeld Gallery, Tel Aviv
Private collection, Paris
→ p. 148

Sweet Sweat |BA|
Justine Frank and
Roee Rosen (b. 1963)
Sternberg Press, Antwerp, 2009
First published in Hebrew: Babel Publishing House, 2001
Jewish Museum Berlin

Lesbian Kiss |BA|
Shayna Schmidt and Melissa Weisz
Ronald L. Glassman (b. 1955)
New Yiddish Rep, USA, 2017
Exhibition print
30 × 42 cm
Photo: Ronald L. Glassman
→ p. 141

Pijpelijntjes |BA|
Jacob Israel De Haan (1881–1924)
Editor: Jacq. van Cleef, Amsterdam, 1904
560Haan k
Jewish Museum, Amsterdam

Untitled (coins, torso) |B|
Lee Lozano (1930–1999)
USA, ca. 1962
Graphite, chalk, paper
23 × 24 cm
Hall Collection

Portrait d'Annie, Homosexuel, Putain Juive |B|
Stéphane Mandelbaum (1961–1986)
Brussels, 1985
Graphite on paper
149 × 114 × 1.5 cm
Private collection

Stalag 217 |BA|
Victor Bolder
2nd Edition
Israel, 1961
Jewish Museum Berlin,
photo: Roman März
→ p. 146

Stalags: Holocaust and Pornography in Israel |BA|
Ari Libsker (b. 1972)
Israel, 2008
Film, 1:18 min.
Courtesy of Heymann Brothers Films

The House of Dolls |B|
K. Tzetnik 135633 (1909–2001)
Granada Publishing Limited, UK, 1973
Jewish Museum Berlin

Immigrant's NO Suitcase (Anti-Pop) |B|
Boris Lurie (1924–2008)
New York, 1963
Assemblage: acrylic, paper collage, and fabric on suitcase
63.5 × 78.74 × 33.2 cm
BLAF 1239
Boris Lurie Art Foundation
→ p. 144

Picture Postcard of the Maison Weinthal Brothel Protesting the New Police Ordinance |A|
Amsterdam, ca. 1900
Printed paper
9 × 14 cm
F002938
Jewish Museum, Amsterdam; Collection of J. van Velzen
→ p. 147

3.2 SEXOLOGY

What's My Perversion?
from Everything You Wanted to Know About Sex |BA|
Woody Allen (b. 1935)
USA, 1972
Film, approx. 1 min.
© Metro-Goldwyn-Mayer Studios Inc. All Rights Reserved. Courtesy of MGM Media Licensing
Jewish Museum Berlin

Love Between Women |B|
Charlotte Wolff (1897–1988)
Harper Colophon Books,
USA, 1972
Jewish Museum Berlin

Aus eines Mannes Mädchenjahren (Memoirs of a Man's Maiden Years) |BA|
N.O. Body/Karl M. Baer (1885–1956)
Editor: Hermann Simon
Berlin, 2022
First published Germany 1907
© 2022 Hentrich & Hentrich Verlag Berlin Leipzig
Jewish Museum Berlin

Felix Abraham in Conversation |B|
Berlin, 1929
Photograph
2013/417/104
Keystone View Company, NY/Berlin
Jewish Museum Berlin – Gifted by Anne Marx in loving memory of her husband Carl Theodore
→ p. 152

Was soll das Volk vom dritten Geschlecht wissen? (What Should People Know about the Third Sex?) |B|
Wissenschaftlich-Humanitäres Komitee
Verlag Max Spohr, Leipzig, 1903
Magnus-Hirschfeld-Gesellschaft e.V., Forschungsstelle zur Geschichte der Sexualwissenschaft, Berlin

Anders als die Andern (Different from the Others) |BA|
Richard Oswald (1880–1963)
Germany, 1919
Film, 1 min.
Filmmuseum München / Edition Filmmuseum
→ p. 151

Figurine of Youthful Eros |BA|
Myrina, Asia Minor, around the turn of the millenium
Terracotta
42.2 × 17.5 × 16.8 cm
3880
On loan from the Freud Museum London

Lekythos with Oedipus and the Sphinx |BA|
Copy of an original from 550
15 × 5 × 5 cm
LDFRD 4425
On loan from the Freud Museum London © Freud Museum London
→ p. 149

Box with Penis Prostheses |BA|
Japan, before 1928
Jade, horn, metal, wood
6 × 22 × 15.5 cm
Magnus-Hirschfeld-Gesellschaft e.V., Forschungsstelle zur Geschichte der Sexualwissenschaft, Berlin
Photo: Jewish Museum Berlin, Jens Ziehe
→ p. 153

Sexologist Herman Musaph Examining a Patient |A|
Photographer unknown
ca. 1953
Photograph
19 × 20 cm
F007100
Jewish Museum, Amsterdam
→ p. 150

3.3 IDENTITIES

I Am in Training Don't Kiss Me |BA|
Claude Cahun (1894–1954)
France (presumed), 1927
Exhibition print
53 × 40 cm
Courtesy of Jersey Heritage
→ p. 154

Gluck |BA|
Howard Coster (1885–1959)
England, 1926
Exhibition print
90 × 65.7 cm
Courtesy of The Fine Art Society Ltd.
→ p. 155

First Time Naked |BA|
Roey Victoria Heifetz (b. 1978)
Berlin, 2021
Graphite, ink, coal, paper
180 × 50 cm
Courtesy of the artist,
photo: Andrea Rossetti
→ p. 161

Body Piece II |B|
Guy Aon (b. 1986)
Tel Aviv, Israel, 2021
Exhibition print
120 × 94.5 cm
Courtesy of the artist
→ p. 160

Synagogo Hat |BA|
Gilbert Block (1944–2010)
San Francisco, undated
Cardboard, rhinestones, glass, textile
13.34 × 20.96 × 20.96 cm
Courtesy GLBT Historical Society, photo: Jeff Raby
→ p. 163

Thank God I'm Gay |BA|
Jean-Baptiste Carhaix (1946–2023)
San Francisco, 1983
Exhibition print
47.7 × 30 cm
Jean-Baptiste Carhaix papers (2019–39), Courtesy of Gay, Lesbian, Bisexual, Transgender Historical Society
→ p. 162

Goldie: A Neurotic Woman |BA|
Wimmen's Comix #1
Aline Kominsky-Crumb (1948–2022)
Last Gasp-Eco Funnies Inc., California, USA, 1972
Jewish Museum Berlin

Radical Cheek |BA|
Miriam Margolyes in *Vogue* (UK)
Photographer: Tim Walker (b. 1970)
British Vogue, 2023
Condé Nast 1909,
New York
Jewish Museum Berlin

The Last of the Red Hot Mamas: Sophie Tucker's Greatest Hits |BA|
Sophie Tucker (1887–1966)
USA, 1983
℗ CBS Records
31.5 × 31.5 cm
Jewish Museum Berlin,
photo: Roman März
→ p. 165

Lilith Magazine |BA|
Lilith Publications Inc., USA, 1976–2022
Jewish Museum, Amsterdam
Jewish Museum Berlin

Lilith |BA|
from the *Finding Home* series #80 (Fereshteh)
Siona Benjamin (b. 1960)
USA, 2006
Gouache, gold leaf, wood
119 × 66.04 cm
Courtesy of the artist
→ p. 164

Maalal |BA|
Halil Balabin (b. 1987)
Merav Kamel (b. 1988)
Israel, 2016
Oil pastels, gouache, ink, paper
210 × 250 cm (15 pcs, each 50 × 70 cm)
Courtesy of the artists

The Tenth Commandment |BA|
Shraga Weil (1918–2009)
Hungary (presumed), 1946
Reproduction
29.7 × 21 cm
Hashomer Hatzair Archives, Yad Yaari Research and Documentation Center
→ p. 156

Let Me Work! |BA|
Palestine, 1930s
Reproduction
58.1 × 50 cm
Central Zionist Archives, Jerusalem
→ p. 157

211

Orthodox Eros |BA|
G. L. H. (b. 1976)
Israel, 2010
Exhibition print
50 × 50 cm

Courtesy of the artist
→ p. 158

Untitled (Soliders Series) |A|
Adi Nes (b. 1966)
Israel, 1996
Photograph
90 × 90 cm

Courtesy of Adi Nes &
Praz-Delavallade Paris, Los Angeles
→ p. 159

4. Eroticism and the Divine

4.1 HOLY SEX

Nose to Nose |BA|
(Los Angeles series #24)
R. B. Kitaj
(1932–2007)
Los Angeles, 2003
Oil on canvas
121.9 × 121.9 cm

Courtesy of Piano Nobile, London
© R. B. Kitaj Estate, courtesy Piano Nobile, London
→ p. 189

Scroll with Kabbalistic Amulets and Texts – Ilan
Ink on parchment |A|
ca. 51 × 28.6 cm
18th century
Reproduction |B|

EH 47 E 53
Ets Haim – Livraria Montezinos, Amsterdam, photo: Ardon Bar-Hama, Israel
→ p. 185

Allegorical Marriage Contract for Shavuot |B|
Gibraltar (presumed),
1830–1840
Ink on parchment
69.3 × 59.2 cm

BCK 26
Braginsky Collection, Zurich, Switzerland, photo: Ardon Bar-Hama, Israel
→ p. 191

Kosher Sex |BA|
Illustration: Vivienne Flesher
Playboy magazine
PLBY Group, Inc., formerly Playboy Enterprises, 1999

Jewish Museum Berlin, photo: Roman März
→ p. 188

Shabbat Sex Positions to Get Your Double Mitzvah On |BA|
 Challah Back Girl → p. 187
 The Shekinah
 The Digital Detox
 The Easy Rester
Melissa Cetlin (b. 1988)
Digital drawings

Melissa Cetlin, a special project for At The Well, 2017

Mitzvah Night I (Installation Photo) |A|
Ruth Schreiber (b. 1947)
2020 (installation 2011)
Photograph

Courtesy of David and Ruth Schreiber
→ p. 186

4.2 DEVOTION

Carrying the Scrolls of the Law |BA|
Simeon Solomon (1840–1905)
England, 1867
Watercolor, gouache, paper, canvas
35.7 × 25.5 cm

D.1919.8
The Whitworth, The University of Manchester
Photo: Whitworth Art Gallery / Bridgeman Images
→ p. 193

Untitled (Species) |BA|
Leor Grady (b. 1966)
Israel, 2019
Exhibition Print
103 × 124 cm

Courtesy of the artist
→ pp. 196/197

Touching Mezuzah |BA|
Sari Srulovitch (b. 1964)
Jerusalem, 2011
Silver

2011/158/1
Jewish Museum Berlin, Gift of the Artist, photo: Roman März
→ p. 190

Yona Wallach |BA|
Micha Kirshner
(1947–2017)
Israel, 1982
Photograph
34 × 52 cm

Courtesy of Micha Kirshner Photography Archive
→ p. 195

Tefillin Schel Jad (Judaica Series) |BA|
Benyamin Reich (b. 1976)
2005
Inkjet print
100 × 100 cm

2011/288/5
Jewish Museum Berlin
→ p. 192

Undergarments |BA|
Dorothea Moerman (b. 1989)
Oakland, California, USA,
2017–2019
Textile

Courtesy of the artist

Mystical Marriage Contract |A|
Samuel ben Itzig
1855
Ink on paper
39 × 49 cm

Slg. IKG, 16371
Jewish Museum Vienna / Jüdisches Museum der Stadt Wien

4.3 SONG OF SONGS

Voices from the Song of Songs |BA|
 Yes I am black and radiant
 → p. 200
 Come let us go out into the fields
 My Dove in the clefts of the rock → p. 200
 How fine you are, my love
 There you stand like a palm → p. 200
 for your scents
Judy Chicago (b. 1939)
New York, after 1998
Helio relief, lithograph, and hand colorings on paper
60.96 × 50.8 cm

Women's Art Collection, Murray Edwards College
Courtesy of the artist; Jeffrey Dietch, New York; and Jessica Silverman, San Francisco
© Judy Chicago/Artists Rights Society (ARS), New York, photos:
© Donald Woodman/ARS, New York
© VG Bild-Kunst, Bonn, 2024

Le Cantique des cantiques |BA|
Jacques Lipchitz (1891–1973)
London, 1946
Plaster, shellac
47 × 96.5 × 27.3 cm

T03532
Tate: Presented by the Lipchitz Foundation 1982 © The estate of Jacques Lipchitz, courtesy, Marlborough Gallery, New York
→ p. 199

212

The Song of Solomon |BA|
Illustrator: Zeev Raban
(1890–1970)
Shulammite-Publ.,
Jerusalem, ca. 1949
Paper, leather, copper
34 × 24.5 × 4 cm
BIB/139782/0
Jewish Museum Berlin,
photo: Jens Ziehe
→ p. 198

In My Mother's House |BA|
Judy Chicago (b. 1939)
USA, 1962–1964
Acryl, vitrified clay
60.96 × 45.72 × 15.24 cm
2019.002
Collection Monterey Museum of Art, Museum purchase by exchange; gift of Mr. and Mrs. Gerald Bates, Mrs. J.B. Heywood, Elizabeth George Lawlor in memory of Dorothy George Meakin, William and Renee Petersen, Mr. and Mrs. John Shephard, Mr. and Mrs. E.V. Staude, Carolyn Lewis Nielson, Albert Denney, Nancy Stillwell Easterbrook, Margaret Wentworth Owings, Naedra B. Robinson, Elizabeth Tompkins, and an anonymous donor, © VG Bild-Kunst, Bonn, 2024
→ p. 201

"Ani Yeshana"–I Sleep |BA|
Concept, music, vocals:
Victoria Hanna
Produced and arranged by:
Tamir Muskat Drum
Jerusalem, ca. 2017
Video, 3:30 min.
Courtesy of the artist

POEMS

Yehuda Amichai
(1924–2000)
We Did It
Cited from: *Yehuda Amichai: Selected Poems,* translated by Assia Gutman and Harold Schimmel, Penguin Books, 1971, page 80; courtesy of The Deborah Harris Agency, Israel.
→ p. 163

Yona Wallach (1944–1985)
Tefillin
Cited from: *Loosen the Fetters of Thy Tongue Woman: The Poetry and Poetics of Yona Wallach,* ed. Zafrira Lidovsky Cohen, Hebrew Union College Press, 2003; courtesy: Copyright Clearance Center, Inc.
→ p. 194

ILLUSTRATIONS

Illustrated Episodes from the Babylonian Talmud
Noa Snir (b. 1987)
Berlin, 2024
Jewish Museum Berlin
The quotes from the Talmud can be found here: www.sefaria.org
→ pp. 1–3; 222–224

Unless otherwise stated here, the image rights are held by the respective lenders.

Last modified March 2024

Acknowledgements

The Jewish Museum Berlin and the Jewish Museum, Amsterdam thank all lenders.

The curators of the exhibition in Berlin and Amsterdam thank for their support of the exhibition and the book project:

Fatima Akalai, Debora Antmann, Daniel Bouw, Linda Duits, Danielle Durchslag, Mirjam van Emden, Lievnath Faber, Nathan James Ford, Lisa de Goffau, Shelley Harten, Felicitas Heimann-Jelinek, Judith Hoekstra, Lody van de Kamp, Clive Kennard, Julia van der Krieke, Hannah Landsmann, Tamar Lewinsky, Dvorah Liss, Martina Lüdicke, Rachel Middleman, Daniela Pscheiden, Lorie Quint, Adam Ring, Aaron Rosen, Shai Secunda, Sivan Rajuan Shtang, Lily Snyder, Barbara Staudinger, David Studniberg, Chantal Suissa-Runne, Ta'ir Wasserman, Sharon Weiser-Ferguson, Daniela Weiss Bronstein, David Wertheim, Judith Whitlau, Sarah Whitlau, Julia Windegger, Irene Zwiep

Literature

Suggested Reading

Biale, David. *Eros and the Jews: From Biblical Israel to Contemporary America.* New York: Basic Books, 1992.

Boyarin, Daniel. *Carnal Israel: Reading Sex in Talmudic Culture.* Berkeley: University of California Press, 1993.

Dorff, Elliot/Ruttenberg, Danya, eds. *Jewish Choices, Jewish Voices: Sex and Intimacy.* Philadelphia, PA: Jewish Publication Society, 2010.

Eilberg-Schwartz, Howard. *People of the Body: Jews and Judaism from an Embodied Perspective.* Albany, NY: SUNY Press, 1992.

Epstein-Levi, Rebecca J. *When We Collide: Sex, Social Risk, and Jewish Ethics.* Bloomington, IN: Indiana University Press, 2023.

Fonrobert, Charlotte. *Menstrual Purity: Rabbinic and Christian Reconstructions of Biblical Gender.* Stanford, CA: Stanford University Press, 2000.

Gilman, Sander. *The Jew's Body.* New York: Routledge Press, 1991.

Irshai, Ronit. "Judaism (On Sexuality and Gender)." In: Adrian Thatcher, ed. *The Oxford Handbook of Theology, Sexuality and Gender.* Oxford: Oxford University Press, 2015, 413–31.

Irshai, Ronit. *Fertility and Jewish Law. Feminist Perspectives on Orthodox Responsa Literature.* Waltham, MA: Brandeis University Press, 2012.

Kirshenblatt-Gimblett, Barbara. "The Corporeal Turn." *Jewish Quarterly Review* 95 (2005), 447–61.

Marienberg, Evyatar. *Traditional Jewish Sex Guidance: A History.* Brill's Series in Jewish Studies vol. 74. Leiden/Boston: Brill, 2022.

Raucher, Michal S. *Conceiving Agency. Reproductive Authority among Haredi Women.* Bloomington, IN: Indiana University Press, 2020.

Ruttenberg, Danya, ed. *The Passionate Torah: Sex and Judaism.* New York: NYU Press, 2009.

Secunda, Shai. *The Talmud's Red Fence. Menstrual Impurity and Difference in Babylonian Judaism and Its Sasanian Context.* Oxford: Oxford University Press, 2020.

Sienna, Noam, ed. *A Rainbow Thread: An Anthology of Queer Jewish Texts from the First Century to 1969.* Philadelphia, PA: Print-O-Craft Press, 2019.

Shapiro, Yaakov. *Halachic Positions: What Judaism Really Says about Passion in the Marital Bed,* 2017.

Zion, Noam S. *Sanctified Sex: The Two-Thousand-Year Jewish Debate on Marital Intimacy.* Philadelphia, PA: Jewish Publication Society, 2021.

Bibliography

Abrams, Nathan. "Circumcised Cinema. Representing Jewishness on Film through Circumcision." In: Monika Kopytowska, ed. *Thought-Sign-Symbol.* Berlin: Peter Lang, 2022, 447–70.

Abu-Lughod, Lila. *Do Muslim Women Need Saving?* Cambridge, MA: Harvard University Press, 2013.

Adler, Rachel. "The Jew Who Wasn't There: Halakha and the Jewish Woman." In: Susannah Heschel, ed. *On Being a Jewish Feminist: A Reader,* New York: Knopf Doubleday Publishing Group, 1983, 12–18.

Adler, Rachel. *Engendering Judaism: An Inclusive Theology and Ethics.* Jerusalem/Philadelphia: Beacon Press, 1998.

Adler, Rachel. "Innovation and Authority: A Feminist Reading of the 'Women's Minyan' Responsum." In: Walter Jacob/Moshe Zemer, eds. *Gender Issues in Jewish Law,* New York: Berghahn Books, 2001, 3–32.

Aiken, Lisa. *To Be a Jewish Woman.* Northvale, NJ, 1992.

Alpert, Rebecca. *Like Bread on the Seder Plate: Jewish Lesbians and the Transformation of Tradition.* New York: Columbia University Press, 1997.

Amborn, Erich. *Und dennoch ja zum Leben. Die Jugend eines Intersexuellen in den Jahren 1915–1933.* Schaffhausen: Meier, 1981.

Ankori, Gannit. "The Jewish Venus." In: Matthew Baigell/Milly Heyd, eds. *Complex Identities: Jewish Consciousness and Modern Art.* New Brunswick: Rutgers University Press, 2001, 247–50.

Antler, Joyce. "Jewish Radical Feminism: Voices from the Women's Liberation Movement." *Nashim: A Journal of Jewish Women's Studies & Gender Issues* 35 (2018), 234–37.

Avishai, Orit. *Queer Judaism: LGBT Activism and the Remaking of Jewish Orthodoxy in Israel.* New York: NYU Press, 2023.

Baker, Cynthia M. *Rebuilding the House of Israel: Architectures of Gender in Jewish Antiquity.* Stanford, CA: Stanford University Press, 2002.

Balka, Christie/Rose, Andy. *Twice Blessed: On Being Lesbian, Gay, and Jewish.* Boston: Beacon Press, 1989.

Baskin, Judith. *Midrashic Women: Formations of the Feminine in Rabbinic Literature.* Hanover: Brandeis University Press, 2002.

Beck, Evelyn Torton, ed. *Nice Jewish Girls: A Lesbian Anthology.* Watertown, MA: Persephone Press, 1982.

Berner, Wolfgang. *Perversion.* Giessen: Psychosozial-Verlag, 2011.

Biale, David. *Eros and the Jews: From Biblical Israel to Contemporary America.* Berkeley: University of California Press, 1997.

Bird, Jon et al. *Nancy Spero.* London: Phaidon, 1996.

Bloom, Lisa. *Jewish Identities in American Feminist Art: Ghosts of Ethnicity.* New York: Routledge, 2006.

Boyarin, Daniel. *Carnal Israel: Reading Sex in Talmudic Culture.* Berkeley: University of California Press, 1993.

Boyarin, Daniel. *Unheroic Conduct: The Rise of Heterosexuality and the Invention of the Jewish Man.* Berkeley: University of California Press, 1997.

Braun, Christina von. "Ist die Sexualwissenschaft eine 'jüdische Wissenschaft'?" *Zeitschrift für Sexualforschung* 1 (2001), 1–17.

Bruch, Rüdiger vom/Müller, Rainer A. *Formen außerstaatlicher Wissenschaftsförderung im 19. und 20. Jahrhundert. Deutschland im europäischen Vergleich.* Stuttgart: Franz Steiner Verlag, 1990.

Cohen, Tova. *Melitzat yeshurun li-Shlomo Levisohn: Ha-yetzira ve-yotzra* [Melitzat Yeshurun of Salomo Löwisohn: The Work and Its Author]. Jerusalem: Bar Ilan University Press, 1988.

Cohn, Norman. *Pursuit of the Millennium.* London: Pimlico, 1993.

Cottin Pogrebin, Letty. *Deborah, Golda, and Me: Being Female and Jewish in America.* New York: Crown, 1991.

Daube, David. *The Duty of Procreation.* Edinburgh: Edinburgh University Press, 1977.

Debow, Yocheved. *Sexuality among Modern Orthodox Teenage Girls in Israel: A Study of the Effects of an Educational Intervention.* Ramat Gan: Bar-Ilan University, 2009.

Dose, Ralf et al. "Sexualreform." In: Kai Buchholz et al., eds. *Die Lebensreform. Entwürfe zur Neugestaltung von Leben und Kunst um 1900,* vol. 1., Darmstadt: Häusser, 2001, 121–25.

Dose, Ralf et al. "Magnus Hirschfeld. Deutscher – Jude – Weltbürger." In: Hermann Simon, ed. *Jüdische Miniaturen,* vol. 15, Teetz: Hentrich & Hentrich, 2005.

Dühring, Eugen. "Moralischer Irrsinn und Unzuchtbeschönigung." *Der moderne Völkergeist* 5 (1898), 177–86.

Efron, John, M. *Defenders of Race. Jewish Doctors & Race Science in Fin-De-Siécle Europe.* New Haven, CT: Yale University Press, 1994.

Elior, Rachel. "Jacob Frank and His Book The Sayings of the Lord: Anarchism as a Restoration of Myth and Metaphor" [Hebrew]. In: Rachel Elior, ed. *Ha-Halom v'Shivro,* vol. 2., Jerusalem: Hebrew University, 2001, 471–548.

Elior, Rachel. *The Mystical Origins of Hasidism.* Portland: Littman Library of Jewish Civilization, 2006, 189–90.

Eller, Cynthia. *Living in the Lap of the Goddess: The Feminist Spirituality Movement in America.* Boston: Beacon Press, 1995, 38–61.

Elqayam, Avraham. "To Know the Messiah: The Dialectics of the Sexual Discourse in the Messianic Thought of Nathan of Gaza" [Hebrew]. *Tarbiz* 65 (1996), 637–70.

Engelhardt, Dietrich. "Die Konzeption der Forschung in der Medizin des 19. Jahrhunderts." In: Alwin Diemer, ed. *Konzeption und Begriff der Forschung in den Wissenschaften des 19. Jahrhunderts.* Meisenheim: Hain, 1978, 58–103.

Englander, Yakir/Sagi, Avi. *The New Religious-Zionist Discourse on Body and Sexuality.* Jerusalem: Academic Studies Press, 2013.

Epstein, Yehiel M. *Arukh ha-shulhan.* 8 volumes. Jerusalem, 1992.

Erenberg, Lewis A. *Steppin' Out: New York Nightlife and the Transformation of American Culture, 1890–1930.* Chicago: University of Chicago Press, 1981.

Ettinger, Yair. 2010. "Dozens of Orthodox Rabbis Penned a Manifesto Calling for Recognition of Homosexuals and Lesbians." *Haaretz,* July 29.

Eulner, Hans-Heinz. *Die Entwicklung der medizinischen Spezialfächer an den Universitäten des deutschen Sprachgebietes.* Stuttgart: Ferdinand Enke Verlag, 1970.

Falk, Candace. *Love, Anarchy, and Emma Goldman.* New York: Holt, Rinehart and Winston, 1984.

Feinstein, Moses. *Sefer Igrot Moshe.* 9 volumes. New York: Bene Berak, 1985.

Feiner, Shmuel. *Origins of Jewish Secularization in Eighteenth-Century Europe.* Philadelphia: University of Pennsylvania Press, 2010.

Feldman, David. *Birth Control in Jewish Law: Marital Relations, Contraception, and Abortion as Set Forth in the Classic Texts of Jewish Law.* New York: New York University Press, 1995.

Fields, Armand. *Sophie Tucker: The First Lady of Show Business.* Jefferson, NC: McFarland & Company, 2003.

Fisher, E. *The Ethos of "Female Modesty" in Rabbinic Literature: Between the*

Woman's Obligation to Conceal Her Body and the Male Prohibition against Looking. Ramat Gan, 2009.

Fonrobert, Charlotte Elisheva. *Menstrual Purity: Rabbinic and Christian Reconstructions of Biblical Gender.* Stanford, CA: Stanford University Press, 2000.

Fonrobert, Charlotte Elisheva. "Regulating the Human Body: Rabbinic Legal Discourse and the Making of Jewish Gender." In: Fonrobert, ed. *The Cambridge Companion to the Talmud and Rabbinic Literature.* Cambridge: Cambridge University Press, 2007, 270–94.

Freud, Sigmund. "Three Essays on the Theory of Sexuality." In: James Strachey, trans. *The Standard Edition of the Complete Psychological Works of Sigmund Freud.* London: Hogarth, 1953, VII:123–246.

Frueh, Joanna. "So Help Me Hannah." In: Thomas H. Kochheiser, ed. *Hannah Wilke: A Retrospective.* Columbia: University of Missouri Press, 1989, 10–104.

Gafni, Isaiah. "The Institution of Marriage in Rabbinic Times." In: David Kraemer, ed. *The Jewish Family: Metaphor and Memory.* New York: Oxford University Press, 1989, 13–30.

Golden, Eunice. "Sexuality in Art: Two Decades from a Feminist Perspective." *Woman's Art Journal* 3/1 (1975), 14.

Goldish, Matt. *The Sabbatean Prophets.* Cambridge: Harvard University Press, 2004.

Goshen-Gottstein, E. R. *Growing Up in Geula: Mental Health Implications of Living in an Ultra-Orthodox Jewish Group.* Ramat Gan: Bar Ilan University, 1980.

Green, Arthur/Holtz, Barry. *Your Word Is Fire: Hasidic Masters on Contemplative Prayer.* Woodstock: Jewish Lights, 1993.

Greenberg, Blu. *On Women and Judaism.* Philadelphia: The Jewish Publication Society of America, 1981.

Greenberg, Steven. *Wrestling with God and Men: Homosexuality in the Jewish Tradition.* Madison: The University of Wisconsin Press, 2004.

Hamánn, Cesar M./Rapoport-Albert, Ada. "Something for the Female Sex: A Call for the Liberation of Women, and the Release of the Female Libido from the 'Shackles of Shame,' in an Anonymous Frankist Manuscript from Prague c. 1800." In: Joseph Dan, ed. *Gershom Scholem (1897–1982): In Memoriam,* vol. 2. Jerusalem: Hebrew University, 2007, 77–135.

Hammerstein, Notker. *Die Deutsche Forschungsgemeinschaft in der Weimarer Republik und im Dritten Reich. Wissenschaftspolitik in Republik und Diktatur 1920–1945.* Munich: C.H. Beck, 1999.

Hartman, Tova. "Modesty and the Religious Male Gaze." In: Hartman, ed. *Feminism Encounters Traditional Judaism: Resistance and Accommodation.* Waltham: Brandeis University Press, 2007, 45–61.

Hauptman, Judith. *Rereading the Rabbis: A Woman's Voice.* Boulder: Westview Press, 1998.

Herder, Johann Gottfried von. "Lieder der Liebe. Die ältesten und schönsten aus Morgenlande; nebst vier und vierzig alte Minnelieder. 1778." In: *Sämtliche Werke,* vol. 8. Hildesheim: Olms, 1967, 485–588.

Herrn, Rainer. "Magnus Hirschfeld, sein Institut für Sexualwissenschaft und die Bücherverbrennung." In: Julius Schoeps/Werner Treß, eds. *Verfemt und Verboten. Vorgeschichte und Folgen der Bücherverbrennungen 1933.* Hildesheim: Olms, 2010, 97–152.

Herrn, Rainer. *Der Liebe und dem Leid. Das Institut für Sexualwissenschaft 1919–1933.* Berlin: Suhrkamp, 2022.

Herzer, Manfred. *Magnus Hirschfeld und seine Zeit.* Berlin/Boston: De Gruyter, 2017.

Higgins, Tracy. "Reviving the Public/Private Distinction in Feminist Theorizing." *Chicago-Kent Law Review* 75/3 (2000), 847–67.

Hirschfeld, Magnus. "Zur Klärung." *Monatsberichte des Wissenschaftlich-humanitären Komitees* 6 (1907), 12, 232.

Hirschfeld, Magnus. "Das Institut für Sexualwissenschaft." *Jahrbuch für sexuelle Zwischenstufen* 19 (1919).

Hirschfeld, Magnus. *Die Verstaatlichung des Gesundheitswesens.* Berlin: Verlag Neues Vaterland, 1919.

Hirschfeld, Magnus. *Sexualpathologie,* vol. 3. Bonn: Marcus & Weber, 1920.

Hirschfeld, Magnus. "Aus der Bewegung." *Jahrbuch für sexuelle Zwischenstufen* 20 (1920), 124.

Hirschfeld, Magnus. *Geschlechtskunde.* vol. 1, Stuttgart: Meier, 1926.

Hirschfeld, Magnus. "Nachwort." In: Hermann Simon, ed. (reprint), *N. O. Body: Aus eines Mannes Mädchenjahren.* Berlin, 1993.

Hughes, Robert. 1980. "An Obsessive Feminist Pantheon." *Time,* December 15.

Hughes, Robert. *Nothing If Not Critical: Selected Essays on Art and Artists.* New York: Alfred A. Knopf, 1990.

Idel, Moshe. *Messianic Mystics.* New Haven: Yale University Press, 1998.

Idel, Moshe. "The Interpretations of the Secret of Incest in Early Kabbalah" [Hebrew]. *Kabbalah* 12 (2004), 89–199.

Idel, Moshe. *Kabbalah and Eros.* New Haven: Yale University Press, 2005.

Irshai, Ronit. "Toward a Gender-Critical Approach to the Philosophy of Jewish Law (Halakhah)." *Journal of Feminist Studies in Religion* 26/2 (2010), 55–77.

Irshai, Ronit. *Fertility and Jewish Law: Feminist Perspectives on Orthodox Responsa Literature.* Waltham: Brandeis University Press, 2012.

Irshai, Ronit/Tzion-Waldoks, Tanya. "Modern Orthodox Feminism in Israel: Between Nomos and Narrative." *Mishpat Umimshal* [Law and Governance] 15 (2013), 233–327.

Irshai, Ronit. "Halakhic Discretion and Gender Bias: A Conceptual Analysis." *Tarbut Demokratit* [Democratic Culture] 16 (2014), 1–38.

Irshai, Ronit. "Cross-Dressing in Jewish Law (Halakha), and the Construction of Gender Identity." *Nashim* 38 (2021), 46–68.

Irshai, Ronit/Avidan, Ilay. "Beyond Essentialism: An against-the-grain reading of Orthodox Jewish Law (Halakhah) on Transgender People." *Nashim* (to be published, 2024).

Kempner, Aviva. "Finally Jewish Women Have Sex on the Screen." In: *Lilith*, 25 March 1999, lilith.org/articles/finally-jewish-women-have-sex-on-the-screen, accessed 20 September 2023.

Kirshenblatt-Gimblett, Barbara. "The Corporeal Turn." *Jewish Quarterly Review* 95 (2005), 447–61.

Klein, Jennie. "Goddess: Feminist Art and Spirituality in the 1970s." *Feminist Studies* 35/3 (2009), 575–602.

Koren, Irit. *Altering the Closet: Stories of Religious Gays and Lesbians*. Tel Aviv: Yehidot Aronot, 2003.

Korff, Gottfried. "Mentalität und Kommunikation in der Großstadt. Berliner Notizen zur 'inneren' Urbanisierung." In: Theodor Kohlmann/Hermann Bausinger, eds. *Großstadt. Aspekte empirischer Kulturforschung*. Berlin: Staatliche Museen Preussischer Kultur, 1985, 343–61.

Krabbe, Wolfgang. "Die Lebensreformbewegung." In: Kai Buchholz et al., eds. *Die Lebensreform. Entwürfe zur Neugestaltung von Leben und Kunst um 1900*, vol. 1. Darmstadt: Institut Mathildenhöhe, 2001, 25–29.

Kramer, Hilton. *The Revenge of the Philistines: Art and Culture, 1972–1984*. New York: The Free Press, 1985.

Kronfeld, Arthur. "Gegenwärtige Probleme und Ziele der Sexuologie." *Deutsche Medizinische Wochenschrift* 45/41 (1919), 1140–41.

Labinsky, E. et al. "Observant Married Jewish Women and Sexual Life: An Empirical Study." *Conversations* 5 (2009), 1–15.

Lamm, Norman. "Judaism and the Modern Attitude to Homosexuality." In: L. I. Rabinowitz, ed. *Encyclopedia Judaica Year Book*. Jerusalem: Thomson Gale, 1974, 194–205.

Lehman, David/Sibzhener, Batia. "Power boundaries and institutions: Marriage in Ultra-Orthodox Judaism." *Archives of European Sociology* 50/2 (2009), 273–308.

Leibowitz, Yeshayahu. *I Wanted to Ask You, Prof. Leibowitz: Letters to and from Yeshayahu Leibowitz*. Jerusalem: Keter Publishing, 1999.

Lerner, Robert E. *Heresy of the Free Spirit in the Later Middle Ages*. Notre Dame: Notre Dame Press, 1972.

Levin, Gail. "Beyond the Pale: Jewish Identity, Radical Politics, and Feminist Art in the United States." *Journal of Modern Jewish Studies* 4/2 (2005), 205–32.

Levin, Gail. *Becoming Judy Chicago: A Biography of the Artist*. New York: Harmony Books, 2007.

Levin, Gail. "Censorship, Politics and Sexual Imagery in the Work of Jewish-American Feminist Artists." *Nashim: A Journal of Jewish Women's Studies and Gender Issues* 14 (2007), 63–96.

Liebes, Yehuda. *The Secret of the Sabbatean Faith: Collected Papers* [Hebrew]. Jerusalem: Mosad Bialik, 1995.

Lubitz, R. "The Jewish Stance on Homosexual Relations and Guidelines for Its Didactic Realization." *Mayim mi-delayav* (1996), 233–51.

Maciejko, Paweł. *The Mixed Multitude: Jacob Frank and the Frankist Movement, 1755–1816*. Philadelphia: University of Pennsylvania Press, 2011.

Maciejko, Paweł. "Coitus interruptus." In: Maciejko, ed. *And I Came This Day unto the Fountain*. Los Angeles, Cherub Press, 2016, 25–32.

Maimonides. *The Code of Maimonides: Book Four: The Book of Women*. New Haven and London: Yale University Press, 1972.

Mandel, Arthur. *The Militant Messiah: or, the Flight from the Ghetto*. Atlantic Highlands: Humanities Press, 1979.

Marcuse, Herbert. *Eros and Civilization: A Philosophical Inquiry into Freud*. Boston: Beacon Press, 1974.

Marienberg, Evyatar. *Traditional Jewish Sex Guidance: A History*. Leiden/Boston: Brill, 2022.

Mathews, Jane de Hart. "Art and Politics in Cold War America." *American Historical Review* 81 (1976), 774.

Matt, Hershel. "Homosexual Rabbis?" *Conservative Judaism* 39/3 (1987), 29–33.

Meir, Jonatan. "Jacob Frank: The Wondrous Charlatan" [Hebrew]. *Tarbiz* 80/3 (2012), 463–74.

Meyer, Laura. "Power and Pleasure: Feminist Art Practice and Theory in the United States and Britain." In: Amelia Jones, ed. *A Companion to Contemporary Art since 1945*. Oxford: Blackwell, 2006, 317–42.

Michaelson, Jay. *The Heresy of Jacob Frank: From Jewish Messianism to Esoteric Myth*. New York: Oxford University Press, 2022.

Montano, Linda. *Performance Artists Talking in the Eighties: Sex, Food, Money/Fame, Ritual/Death*. Berkeley: University of California Press, 2000.

Neusner, Jacob. *Song of Songs Rabbah. An Analytical Translation*. Georgia: Scholars Press, 1989.

Ozick, Cynthia. "Notes toward Finding the Right Question." In: Susannah Heschel, ed. *On Being a Jewish Feminist: A Reader*. New York: Knopf Doubleday Publishing Group, 1983, 120–51.

Pachter, S. *Shmirat Habrit: The History of the Prohibition of Wasting Seed*. Jerusalem: The Hebrew University, 2006.

Pardes, Ilana. *Countertraditions in the Bible. A Feminist Approach*. Cambridge: Harvard University Press, 1992.

Pardes, Ilana. *Agnon's Moonstruck Lovers. The Song of Songs in Israeli Culture*. Seattle: Washington

Pardes, Ilana. *The Song of Songs. A Biography*. Princeton: Princeton University Press, 2019.

Pedaya, Haviva. "The Iggeret HaKodesh of the Baal Shem Tov: The Style of the Text and Its Worldview—Messianism, Revelation, Ecstasy, and Sabbateanism" [Hebrew]. *Zion* 70/3 (2005), 311–54.

Pettman, Dominic. *After the Orgy: Toward a Politics of Exhaustion*. Albany: State University of New York Press, 2002.

Plaskow, Judith. *Standing Again at Sinai*. New York: Harper Collins, 1991.

Porush, Tova. *A Study of Pre-marital Education Predominantly within the Haredi Community*. MA Thesis. Jerusalem: Touro College, 1993.

Prins, Michal. *The Coping of Orthodox Women with Body and Sexuality after Marriage*. Ramat Gan: Bar Ilan University, 2011.

Quindeau, Ilka. *Verführung und Begehren – die psychoanalytische Sexualtheorie nach Freud*. Stuttgart: Klett-Cotta Verlag, 2008.

Rapoport-Albert, Ada. *Women and the Messianic Heresy of Sabbatai Zevi, 1666–1816*. London: Littman Library of Jewish Civilization, 2011.

Raucher, Michal. "People of the Book, Women of the Body: Ultra-Orthodox Jewish Women's Reproductive Literacy." *Body and Religion* 3/2 (2019), 108–29.

Raucher, Michal. *Conceiving Agency: Reproductive Authority Among Haredi Women*. Bloomington: Indiana University Press, 2020.

Reiche, Reimut. "Nachwort." In: Sigmund Freud. *Drei Abhandlungen zur Sexualtheorie* (reprint), Frankfurt a. M.: Fischer, 2005.

Ribner, David/Rosenbaum, Talli. "Evaluation and Treatment of Unconsummated Marriage among Orthodox Jewish Couples." *Journal of Sex and Marital Therapy* 31 (2005), 341–53.

Rose, Barbara. "Vaginal Iconography." *New York* 7 (1974), 59.

Rosenberg-Friedman, Lilach. *Birthrate Politics in Zion: Judaism, Nationalism, and Modernity under the British Mandate*. Bloomington: Indiana University Press, 2017.

Rosen-Zvi, Ishay. "The Evil Inclination, Sexuality, and Prohibitions against Men and Women Being Alone (*Yihud*): A Chapter in Talmudic Anthropology." *Theory and Criticism* 14 (1999), 84–55.

Rosen-Zvi, Ishay. "Do Women Possess *Yetzer?* Anthropology, Ethics, and Gender in Rabbinic Literature." In: H. Kreisel et al., eds. *Spiritual Authority: Struggles over Cultural Power in Jewish Thought*. Beer Sheva: Ben-Gurion University of the Negev Press, 2000, 21–33.

Rosen-Zvi, Ishay. "Sexualising the Evil Inclination: Rabbinic 'Yetzer' and Modern Scholarship," *Journal of Jewish Studies* 60/2 (2009), 264–81.

Rosen-Zvi, Ishay. *The Mishnaic Sotah Ritual: Temple, Gender and Midrash*. Leiden: Brill, 2012.

Rosen-Zvi, Ishay. "The Current Halakhic Status of Homosexuals: A Test Case." In: A. Rosenak, ed. *Proceedings of the Conference on "Halakhah as an Event: New Trends in the Study of the Philosophy of Halakhah."* To be published.

Ross, Tamar. "The Feminist Contribution to Halakhic Considerations: *Qol be-ishah ervah* as a Test Case." In: Avinoam Rosenak, ed. *Philosophy of Halakhah: Halakhah, Meta-Halakhah and Philosophy: A Multidisciplinary Perspective*. Jerusalem: The Jewish Law Association, 2011, 35–64.

Roth, Norman. "'Deal Gently with the Young Man': Love of Boys in Medieval Hebrew Poetry of Spain." *Speculum* 57 (1982), 20–51.

Rothstein, Gideon. 2010. "Should Orthodox Homosexuals Be Encouraged to Marry?" *Hirhurim—Musings*, 22 August.

Ruttenberg, Danya. "Heaven and Earth: Some Notes on New Jewish Ritual." In: *Reinventing Ritual: Contemporary Art and Design for Jewish Life* [Exhibition catalog, The Jewish Museum New York]. New York/New Haven: Yale University Press, 2009.

Samet, Hadar. "Ottoman Songs in Sabbatian Manuscripts." *Jewish Quarterly Review* 109/4 (2019), 567–97.

Satlow, Michael. "'Wasted Seed': The History of a Rabbinic Idea," *Hebrew Union College Annual* 65 (1994), 137–75.

Satlow, Michael. *Tasting the Dish: Rabbinic Rhetorics of Sexuality*. Atlanta: Brown Judaic Studies, 1995.

Satlow, Michael. *Jewish Marriage in Antiquity*. Princeton: Princeton University Press, 2001.

Schiff, Ellen. "What Kind of Way is that for Nice Jewish Girls to Act? Images of Jewish Women in Modern American Drama." *American Jewish History* 70/1 (1980), 106.

Scholem, Gershom. *Sabbatai Sevi: The Mystical Messiah 1626–1676*. Transl. R. J. Z. Werblowsky. Princeton: Princeton University Press, 1973.

Scholem, Gershom. *The Messianic Idea in Judaism and Other Essays on Jewish Spirituality*. New York: Schocken, 1988.

Semmel, Joan. *Imaging Eros: The Politics of Pleasure*. Unpublished essay.

Shai, Eli. *Messiah of Incest*. Tel Aviv: Yediot Ahronot, 2002.

Shmeruk, Chone. "The Frankist Novels of Isaac Bashevis Singer." In: Ezra Mendelsohn, ed. *Literary Strategies: Jewish Texts and Contexts*. Oxford: Oxford University Press, 1996, 118–27.

Shneer, David/Aviv, Caryn, eds. *Queer Jews*. New York: Routledge, 2002.

Sigusch, Volkmar. *Geschichte der Sexualwissenschaft*. Frankfurt a. M.: Psychosozial-Verlag, 2008.

Şişman, Cengiz. *The Burden of Silence: Sabbatai Sevi and the Evolution of the Ottoman-Turkish Dönmes*. Oxford: Oxford University Press, 2015.

Şişman, Cengiz. "The Redemptive Power of Sexual Anarchy." *AJS Perspectives*

(2017), http://perspectives.ajsnet.org/transgression-issue/the-redemptive-power-of-sexual-anarchy/.

Sperber, David. "The Abject: Menstruation, Impurity, and Purification in Jewish Feminist Art." In: *Matronita: Jewish Feminist Art* [Exhibition catalog, Mishkan Museum of Art, Ein Harod], Jerusalem/Tel Aviv 2012, 131–34.

Sperber, David. "Mikva Dreams: Judaism, Feminism, and Maintenance in the Art of Mierle Laderman Ukeles." *Panorama: Journal of the Association of Historians of American Art* 5/2 (2019), 1–22.

Spero, Moshe Halevi. "Homosexuality: Clinical and Ethical Challenges." *Tradition* 17/4 (1979), 53–73.

Stadler, Nurit. *A Well-Worn Tallis for a New Ceremony: Trends in Israeli Haredi Culture*. Boston: Academic Studies Press, 2012.

Steakley, James. *Die Freunde des Kaisers. Die Eulenburg-Affäre im Spiegel zeitgenössischer Karikaturen.* Berlin: Bibliothek rosa Winkel, 2004.

Steakley, James. *Anders als die Andern. Ein Film und seine Geschichte.* Hamburg: Männerschwarm Verlag, 2007.

Taragin-Zeller, Lea. "Have Six, Have Seven, Have Eight Children: Daily Interactions between Rabbinic Authority and Free Will" [Hebrew]. *Judaism, Sovereignty, and Human Rights* 3 (2017), 113–38.

Taragin-Zeller, Lea. "A Rabbi of One's Own? Navigating Religious Authority and Ethical Freedom in Everyday Judaism." *American Anthropologist* 123/4 (2021), 833–45.

Ta-Shma, Israel. *Ha-Nigle She-Banistar: The Halachic Residue in the Zohar.* Tel Aviv, 1995.

Ukeles, Mierle Laderman. "Mikva Dreams – A Performance." *Heresies: The Great Goddess* 5 (1978), 53.

Urban, Hugh. *Magia Sexualis*. Berkeley, CA: University of California Press, 2006.

Van der Haven, Alexander. *From Lowly Metaphor to Divine Flesh: Sarah the Ashkenazi, Sabbatai Tsevi's Messianic Queen and the Sabbatian Movement.* Amsterdam: Menasseh ben Israel Instituut, 2012.

Versluis, Arthur. *Secret History of Western Sexual Mysticism*. Merrimac: Destiny Books, 2008.

Wegner, Judith. *Chattel or Person? The Status of Women in the Mishnah*. New York: Oxford University Press, 1988.

Weil, Arthur. *Sexualreform und Sexualwissenschaft. Vorträge gehalten auf der I. Internationalen Tagung für Sexualreform auf sexualwissenschaftlicher Grundlage in Berlin.* Stuttgart: Julius Püttmann, 1922.

Weiss, Susan. "Under Cover: Demystification of Women's Head Covering in Jewish Law." *Nashim,* 17 (2009), 89–115.

Wilke, Hannah. "Intercourse With …" In: Thomas H. Kochheiser, ed. *Hannah Wilke: A Retrospective*. Columbia: University of Missouri Press, 1989, 139.

Wolfson, Elliot. "'Tiqqun ha-Shekhinah': Redemption and the Overcoming of Gender Dimorphism in the Messianic Kabbalah of Moses Hayyim Luzzatto." *History of Religions* 36/4 (1997), 289–332.

Yahalom, Shalem. "Moch: Family Planning in the Jewish Communities of France and Catalonia in the Middle Ages." *Pe'amim* 128 (2011), 99–162.

Yosef, Ovadia. *Responsa: Yehaveh Da'at.* 6 volumes. Jerusalem, 1977–1980.

zur Nieden, Sabine, "'Heroische Freundesliebe' ist ‚dem Judengeiste fremd'. Antisemitismus und Maskulinismus." In: Julius Schoeps/Elke-Vera Kotowski, eds. *Magnus Hirschfeld. Ein Leben im Spannungsfeld von Wissenschaft, Politik und Gesellschaft*. Brandenburg: Be.bra Wissenschaft, 2004, 329–42.

Colophon

JÜDISCHES MUSEUM BERLIN

Joods Museum

This book was published on the occasion of the exhibition

Sex: Jewish Positions

17 May–6 October 2024 at the Jewish Museum Berlin

22 November 2024– 25 May 2025 at the Jewish Museum, Amsterdam

Curated by Miriam Goldmann, Joanne Rosenthal, Titia Zoeter, and Mirjam Knotter

Exhibition at the Jewish Museum Berlin

Director
Hetty Berg

Director of Collections and Exhibitions
Julia Friedrich

Managing Director
Lars Bahners

Management Assistants
Milena Fernando, Mathias Groß, Vera von Lehsten, Eva Weinreich

Head of Exhibitions
Nina Schallenberg

Curator
Miriam Goldmann

Curatorial Assistance
Sarah von Holt, Lea Simon, Toni Wagner (research trainees)

Project Management
Deniz Roth

Student Assistant
Mascha Lücken

Volunteers (FSJ Kultur)
Paul Müller, August Went

Exhibition Design
Space4, Stuttgart

Production Management
Thomas Doetsch, Berlin

Art Handling
Fißler & Kollegen GmbH

Texts
Maren Krüger and Martina Lüdicke (German), Joanne Rosenthal (English)

Translations
Adam Blauhut, Allison Brown, Jake Schneider (German–English), Sylvia Zirden (English–German), Anne Birkenhauer (Hebrew–German)

Campaign Design
e o t. essays on typography Lilla Hinrichs + Anna Sartorius

Head of Collection Management
Gisela Märtz

Conservators
Barbara Decker, Franziska Lipp, Stephan Lohrengel, Regina Wellen

Registrars
Ulrike Gast, Petra Hertwig, Nina Fischäss (research trainee)

Documentation
Iris Blochel-Dittrich (Collections), Birgit Maurer-Porat and Valeska Wolfgram (Photoarchives)

Education Department
Oliver Glatz, Andy Simanowitz

Accompanying Program
Maria Röger, Signe Rossbach, Katja Vathke, Daniel Wildmann

Digital & Publishing
Marina Brafa, Ariane Kwasigroch (web feature), Debora Antmann

Marketing & Communication
Melanie Franke, Margret Karsch, Amelie Neumayr, Sascha Perkins, Judith Westphal, Sylvia Winkler

Fundraising
Anja Butzek, Kristin Mayerhofer
Johanna Brandt, Maria Rudolfer (FRIENDS OF THE JMB)

Events
Eva-Maria Helfrich, Yvonne Niehues, Katja Rein, Falk Schneider, Danny Specht-Eichler, Gesa Struve

Collections
Inka Bertz, Michal Friedlander, Tamar Lewinsky, Theresia Ziehe

Library
Bernhard Jensen, Monika Sommerer, Ernst Wittmann

Archives
Aubrey Pomerance, Jörg Waßmer

Exhibitions
Gelia Eisert, Shelley Harten, Daniel Ihde, Maren Krüger, Martina Lüdicke

Visitor Experience & Research
Christiane Birkert, Susann Holz, Johannes Rinke

Legal Department & Tendering
Sascha Brejora, Olaf Heinrich, Martina Krause, Julia Lietzmann, Jonas Nondorf

Controlling & Finances
Odette Bütow, Rainer Christoffers, Stefan Rosin, Katja Schwarzer

Human Resources
Manuela Gümüssoy, Mario Krogulec, Brit Linde-Pelz

Building Management
Guido Böttcher, Mirko Dalsch, Manuela Konzack, Christian Michaelis

IT
Michael Concepcion, Anja Jauert, Kathleen Köhler, Sebastian Nadler

Sponsored by

Minister of State for Culture and the Media

220

Exhibition at the Jewish Museum, Amsterdam

General Director
Emile Schrijver

Director of Finance & Operations
Liesbeth Bijvoet

Head of Exhibitions
Mirjam Knotter

Curators
Mirjam Knotter, Joanne Rosenthal, Titia Zoeter

Exhibition Management
Rianne Trap (project leader), Jos van Doesburg (exhibition coordinator)

Student Assistants
Ruben Blom, Guido Leguit, Belsie Pidcock, Lucie Ufheil, Lianne Wilhelmus

Exhibition Design
OPERA Amsterdam, Boaz Bar-Adon

Editors Exhibition Texts
Sarah Whitlau (Dutch), Joanne Rosenthal (English)

Campaign Design
Van Lennep

Conservator
Anne Roos

Registrar
Niki Lischow

Accompanying Program
Steffan Haans, Natania Dan

Marketing & Communication
Marieke van Iterson

Fundraising
Anita Soer, Ada de Mol van Otterloo

Collections
Henrike Hövelmann, Marischka de Louw

IT
VHS

Catalog

Edited by
Miriam Goldmann, Joanne Rosenthal, Titia Zoeter

Project Management & Copyediting
Marie Naumann, Helena Lutz (student assistant), Anna Reindl (research trainee), Katharina Wulffius

Translation
Jake Schneider (German–English)

Proofreading
James Copeland

Rights
Martina Krause, Anna Reindl (research trainee)

Design & Typesetting
e o t. essays on typography
Lilla Hinrichs + Anna Sartorius

Project Direction, Hirmer Publishers
Kerstin Ludolph

Project Managagement, Hirmer Publishers
Karen Angne, Katja Durchholz

Lithography
Repromayer GmbH, Reutlingen

Production
Katja Durchholz

Paper
GardaMatt Art 150g, 300g

Typeface
JMB Pro

Printing & Binding
Printer Trento srl, Trento

Printed in Italy

© 2024 Stiftung Jüdisches Museum Berlin, Hirmer Verlag GmbH, Munich, the authors, and the artists

Bibliographic information published by the Deutsche Nationalbibliothek

The Deutsche Nationalbibliothek lists this publication in the Deutsche Nationalbibliografie; detailed bibliographic data is available on the Internet at http://www.dnb.de.

The assertion of all claims according to Article 60h UrhG (Copyright Act) for the reproduction of exhibition/collection objects is carried out by VG Bild-Kunst.

The publisher reserves the right to text and data mining according to § 44b UrhG, which is hereby prohibited to third parties without the consent of the publisher.

ISBN 978-3-7774-4329-4 (English edition)

ISBN 978-3-7774-4328-7 (German edition)

www.jmberlin.de
www.jck.nl
www.hirmerpublishers.com

We have made every effort to identify all image rights and copyright holders. If we have not been able to do so, please contact the Jewish Museum Berlin.

Cover
Collage: e o t. essays on typography

including details from:

Siman Heker
Ken Goldman
Israel, 2012

WaterSlyde™
Maureen Polack
2014

That Place
Naama Snitkoff-Lotan
Israel, 2013

Catalog sponsored by

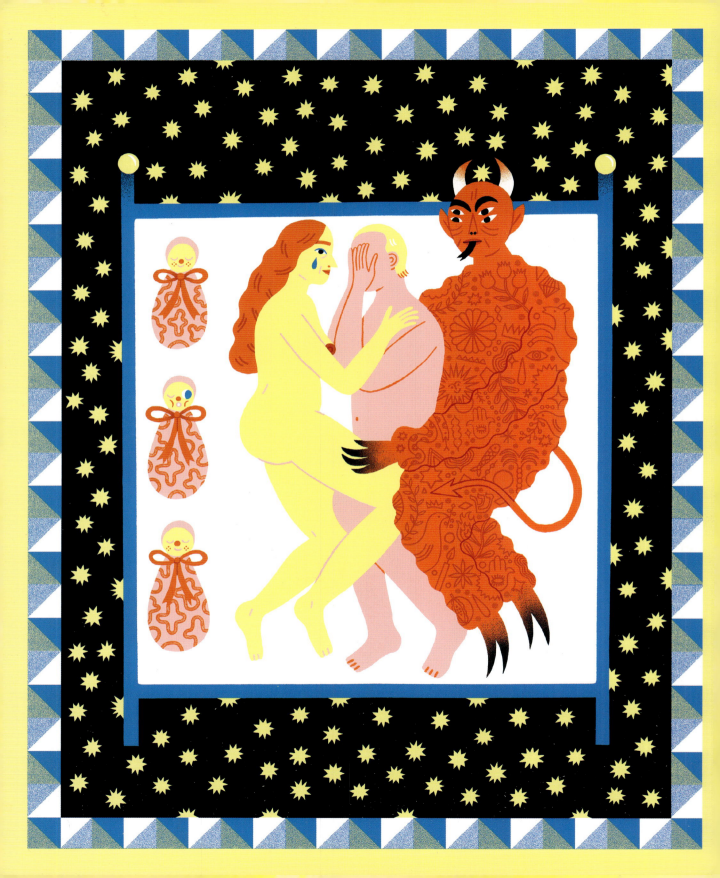

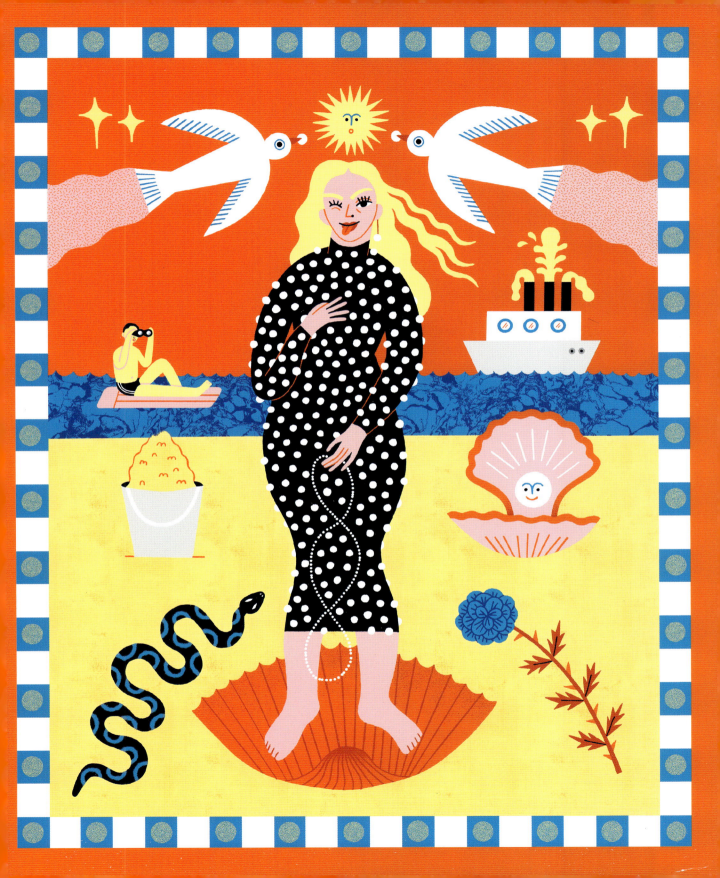

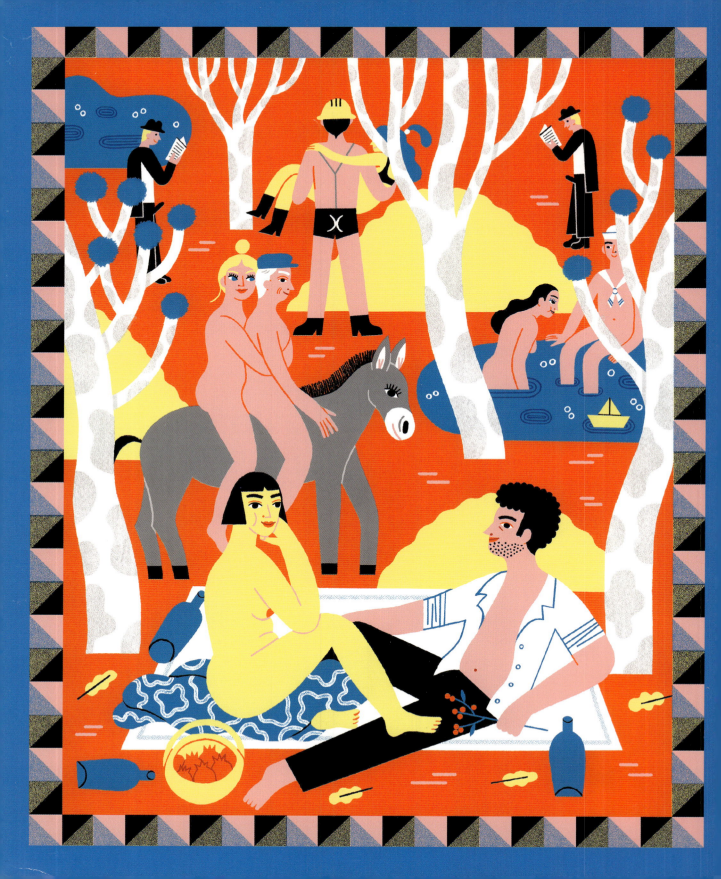